Shadows of a Hand

THE DRAWINGS OF

VICTOR HUGO

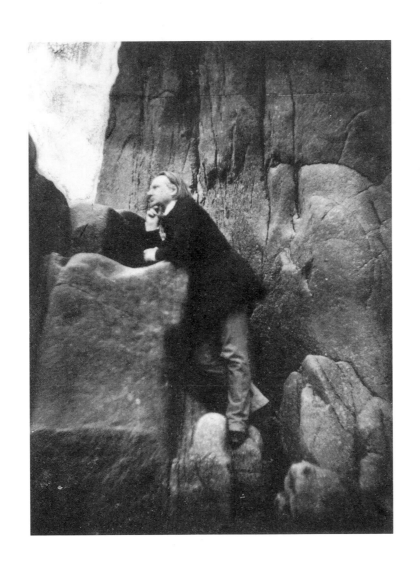

Hatching from a nameless gleam of light I see

Monstrous flowers and frightening roses.

I feel that out of duty I write all these things

That seem, on the lurid, trembling parchment,

To issue sinisterly from the shadow of my hand.

Is it by chance, great senseless breath

Of the Prophets, that you perturb my thoughts?

So where am I being drawn in this nocturnal azure?

Is it sky I see? Am I in command?

Darkness, am I fleeing? Or am I in pursuit?

Everything gives way. At times I do not know if I am

The proud horseman or the fierce horse;

I have the scepter in my hand and the bit in my mouth.

Open up and let me pass, abysses, blue gulf,

Black gulf! Be silent, thunder! God, where are you leading me?

I am the will, but I am the delirium.

Oh, flight into the infinite! Vainly I sometimes say,

Like Jesus calling out *"Lamma Sabacthani,"*

Is the way still long? Is it finished,

Lord? Will you soon let me sleep?

The Spirit does what it will. I feel the gusting breath

That Elisha felt, that lifted him;

And in the night I hear someone commanding me to go!

VICTOR HUGO

From *'Le bien germe parfois ...'* (Good sometimes germinates ...),
from the collection *Toute la lyre*, first published 1888

Shadows of a Hand

THE DRAWINGS OF

VICTOR HUGO

FLORIAN RODARI

PIERRE GEORGEL

LUC SANTE

MARIE-LAURE PRÉVOST

ORGANIZED BY

ANN PHILBIN AND FLORIAN RODARI

The Drawing Center

NEW YORK

in association with

MERRELL HOLBERTON

PUBLISHERS LONDON

This book accompanies the exhibition
'Shadows of a Hand: The Drawings of Victor Hugo'
at The Drawing Center, New York, April 16 – June 13, 1998

*This exhibition has been made possible through
generous grants from the following:*

The Howard Gilman Foundation
The Horace W. Goldsmith Foundation
The Florence Gould Foundation
New York State Council on the Arts

Cultural Services of the French Embassy
Herman H. and Ruth S. Kahn Foundation
The Lorne Michaels Foundation
Ninah and Michael Lynne Foundation
National Endowment for the Arts
Pinewood Foundation

Exhibition coordinator: Elizabeth Finch
Translations from the French by Judith Hayward
and Mark Hutchinson

British Library Cataloguing in Publication Data
Shadows of a hand : the drawings of Victor Hugo
1.Hugo, Victor 1802-1885 2.Drawing, French 3.Drawing -
France - 19th century 4.Authors as artists
I.Rodari, Florian II.Hugo, Victor, 1802-1885
741.9'44

United States Library of Congress Catalog Card Number
97–076220
ISBN 1 85894 050 8 (hardback)

© 1998 the authors
© 1998 "The Artist in spite of Himself"
Réunion des Musées Nationaux, Paris

First published in 1998 by
Merrell Holberton Publishers Ltd
Willcox House, 42 Southwark Street, London SE1 1UN

Designed by Roger Davies

Produced by Merrell Holberton Publishers
Printed and bound in Italy

JACKET/COVER Victor Hugo, *Abstract composition* (detail),
brown ink on vellum paper, Paris, Maison de Victor Hugo (cat. 16)

HALF-TITLEPAGE Charles Hugo, *Victor Hugo among the
rocks on Jersey*, 1853–55, photograph, Paris, Maison de Victor Hugo

CONTENTS

Foreword

Since its inception in 1977, The Drawing Center has pursued its mandate to present exhibitions of drawings of both emerging artists and acknowledged old masters. On rare occasions, however, we have the opportunity to present historical drawings of importance that have remained largely unknown to an American audience. 'Shadows of a Hand: The Drawings of Victor Hugo' is such an exhibition. It is with great honor that The Drawing Center presents the first museum exhibition in the United States devoted solely to Victor Hugo's drawings.

As the preeminent figure of nineteenth-century French letters, Victor Hugo (1802–1885) was accomplished as a lyric poet, playwright, novelist, and literary critic who loomed large over French cultural life for the major part of the century. Acknowledged as a leader of the Romantic movement and as an outspoken political activist whose ideals included universal suffrage and free education, Hugo embodied the notion of the poet as a public and prophetic figure. Hugo was also a devoted draftsman, producing several thousand works on paper. Despite this substantial corpus of work, Hugo's drawings remained largely a private enterprise during his lifetime, overshadowed by his stature as a writer and his own reluctance to exhibit. Although our understanding of Hugo as a draftsman is inseparable from our knowledge of him as a writer, and indeed the parallels between writing and drawing in his oeuvre are compelling to consider, this exhibition celebrates, first and foremost, Hugo's legacy as a visual artist. It presents his drawings as true products of the Romantic movement which nonetheless possess an uncanny freshness for contemporary viewers. As a draftsman, Hugo worked with a free spirit and an open mind, frequently employing found materials and chance processes which would not, for the most part, be seen again until the twentieth-century art movements of Surrealism and Abstract Expressionism. This exhibition considers Hugo's drawings within their historical context while also addressing their prescient nature.

A project such as this is the result of the efforts and support of many individuals, and we would like to take this opportunity to acknowledge and thank those who participated in its realization. Several years ago, through the good graces of Mrs Dimitri Negroponte, we were fortunate to be introduced to the great-great-granddaughter of Victor Hugo, Marie Hugo Gosh. Marie's immediate and sustained enthusiasm for our project was essential to its success, and we are greatly indebted to her and her siblings Charles, Jean-Baptiste, Adèle, Jeanne, Sophie and Léopoldine, and especially her mother Lauretta Hugo, wife of Jean Hugo, for their encouragement and cooperation.

It has been our profound good fortune to have worked on this exhibition with Florian Rodari. As co-curator of the exhibition, Florian undertook its organization with great dedication, passion and insight, and was instrumental in ensuring its success on all fronts. We offer him our gratitude for his fine scholarship and superb eye as well as his generous spirit of collaboration and friendship. For the fortuitous introduction to Florian we thank Margit Rowell, chief curator in the Department of Drawings at The Museum of Modern Art, New York.

This exhibition has also been made possible primarily through the support and commitment of two institutions in Paris: the Bibliothèque nationale de France and the Maison de Victor Hugo, who generously shared their superb collections of Hugo's beautiful works. At the Bibliothèque nationale we extend our gratitude to Jean-Pierre Angremy, president; Philippe Belaval, general director; Florence Callu, chief curator of the Department of Manuscripts, Western Division; Marie-Laure Prévost, chief curator of the Department of Manuscripts, Special Collections, whose wisdom and expertise were invaluable; Pierrette Turlais, in charge of exhibitions at Richelieu; Hélène Fauré, in charge of traveling exhibitions; René Hardy, chief conservator of the Atelier des Estampes. At the Maison de Victor Hugo our deepest appreciation goes to Danielle Molinari, director, and to Sophie Grossiord, curator of the collection, for sharing her extensive knowledge and understanding of Hugo's oeuvre. We thank as well Françoise Cachin, director of the Musées de France, for her advocacy of this project. In addition, we acknowledge the generosity of the following institutions and individuals who also graciously agreed to lend drawings to the exhibition: Musée Victor Hugo de Villequier, with deep thanks to the Conseil Général Seine-Maritime and Evelyne Poirel, curator; Musée des Beaux-Arts, Dijon, especially Emmanuel Starcky, chief curator, and Hélène Meyer, curator; Musée du Louvre, Paris, with particular appreciation extended to Françoise Viatte, general curator in the Department of Graphic Arts; Musée des Beaux-Arts et d'Archéologie, Besançon, with special thanks to Françoise Soulier-François, curator; The Art Institute of Chicago, where we are indebted to

Douglas Druick, Searle curator of European paintings and Prince Trust curator of prints and drawings, and Suzanne Folds McCullagh, curator of earlier prints and drawings; and Galerie Jan Krugier, Ditesheim & Cie, Geneva, especially Evelyne Ferlay, and the Jan Krugier Gallery, New York, especially Emmanuel Benador. This exhibition has been greatly strengthened and enriched by the generosity of the following private collectors: Anisabelle Berès, Mr and Mrs Philippe Devinat, John and Paul Herring, Jan and Marie-Anne Krugier-Poniatowski, Louis-Antoine Prat and Carol Selle. The willingness of all of the lenders to share their collections with us has given the exhibition its quality and depth.

We would like to acknowledge the contributors to this catalogue – Luc Sante, Marie-Laure Prévost, Pierre Georgel and Florian Rodari – for their thoughtful essays. In particular, we thank Mr Rodari and Mr Sante, whose insightful writings will be of particular interest to an audience versed in art of the twentieth century. We also wish to express our great appreciation to Merrell Holberton Publishers in London for co-publishing this stunning volume with us. In particular we recognize Paul Holberton, Hugh Merrell and Annabel Taylor for their great taste and patience in equal measure. For his role as advisor to the catalogue in its preliminary stages we are indebted to Christopher Sweet. For their contributions as translators we thank Judith Hayward and Mark Hutchinson. We wish as well to express our gratitude to the Réunion de Musées Nationaux, and especially Anne de Margerie, for allowing us to translate and republish Pierre Georgel's essay which originally appeared in the exhibition catalogue *La Gloire de Victor Hugo*.

We are, as usual, extremely fortunate to have on staff at The Drawing Center several talented and dedicated individuals who have made this exhibition an absorbing concern for the past several years. In particular, our endless gratitude is extended to assistant curator Elizabeth Finch who brilliantly supervised the coordination of the exhibition, catalogue and public programs. For her facilitation of all matters pertaining to the transport of the drawings, we greatly appreciate the work of registrar Sarah Falkner. In addition, we are grateful for the contributions of Anne Blair Wrinkle, Peter Gilmore, James Elaine, Bellatrix Hubert, Allison Plastridge and Paola Morsiani. The Drawing Center is indebted to numerous individuals who contributed to the exhibition in countless ways. In particular, we thank the following individuals for sharing with us their expertise, knowledge and wise counsel: Maryam Ansari, Alexander Apsis, director, Impressionist and Modern Art, Sotheby's; Jacques Benador, Jean-Pierre Biron, Elisa

Breton, Jay Clarke, Isabelle Duchesne, Marie Jaccottet-Bigand, Pierre-Antoine Lafortune, Hilary Ley, Alain Madeleine-Perdrillat, Isabelle Monod-Fontaine, Jill Newhouse, François Perreau-Saussine, Mr. and Mrs. François Raoul-Duval, Pierre Schneider and Arturo Schwarz. For their expert handling of the packing and transportation of the artworks we thank Isabelle Briand, Jean-Pierre Royer, Françoise Volat and Katharine Buckley of André Chenue. For an institution the size of The Drawing Center an ambitious project of this sort can be extraordinarily daunting, particularly with regard to fundraising, and the job is most certainly shared by intrepid and committed members of the staff and Board of Directors. On the Board we are most indebted to Edward Tuck for his tireless engagement in this process as well as Dita Amory, Frances Beatty Adler, Michael Iovenko, Werner Kramarsky and Michael Lynne. We are also very grateful to Ellen Haddigan, director of development, for her sensitive and creative orchestration of these efforts. We thank as well the following individuals whose interest and enthusiasm were vital to our fundraising efforts: Carolyn Alexander, Frederick C. Allen, Pierre Apraxine, Adam Bartos, Estelle Berruyer, Jeff Bewkes, Pierre Buhler, Patrice Burel, Michael Carroll, George De Gramont, Denis Delbourg, Robert Hughes, Elizabeth and Sidney Kahn, Christina McGinniss, Hughes Marchal, Richard Plepler, Tom Slaughter, Jacques Souilou and John Young.

Finally, it is with immeasurable appreciation that we acknowledge the following individuals and foundations whose benevolent financial support have made possible the planning and presentation of this exhibition. We express our deep gratitude to the exhibition's primary supporters: The Howard Gilman Foundation, The Horace W. Goldsmith Foundation, The Florence Gould Foundation, and the New York State Council on the Arts. We thank as well the following funders who also enabled the exhibition's realization: Herman H. and Ruth S. Kahn Foundation, André Chenue, Ninah and Michael Lynne Foundation, The Lorne Michaels Foundation, Pinewood Foundation, the National Endowment for the Arts, and the Cultural Services of the French Embassy. In addition we offer our gratitude to Air France for its in-kind support of the air travel. We are extremely grateful to all of these funders for trusting and believing that this project would constitute an important contribution to the scholarship and understanding of one of the greatest minds of the nineteenth century and for offering us all a gift of great visual pleasure.

ANN M. PHILBIN *Executive Director*
GEORGE NEGROPONTE *Co-chairman, Board of Directors*
THE DRAWING CENTER

The Octopus Bearing the Initials V H

LUC SANTE

Victor Hugo (1802–1885) has fallen into a curious sort of limbo for English-language readers; he is famed the world over for two major literary works – *Les Misérables* and *Notre-Dame de Paris* – but both are largely unread these days and known only by way of a vastly commercial musical or a Disney cartoon. Collected editions of his works in translation, published around the turn of the last century, languish in book barns, their high-acid-content paper disintegrating as you turn the previously unopened pages. The most memorable allusion to his stature is André Gide's reply, upon being asked who was the greatest poet of the nineteenth century, *"Victor Hugo, hélas!"* It is the 'alas!' that sticks. Thus Hugo might appear a grandiloquent hack, a sagging balloon leaking the tepid air of dated pomposity, a flyblown plaster bust placed somewhere with Dumas *père* and Dumas *fils* in the panorama of nineteenth-century French literature, certainly well below those enduring monuments, Balzac and Flaubert. While unjust, this assessment nevertheless contains some truth. Hugo was indeed a grandiloquent hack, but that is only one of the myriad job descriptions to which he answered in his improbably long and varied career.

In the context of his time and place, Hugo is so vast a figure that no lens can frame him. If we can call Balzac the novelist as department store – the overstimulated encyclopaedist of *petit-bourgeois* pretensions and miseries – and Flaubert the anguished miniaturist – insomniac on his fainting couch as he hesitates for weeks over a single word choice – Hugo lends himself to no such caricature except by slices. He was the boy poet long before Rimbaud (teenage *Odes* published to fanfare at twenty, in 1822), the inexhaustible Gothic-serial manufacturer (*Han d'Islande* and *Bug-Jargal* before he hit twenty-five), the fevered Orientalist (*Les Orientales*, 1829), an instigator of the 1830 July Revolution (the staged battle at the premiere of his *Hernani*), the Fagin of the very first bohemians (the Jeune-France decadents, including Gautier and Nerval, whom he conscripted for his riot). He was a stolid bourgeois, an Academician, a friend of royalty, a Peer of the Realm, a wind-filled speechifier in the Chamber and at the same time a Romantic visionary, a coiner of phrases, a deviser of enduring Gallic commonplaces, a tormentor of schoolchildren, who were made to memorize his alexandrines at great length. Before he was fifty he was known as an infamous philanderer, a scandal-monger, an opponent of authority, an increasingly militant leftist, an exile. In old age, after his return upon the fall of his enemy Napoleon III in 1870, he became epic. The nation soared on the wings of his triumphs, was racked by the grief of his many bereavements. By the time he died in 1885 he was virtually France itself. His catafalque was pharaonic, nearly filling the span of the Arc de Triomphe, which was hung with enough crepe for an army of mourners, appropriately enough since the funeral, which lasted seven and half hours, drew a crowd of half a million. His memory was preserved by heroic statuary of all distinctions; his face appeared on crockery, on soap wrappers, on ink bottles, on meerschaum pipes. It is safe to say that the world will never again see a mere writer attain that sort of overwhelming fame in his own time.

Hugo – "great, terrible, as immense as a mythic being, Cyclopean" (Baudelaire) – embodied every contradiction of his century. Although his plays have aged badly, his prose, and especially his poems, continue to be rediscovered. It might be argued that he wrote so much that his work could hardly fail to contain something for perpetual reinterpretation, but Hugo's posthumous reputation runs the whole range from the mothballed to the evergreen, touching every point along the spectrum, and this could not be happenstance or a mere by-product of excess. His poetry in particular is by turns bathetic and austere, populist and Olympian, whimsical and illuminated, pedestrian and transcendent, and appears to contain somewhere in its great mass the seeds of nearly everything that was to occur in French verse in the ensuing century. Rather than reading as the work of one man, it encapsulates the collected breath of national cross-currents. Accounting for Hugo as a totality is a task that has beggared the best minds.

On top of this we are confronted by Hugo the visual artist. Though far from being the only poet who ever painted, Hugo the artist stands out as a uniquely self-created entity, even allowing that a poet's visual expressions are generally more original and idiosyncratic than the Sunday daubings of politicians or popular singers. Hugo approached visual art as if he himself had made the concept up out of whole cloth. Scholars may well have found antecedents for his method. Earlier visionaries may also have thought that painting could, for example, involve the use of soot, black coffee, fingerprints, fingernails, matchsticks, ink-blots,

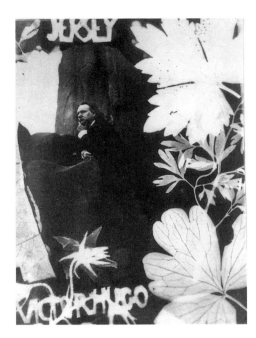

FIG. 1 Auguste Vacquerie and Charles
Hugo, *Portrait of Victor Hugo with vegetal
shapes*, photographic montage
Paris, Maison de Victor Hugo

and 2), and that in his exile on the islands of Jersey (1852–55) and
Guernsey (1855–70) he would go out with his son Charles almost
daily, posing on promontories and in front of dramatic ruins. If this
seems comical to us it is only because we have been made jaded
by a century and a half of promotional photographs and satiric
snapshots. Hugo's poses stemmed directly from conventions of
portrait painting, by Delacroix for instance, but photographically
there was little precedent. The stone porches and menhirs and
crags were for him the furniture of the demiurge – no more than
his element.

So Hugo's paintings and drawings might be seen as drawn from
the same well. Many are indeed of titanic subjects, grandiosely
depicted (see fig. 3). It does not require much of a leap to imagine
his numerous dark towers, enshrouded in mist and poised alone
on unscalable peaks, as being in some measure self-portraits. Of
course, the grandeur of Hugo's vision, and the idea he had of his
own importance, is to a certain extent a product of the Romantic
ideal he exemplified in France. The cascading vertical forms, the
storms and torrents, shipwrecks and caves and black suns were
almost Romantic boilerplate by the time of Hugo's most sustained
period of artistic production, during the nearly twenty years of his
exile. The atmosphere of many works, paintings especially, is
manifestly the same extreme world of heights and abysses first
suggested by Mannerism, brought to term by Romantics from
Caspar David Friedrich to Thomas Cole, and reaching its nearly
absurd apotheosis with the *Last Judgment* canvases of John Martin
(the eccentric who died on the Isle of Man in 1854, during Hugo's
highly charged tenancy on Jersey). But Hugo's vainglory did not
stop at identifications with landscape: his name itself looms over-
whelming in a number of works, not all of which were studies for
frontispieces to his books. The octopus that traces his initials with
its tentacles (cat. 25, p. 59) might be another sort of alter ego.

If Hugo's paintings risk appearing at first glance as further
expressions of an insatiable self finding itself too restricted by mere
words – so that his very originality of method could be called into
question as yet more arrogation, as if conventional procedures
might risk equating Hugo with beings as ordinary as simple
painters – various contradictions do present themselves. There is
the homeliness of his materials, the childlike playfulness of many
of his sketches. And there is the fact that in so many of his visual
works Hugo appears to have been groping for a way to elude his
own conscious control. A quest for untrammeled spontaneity seems
a likely explanation for his idiosyncratic methods. He did not plan
or scheme – he attacked, as one witness after another has recorded.
"Any means would do for him," wrote his friend Philippe Burty,
"the dregs of a cup of coffee tossed on old laid paper, the dregs of

stencils, sprays of water, the impression of cloth textures, of lace,
of stones, but we can be reasonably certain that rather than research-
ing the matter, Hugo simply acted, employing whatever materials
and techniques came to hand. Even if he did not invent his aleatory
procedures, he might yet have invented the ready-made more than
half a century before Marcel Duchamp – his signing and dating of
pebbles found on the beach certainly has no useful precedent. And
he presumably did none of these things to earn himself a niche in
the history of art, since his productions were intended solely for
his own pleasure or that of his children, mistresses or friends.

Those pebbles do offer one perhaps misleading key to his art.
Hugo could sign and date objects found in nature because they
came into being when he looked at them. He was not making a
statement about the illusory nature of the work of art, or engaging
in a debate about the relative value of attribution, he simply owned
the world; he might even have said, a century before Jackson
Pollock, "I am nature." The word 'ego' seems pedantically small
and flat in regard to a man who did not stop at identifying him-
self with Shakespeare and Dante – among the only mortals he
regarded as peers – but felt quite at ease seeing through the eyes
of God and Satan. Hugo's self-regard was sculpted on a titanic
scale, and was inevitably self-fulfilling. 'Vanity' seems an impre-
cise term as well; it is a word for movie actors and financiers. We
know that Hugo was fond of being photographed (see figs. 1

FIG. 2 Charles Hugo, *Victor Hugo 'listening to God,'* 1853–55, photograph
Paris, Maison de Victor Hugo

an inkwell tossed on notepaper, spread with his fingers, sponged up, dried, then taken up with a thick brush or a fine one Sometimes the ink would bleed through the notepaper, and so on the reverse another vague drawing was born." If the constituent ingredients of a given work sound vaguely like the makings of an alchemical recipe, the procedure itself is difficult to imagine taking place before the 1920s. It was aggressive and receptive at once: action painting.

Not coincidentally, it is during his exile in Jersey – between his flight in the wake of the upheaval of 1848, until a few months before his expulsion from Jersey and removal to neighboring Guernsey in autumn 1855 – that Hugo immersed himself, for an increasingly feverish two years, in an aleatory procedure of another order: communication with the spirit world. In the autumn of 1853, at the instigation of the medium Delphine de Girardin, the Hugo family and their entourage engaged in 'table-turning' sessions, in which Victor Hugo was at first a bemused onlooker and gradually an ever more active participant. The sessions appear to have begun as an attempt to make contact with the ghost of Léopoldine, Hugo's older daughter, who had drowned at twenty-one along with her husband on a boating excursion ten years earlier. In these activities the Hugos were in the vanguard, since the phenomenon of table-rapping and table-turning had begun only in 1848, with the Fox sisters, aged 12 and 15, at their family's farmhouse in Hydesville, New York. The herald among French mediums, Allan Kardec (born Léon Rivail), did not publish his *Livre des Esprits* until 1857.

The extent of Victor Hugo's belief in the manifestations that occurred at the séances remains questionable. He seems to have swung from one extreme to the other. At the beginning he took the whole thing as a joke, engaging via the table in a dialogue with the indisputably alive "*petit Napoléon.*" (As well as making the table shift from side to side – as opposed to 'turning' – the spirits would appear to have spoken through the agency of a ouija board principally manipulated by Charles; their loquacity, which increased as time went by, must have made for some very long evenings.) But Hugo seems to have been genuinely shaken by the communications from Léopoldine, who had already been appearing to him in dreams for some time. At length and after various monosyllabic encounters with a series of fairly obscure specters, he conjured up appearances by a whole pantheon: Dante, Shakespeare, Molière, Aeschylus, Galileo, Moses, Jesus Christ, St. Augustine, Voltaire, Marat, the poet André Chénier, the Ocean and Death itself. Their replies become increasingly elaborate until eventually they began speaking in verse. This verse tends, notably in cases such as those of Dante and Shakespeare, to resemble more the style of Victor Hugo than that which they themselves had written in life.

In the transcripts there are reams of nonsense, petulant snipings, strictly topical disquisitions, esoteric vagaries, and great lyric outbursts. There are evenings such as that (to choose one at random) of April 23, 1854. Charles and his mother are holding down the table; Théophile Guérin is manipulating the planchette. They have made contact with the Ocean, whose replies are brief, not to say perfunctory, and threaten to break off altogether. The Ocean has previously dictated a piece of music, and the questioners are uncertain of the key, since they are attempting to arrange a transcription for flute. Then Victor Hugo enters, and suddenly the Ocean is aroused to tumbling paragraphs:

Your flute pierced with little holes like the ass of a shitting brat disgusts me. Bring me an orchestra and I'll make you a song. Take all the great noises, all the tumults, all the fracases, all the rages that float free in space, the morning breeze, the evening breeze, the wind of night, the wind of the grave, storms, simooms, nor'easters that run their violent fingers through the hair of trees like desperate beings, rising tides on beaches, rivers plunging into seas, cataracts, waterspouts, vomitings of the enormous breast of the world, what lions roar, what elephants bellow with their trunks, what impregnable snakes hiss in their convolutions, what whales low through their humid nostrils, what mastodons pant in the entrails of the earth, what the horses of the sun neigh in the depths of the sky, what the entire menagerie of the wind thunders in its aerial cages, what insults fire and water throw at each other, one

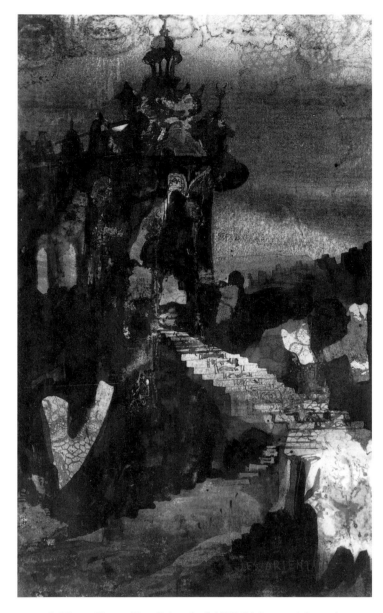

FIG. 3 Victor Hugo, "*Les Orientales*," 1855–56, brown-ink wash, charcoal, red, green and gold ink and lace impression on white paper, 7¹⁄₁₆ × 4⅜" (180 × 110 mm)
Bibliothèque nationale de France, Mss, NAF 13351, fol. 8

from the bottom of his volcanic yap the other from the bottom of his abysmal yap, and tell me: here is your orchestra – make harmony from this din, make love from these hates, make peace from these battles, be the maestro of that which has no master.

It might be said, as at least one commentator has noted, that Victor Hugo was channeling Victor Hugo. Death advised him, "Be the Oedipus of your life and the Sphinx of your grave." The most useful of the spirits proved to be the 'Shadow's Mouth,' who

dictated a sibylline revelation in six hundred verses, which Hugo went on to publish essentially intact as 'What the Shadow's Mouth Says' (*Ce que dit la bouche d'ombre*) – without, however, revealing its nominal source (the table-turning sessions were not acknowledged in print until Gustave Simon published a selection in 1923). Not that there would have been particular grounds for suspicion – the epic voice and themes bear Hugo's unmistakable mark; the verses are akin to the vast, posthumously published poems *Dieu* and *La Fin de Satan*. Had the sessions been publicized, they would have sparked ridicule (as did Simon's book retrospectively when it was published), but Hugo was sufficiently self-aware to have known that, for himself at least, the occult folderol was only cosmetic. He had discovered a means of overriding conscious control of his verse.

In addition, a certain amount of 'spirit drawing' went on in the table sessions, effected by means of a pencil replacing one of the legs of the planchette. These bear a family resemblance to other such productions, such as the drawings of the celebrated Swiss medium Hélène Smith (born Elise Mueller), whose mental excursions later in the century were studied by the psychologist Théodore Flournoy in *From India to the Planet Mars* (1899). Smith, while in the trances that took her first to "India" and then to "Mars," wrote and spoke in the languages of those places, and drew pictures that are variously childlike, ornate, and pictographic. The last resemble the planchette drawings of Jersey, in some cases echoing the effect of the pencil never being lifted off the page (see cat. 80). Flournoy was interested in Smith's productions as fruits of the unconscious mind (a linguist who studied her emanations in the Martian language found that all but two per cent consisted of altered French), while, naturally, devotees pointed to the drawings as proof that her discorporate being had actually visited those places.

Trance art of all sorts appears to have consistent features – a primitivism of conception, for example, allied with an obsessive rendering of intricate vegetal–architectural details. From the depiction of "Mozart's house on Jupiter" by the French theatrical personality Victorien Sardou in a nine-hour trance in 1858, to the three-dimensional 'Ideal Palace' in Hauterives, France, built over many years by the mailman Cheval, along with numerous examples of the art of the insane, much spontaneous artwork is driven by rhythm and repetition; line breaks down into smaller and smaller constituent elements, bauble and flourish multiply. Hugo, already possessed of Orientalist–architectural inclinations, made notebook drawings which, while rapid and cartoonish, are distinguished by a trance-like line that could best be described as fractal, their curves interrupted by a constant insect-like zigzagging.

We do not know whether Hugo's hand was indeed being pulled

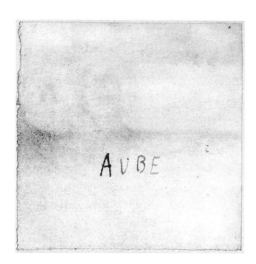

FIG. 4 Victor Hugo, *"Aube"* (Dawn),
brown-ink wash on cream paper, 2⁹⁄₁₆ × 2⁹⁄₁₆"
(65 × 65 mm), Collection Elisa Breton and
Aube Breton-Elleouët

along by an imagined force that merely used it as a mechanical extension of the pencil, as in the recorded cases of drawing mediums. Does the doodler speaking on the telephone have any more control over what issues from his hand? Though Hugo failed to leave any kind of manifesto or record, his years on the Channel Islands, during which he was bored and dislocated, trying out one venture after another – science, witchcraft, play – are powerfully evoked.

The séances ended abruptly and without explanation in the summer of 1855. Maybe Hugo no longer required their trappings. His paintings from the Jersey era generally adhere to the brooding Romantic landscape vein he had already been occasionally mining for some time (see p. 104f.), although his first use of stencils dates from the same period (see p. 78f.). In Guernsey, after the séances had stopped, Hugo's visual work became looser and freer; lace, ink-blots and coffee stains now determine subjects as well as textures (see pp. 48f., 72f.). Though now channeling matter, Hugo never truly departs from the realm of the spirits, either in his writings or his paintings. So it was with work that tapped the unconscious realm in the nineteenth century. Eidetic imagery and the occult ran in tandem, without any pretension that spirits or astral presences were in control. This applies to Goya's black paintings and *Caprichios*, the engravings of Grandville (even many of his satires), and the hallucinatory black drawings of Odilon Redon. There are rhymes and correspondences between various of these and Hugo's paintings. The hangover of Romanticism, the lingering Gothic, the subliminal power of Catholicism that extended even to the rejection of Catholicism – all contributed to a vocabulary of ritual and mystery, eyeballs and darkness and ghost ships and swirling stars.

What cleared the decks, finally, was Surrealism. André Breton's program called for a harnessing of unconscious energies while eliminating all the attendant mystification. Breton recognized Hugo from the start, including him among the predecessors of the movement. "Victor Hugo is Surrealist when he is not stupid," he wrote, an uncharitable assessment, maybe, but not untrue. At times in his work, Hugo appears to be inches away from discovering the first Surrealist principles, but blows it through his massive and grotesque sentimentality. Breton called the Jersey séances "productions ... of an astounding naïveté" in 'The Automatic Message,' the essay he published in *Minotaure* in 1933 in which he distinguished between automatism and spirit channeling, and which he illustrated with Hugo's *"Aube"* (fig. 4), reproduced to scale. Not long before this, the group had gone through its own period of séances, in which Robert Desnos would fall into a trance and emit lyrically disconnected phrases in response to questions. (The Surrealists were as fascinated with the trappings of the occult as they were repelled by its premises; many of their publications bear the pedantic appearance of *La Revue Spirite* and its counterparts, and the Bureau of Surrealist Research was a virtual parody of the various bureaus of psychic researches.)

At the same time, the Surrealists were employing ink-blots, rubbings, decalcomania, the exquisite corpse, and sundry other automatic methods, extending Hugo's experiments. Leonardo had, famously, counseled his pupils to stare long and hard at ruined walls, whose cracks and stains contained an abundance of images free for the taking; Hugo, free from any academic training, had gone further and done actual violence to his materials in order to uncover the images they concealed. He did not succeed in freeing himself from the more operatic conventions of his time but he discovered, perhaps despite himself, that the road to transcendence runs through coffee dregs. We can only surmise what he could have accomplished had he foresworn imagining himself as an immortal. Maybe his case defines genius – the triumph of the canny unconscious over the most dubious premises of the conscious mind. Hugo's feet were stuck in the ether but his vision kept touch with the ground.

"The Artist in spite of Himself"

PIERRE GEORGEL

In 1862 Hugo wrote, "I would never have imagined that my drawings … could attract attention … ." Would he not then find it incongruous that people should be concerned with them today? When he talks of these "sort of attempts at drawing … these things people insist on calling my drawings … ," "these mediocre pen-and-ink lines put down on paper more or less awkwardly and any old how by a man who has other things to do … ," we might think so. Yet Hugo also said he was "very happy and very proud" at the flattering lines Baudelaire devoted to his drawings in the *Salon of 1859*; and he kept them, framed them, exhibited them on his own walls, offered them to his circle of friends, even to painters and art critics, and indeed allowed a few dozen of them to be reproduced.

The contradictions are only apparent, and Hugo's remarks have to be put into their context, in the period around 1860. At that time there was a controversy brewing between the proponents of 'art for progress,' advocated by the author of *Les Misérables*, and those believing in 'art for art's sake,' who, not without some malice, liked to praise Hugo's drawings at the expense of his writing. It was at this very point that the engraver Paul Chenay, introduced into Hugo's circle by chance, finally got him to agree to publishing a whole album of his drawings (fig. 5). By trying first to ignore public interest in his drawings, then to moderate the zeal of certain enthusiasts – the critic Philippe Burty in particular, who had been exhorting him for years to make his drawings publicly known and even to devote himself to engraving – Hugo set out to stifle a diversion that could detract from his books, and to bring the attention of the public back to what he regarded as his primary endeavor. He saw it as in his best interests to remind people that he had "other things to do" and to present his drawings as a "simple relaxation." Until his final years that attitude would hardly change. Then, when his work would no longer be his and was about to embark on a life of its own, he bequeathed the hundreds of drawings still in his possession to the Bibliothèque nationale de France, in other words he gave them to the public: "I give all my manuscripts, and everything that is found written or drawn by me, to the Bibliothèque nationale in Paris … ."

This last move restores the true perspective. Hugo's attitude toward his drawings had a dual time scale: temporary concealment, long-term revelation. This duality can be explained by the circumstances of the day and by his determination to keep his rep-

utation under his own control, but also at a deeper level by his awareness of the drawings' motivation and 'place'. Although many of them – the sketches after nature, the caricatures, most of the imaginary compositions, which generally speaking fall within the picturesque tradition – fitted into the panorama of contemporary art without any difficulty, many others were alien to it, or at least apparently so. It was probably these "rather wild" pages, as he put it, that Hugo had in mind when he spoke in his preface to the Chenay album of the "hours of almost unconscious daydreaming" when, far away from the public and professional circles, the hand played with the materials and expressed what was beyond words. Hence, of course, the freedom of some of these drawings, so 'modern' in appearance, with which, however, he shied away from confronting the conformist conventionality of the day. Hence also their revelatory power – the power of 'automatic' writing in which

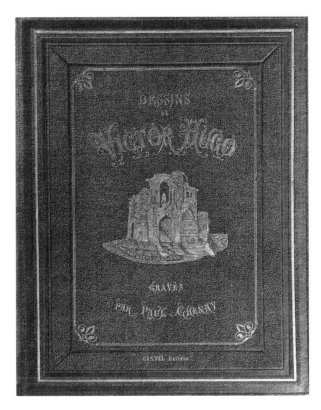

FIG. 5 Cover of the album *Dessins de Victor Hugo gravés par Paul Chenay* (Drawings by Victor Hugo engraved by Paul Chenay), Paris (Castel) 1863, Private collection

human desires and failings show through, safe from censorship.

Nonetheless, from the very beginning in about 1825 and in the decade that followed, Hugo's drawings always had a public – a limited public, in keeping with a still modest output, though it was enough to earn wholehearted applause from his family circle and friends of the house: "little caricatures" scribbled in front of close friends then placed on the beds of children who "find them when they wake up in the morning, to their great delight;" sketches sent to the family from his travels, with each arrival provoking "explosions of joy from all the children." His household started showing them to visitors, ladies requested them for their albums, and some even ended up in *amateurs'* collections, such as *The belfry of Lière* (fig. 6) published in 1838 in the *Album cosmopolite* with comments by Théophile Gautier, and immediately reprinted by *La Presse* under the heading "*Monsieur Victor Hugo dessinateur* [the draftsman]." This meant something: *La Presse* was a newspaper with a large circulation and Gautier was already a well known critic, who was unafraid to write: "M. Hugo is not only a poet, he is a painter as well, and a painter that Louis Boulanger, C. Roqueplan and Paul Huet would not disdain to acknowledge as a brother … ." From that time on until his exile in 1851, engraved reproductions turned up in journals such as *La France littéraire*, which had a fairly limited readership, but also in *L'Illustration* and *L'Artiste*. In 1847, Hugo even entrusted four drawings to the leading etcher Alfred Marvy, who used them to make engravings intended as prizes in a lottery (see fig. 7). And they certainly excited comment, as Auguste Vacquerie, then in the first flush of his Hugo worship, noted in a poem written in 1842 and published three years later:

"*Chacun explique à son gré*
Vos dessins que chacun vante … "
[Everyone explains as he pleases
Your drawings which everyone praises …]

This acclaim all amounts to very little when compared with Hugo's literary fame, and initially it was mainly in relation to his work as a writer that people took an interest in his drawings. One of them was published in 1847 in a portfolio of engravings entitled *Les Paysagistes actuels*, where it appeared alongside works by Corot, Daubigny, Dupré and Decamps. But this early incursion into artists' territory was of virtually no consequence – for Hugo at that time drawing was still a completely secondary activity. The same is not true, however, of the years from 1848 until his exile in 1851, when he virtually stopped writing. This break in his literary creativity went hand in hand with intense activity in the graphic field. *Le Burg*

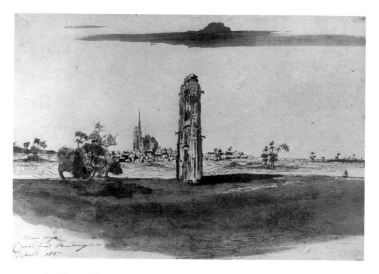

FIG. 6 Victor Hugo, Untitled drawing *(The belfry of Lière)*, 1837, dedicated to Louis Boulanger
Dijon, Musée des Beaux-Arts, Donation Granville

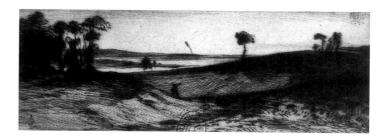

FIG. 7 Alfred Marvy after Victor Hugo, *Landscape*, etching, 1847
Paris, Bibliothèque nationale de France

à la croix (Castle with the cross; fig. 10) and other drawings, most of them dated 1850 (see p. 104f.), are real pictures, worked on for a long time; expressing a repressed poetic genius, their fantasy pushes beyond the conventions of the contemporary art of the day. Nonetheless, Hugo refrained from circulating them widely, as if he sensed their depth and unconventional nature. When Théophile Gautier described them in an article published in 1852, on the occasion of the sale of the exiled poet's furniture and effects, he started by writing: "If Victor Hugo was not a poet he would be a first-rate painter," which amounts to recognizing him as a visual artist, but is also a reminder of the primacy of his work as a writer.

So, at the very time when his graphic work was really taking shape, Hugo was also keeping the public at a distance and refusing to enter into the arena of the artists. This approach was particularly in evidence in the 1860s, when his humanitarian crusade was at its height, even though many who were nostalgic for things

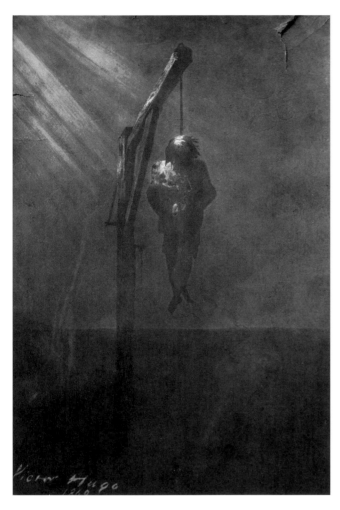

FIG. 8 Paul Chenay after Victor Hugo, *John Brown*, 1860, engraving, Paris, Maison de Victor Hugo

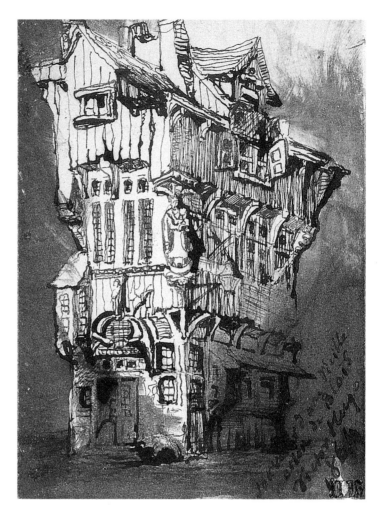

FIG. 9 Victor Hugo, *"Souvenir d'une vieille maison de Blois"* (Memory of an old house in Blois), 1864, given to Philippe Burty Paris, Maison de Victor Hugo

romantic and sated with moral literature took the opportunity to make much of his drawings, exalting their "wonderful plastic feeling" (Gautier) or "magnificent imagination" (Baudelaire). Chenay's appearance on the scene, the publication of one engraving in 1860 and in particular that of the album two years later (which turned out to be a commercial flop anyway) were ill-timed steps for Hugo, forcibly placing him – "unwillingly and in spite of myself" he was to say – in a position in which he did not want to be. The mis-understanding immediately assumed considerable proportions, as this spiteful comment by Paul Huet indicates: "The whole of Paris is absorbed by the *aqua-tinta* of Hugo, who has just published the freakish musings of his dreams to the accompaniment of fanfares and trumpets." Hugo himself summed up his position when ded-icating the fateful album to Juliette Drouet:

L'auteur, sous votre aile, aujourd'hui,
Cache ces dessins qu'on déterre.
Plaignez-le pour ce double ennui,
Etant le proscrit volontaire,
D'être le peintre malgré lui.
(The author, under your wing, today,
Conceals these drawings which are being unearthed.
Pity him for this double affliction,
Of being an exile of his own free will,
Of being an artist in spite of himself.)

At least the engraving made by Chenay in 1860 had a political bearing. It reproduced a drawing made six years earlier on Jersey following the hanging of a criminal for whom Hugo had tried to obtain a pardon, to no avail (see also cat. 77). The drawing had no

15

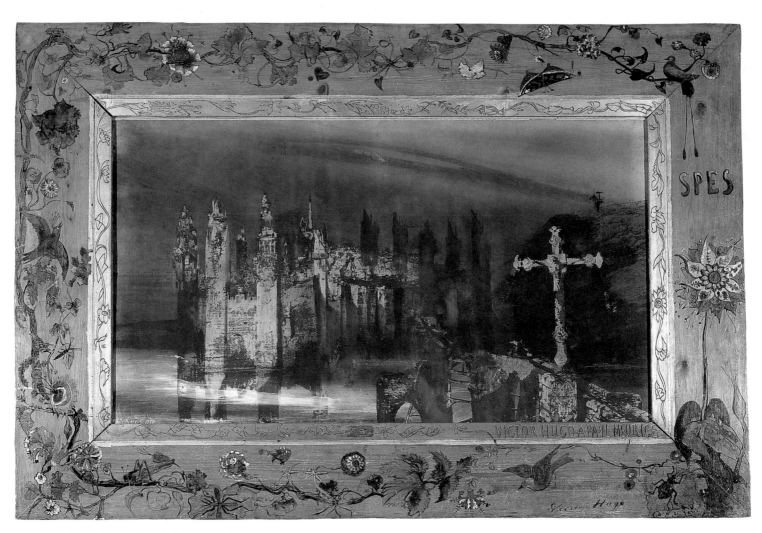

FIG. 10 Victor Hugo, Untitled drawing, known as *Le Burg à la croix* (The castle with the cross), 1850, pencil, pen and brown-ink wash, charcoal and scraping on white paper, 28 × 49⁷⁄₁₆" (711 × 1256 mm), purchased by Paul Meurice at the sale of Victor Hugo's furniture and effects in 1852 Paris, Maison de Victor Hugo

title and simply depicted a gibbet in darkness, a powerful symbol of the death penalty. In 1859 Hugo had intervened yet again – to equally little effect – in favor of another condemned man, John Brown, the American Abolitionist. It was to support his protest campaign that Hugo agreed to the reproduction of the 1854 drawing; it was engraved with the date *1860* and the title *John Brown*. The remarks in a letter sent by Hugo to the engraver with the drawing make it very clear that he was obeying a humanitarian impulse and not an aesthetic one: "Everything that contributes to the great aim of Freedom constitutes a duty as far as I am concerned, and I will be happy if this drawing, reproduced in multiple copies by your art, can contribute to keeping the memory of this liberator of our black brethren alive in people's minds … ."

By contrast the 1862 album, made up solely of landscapes and prefaced with an essay by Théophile Gautier, the high priest of art

for art's sake, was without any ideological intent. Its audience, moreover, consisted mainly of *amateurs* like Baudelaire (who twice drafted, but never published, an article on the album), the Goncourt brothers and Philippe Burty. Burty devoted an article to it in the relatively newly established *Gazette des Beaux-Arts*, quite correctly emphasizing the way the book coincided with 'the new doctrine,' the great protest movement against conservatism, rigidity, routine and compromise that was then shaking up the fine arts, and would culminate the following year with the Salon des Refusés and the reform of the Ecole des Beaux-Arts. "It is a strange thing, and we are not afraid to insist on this point, that these twenty-four drawings are in their way what the preface to *Cromwell* was to the literary school of 1830. They contain all the new doctrine … ." This view is evidence of Burty's critical talents, but, by placing him right at the heart of the arguments over contemporary art, it ran

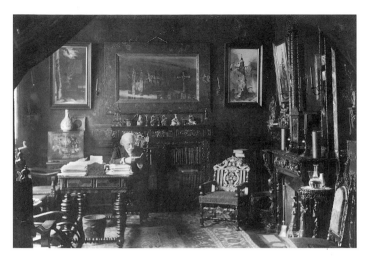

FIG. 11 *Paul Meurice in his study, ca.* 1900, photograph, Private collection. On the wall are hung one of the *Lighthouse* series (fig. 12) and *Le burg à la croix* (The castle with the cross; fig. 10)

counter to the tactics adopted by Hugo. In fact the work published by Chenay provoked favorable reactions from professional artists (both from older Romantics like Boulanger, who proclaimed *John Brown* a "work of art," declaring that "the gibbet is masterly," and from younger artists), while the influence of Hugo's drawings on the engravers of the day can be widely discerned – from Gustave Doré to François Chifflart and perhaps to Bresdin. Later on Van Gogh, not to mention anyone else, would several times express his admiration for Hugo's drawings.

At the same time as trying to shield his drawings from the curiosity of the public at large, Hugo carried on showing them to his immediate circle and giving them to his friends: as he explained in 1863, "These scribbles are for private use and to indulge very close friends." Those who benefited were his family, Juliette Drouet, his loyal friends Paul Meurice and Auguste-Edmond Vacquerie, old friends like Jules Janin, Delphine de Girardin and Léonie Biard, his companions in exile, Republicans of the new generation, and so on. Other drawings were brought back by visitors who had come from France to see him, such as Louise Colet and the painters Jules Laurens and Chifflart. Every year when New Year presents were given, 'visiting cards' in Hugo's own hand arrived in Paris with his own name appearing in symbolic landscapes (see p. 98f.). This private distribution fueling the enthusiasm of the *amateurs* carried on after the Chenay experiment, but Hugo learnt from it and for several years took to discouraging requests for drawings. Even Burty, whose persistence ended up by "degenerating into an obsession" (as he himself admitted), did not manage to extract out of him the etching he dreamt of, and had to make do with one drawing to reproduce and a few more for his personal collection (fig. 9). But

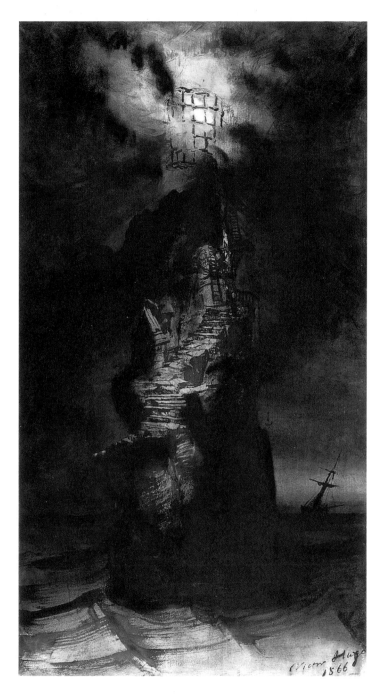

FIG. 12 Victor Hugo, *The Casquets lighthouse*, 1866, pen and brown-ink wash with lithographic crayon on white paper, 35⅜ × 18⅞" (898 × 480 mm), Paris, Maison de Victor Hugo, inv. 185

these were the last defences of "the artist in spite of himself," overwhelmed by his own fame. After his return to Paris in 1870, in the whirl of work, visits, political meetings, new books and new editions that followed one after the other, he quickly lost control of the drawings: people fought over them – his close friends, social contacts, passing conquests, art critics like Jules Claretie and Paul de Saint-Victor, actors in new productions of his plays like Sarah Bernhardt and Mounet-Sully, etc – reproduced them, wrote about them in the newspapers, and from 1876 they became one of the main attractions of *Victor Hugo illustré* published by Eugène Hugues for the popular market. It was there in particular that the drawings with which Hugo had embellished the manuscript of *Toilers of the Sea* were published; previously only a few initiates such as Chifflart had had the opportunity of seeing them.

In 1888, three years after Hugo's death, the Galerie Georges Petit put on the first exhibition of his drawings, organized by Paul Meurice (see fig. 11). It was opened by the President of the Republic, and created a great stir in the newspapers. Albert Wolff writing in *Le Figaro* commented, "For the first time we can see in outline the figure of an artist who has his place in the history of the century." He launched the idea, which was immediately taken up by Verhaeren in an article published in a Belgian journal, that "some of these drawings should go to the Louvre." Entering the Louvre without even passing through the antechamber represented by the Luxembourg collections would be the ultimate accolade for a modern artist – what a turn-about for "the artist in spite of himself!" Meanwhile Meurice was expending his energies on a project that was hardly less ambitious – the creation of the Maison de Victor Hugo. Inaugurated for the centenary of his birth in 1902 (with a little delay), from the moment it opened it displayed several hundred drawings by Hugo, and, as Edmond Rostand records, it was "a stupefying revelation." But there were still more surprises in store, for the strangest items stayed buried amongst Hugo's papers: ink-blots, prints, cut-outs, doodles from table-turning or table-rapping sessions – a dubious fringe inspired by chance, play or daydreaming. Hugo had rightly doubted that these could be described as 'drawings.' Only glimpses of these practices showed through in the more orthodox examples chosen by the careful Meurice, but what could be divined of them was enough to stir the air. Had Hugo not already spoken of his "strange mixtures" in a letter dated 1860? Since that time they had been talked about and from year to year the stories lost nothing in the telling, ending up with Léon Daudet's disquisition in his book *Le Voyage de Shakespeare* of 1896: "He had a singular and improbable method of working … . On a sheet of paper he spilt some wine, ink, prune juice, sometimes blood, when he pricked one of his veins … ."

It took a few more years for the whole gamut of his work to become apparent, and it is significant that the revelation was made by the Surrealists, the only group capable of perceiving both the poetic virtue of these strange works and the aesthetic revolution they implied. Those involved were Jean Hugo, the poet's great-grandson and himself a painter, and his first wife Valentine, also a painter, a member of the Surrealist group who for a time (*ca.* 1931–32) shared the life of André Breton. It was through her that Breton became one of the first to gain access to the famous ink-blots or *taches* (figs. 13–14; see further p. 48f.); writing in 1936 he emphasized their "unequaled power of suggestion" and he kept several examples given to him by Valentine throughout his life. Among those close to the Surrealists we may also mention Jean Cocteau, who was given two of Victor Hugo's drawings by Jean Hugo, and in Breton's immediate circle Max Ernst and André Masson, who personally confirmed to me the fascination the poet's "double vision" exerted on them (the expression comes from an essay written by André Masson in 1971). In parallel with these discoveries, confined to an avant-garde environment, from 1960 the gradual publication of the collection held by the Bibliothèque nationale and of several private collections was to reveal to the general public the complete range of Hugo's drawings. In particular the book of 1963 by René Journet and Guy Robert must be mentioned, intended for a scholarly public but widely drawn upon in popular works; also the album published in 1963 by Editions du Minotaure, a publishing house with a Surrealist tradition; the Massin edition of 1967–69, which for the first time set out to bring Hugo's graphic work together in its entirety (and successfully recorded more than two thirds of it), integrating it with his literary *Œuvres complètes*; then the exhibitions presented in 1971–72 at Villequier and Paris, and in 1974 at the Victoria and Albert Museum in London. On the centenary of Hugo's death in 1985 the entire collection of the Maison de Victor Hugo (including drawings generally kept in reserve) and a superb choice of drawings from the Bibliothèque nationale (accompanied by various works from private and public collections) were exhibited at the Petit-Palais in Paris. Other exhibitions over the last thirteen years include those held in Besançon, Zurich and Venice, as well as at the Jan Krugier galleries in Geneva and New York. The majority of these clearly showed the influence of the Surrealist vision of Hugo.

Virtually all of the views that have been expressed with regard to Hugo's drawings revolve around two concerns, namely the richness of imagination they show, which makes them a direct extension of his literary activity, and the unique position they occupy in the history of art. Under the first aspect, which relates particularly to the visionary compositions, the most interesting things

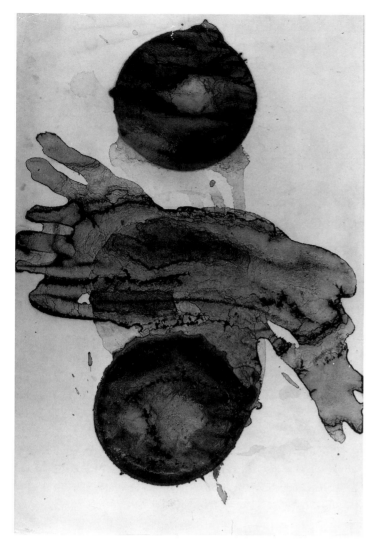

FIG. 13 Victor Hugo, *Ink-blot (tache)*, Private collection

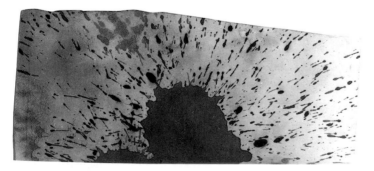

FIG. 14 Victor Hugo, *Ink-blot (tache)*, 3⅛ × 6¹¹⁄₁₆″ (80 × 170 mm), featured in the Surrealist '*musée imaginaire*,' Private collection

have been said by writers: Gautier, Baudelaire, Verhaeren, Huysmans, Claudel, Breton, etc, and by a few painters who do not share the prejudices of their profession, such as Van Gogh and André Masson (Picasso also owned several drawings by Hugo). They all agree in emphasizing the fantastical quality of these works, and the disturbed feelings they inspire in the viewer, from the "nightmare" sensation noted in 1852 by Gautier to the "kind of panic-filled contemplation" Paul Claudel talks of so magnificently in 1928. There is no substitute for direct recourse to these writings, which often have a poetic intensity matching that of the works they are commenting on. The same is true of some of the art critics, such as Burty on his good days, Gustave Geffroy, Henri Focillon, and – closer to our own day – Gaétan Picon.

Although the second concern is more historical, it cannot be separated from subjective appreciation and has given rise to very schematic views. They can be explained by the seeming isolation of these truly marginal works (which never pretended to be anything else) and the enduring persistence of the old academic debates among both critics and public. It was integral to Hugo's approach as a graphic artist to hold himself aloof, to be ignorant of the professional skills of 'real' painters, of the progress of their careers, of their relationship with the general public and the critics. Yet we are contriving to promote him to the rank of a 'true artist,' either to praise him for his professional competence – recognized particularly by Louis Boulanger, then by artists of the calibre of Benjamin-Constant, Bartholomé, Albert Besnard, Emile Bernard and Jacques-Emile Blanche – or to reproach him for his "total lack of technical mastery." Authorities of this persuasion include Schuler, the illustrator of *Les Châtiments*, who deplored his lack of "anatomical knowledge," or the brilliant teacher André Lhote, who said with regard to one drawing: "To transform this fine wash drawing, for all that it may be *inspired* (nothing is less certain), into a picture worthy of the name, would require days of work and thought … ."

This normative attitude can be seen at its most perverse in the interventions that some went so far as to perpetrate on the drawings themselves. The custodians of the great man's reputation, the successive directors of the Maison de Victor Hugo, Raymond Escholier and Jean Sergent in particular, spent some sixty years keeping everything that could nurture the "childish legend" of the "mixtures" away from the eyes of the public. They not only concealed, but 'improved.' Even in Hugo's lifetime, in 1882, the Hugues edition of *Toilers of the Sea* reorganized the manuscript, rearranging the drawings and mingling them with compositions by other illustrators. Above all, the engraved transcriptions cut out the bold touches of the originals, reducing them to the norm then prevailing for illustrated books.

Already writers of the nineteenth century like Huysmans, Verhaeren and Geffroy, or the early twentieth, like Claudel, had realized that Hugo's drawings had to be considered outside the margins of taste and professional competence, as feats of nature rather than of culture, "without rhetoric, paraphrase or translation." The first person to develop this idea at length was Henri Focillon in an article written in 1914. Here he anticipated the Surrealist aesthetic, and Breton, who found it "intellectually satisfying" that Hugo's drawings were "the work of a man who was neither an engraver nor a painter by profession," soon assigned them a revelatory place in his panorama of "magic art," opposed to the cultural arts. Following in Breton's footsteps, Gaétan Picon, in his preface to the album published by Minotaure, makes the consequences of the "ontological promotion" of the drawings clear while positioning them in Hugo's work as a whole. "The majority" seem to him to reflect "the intuitive vision of the supernatural" which, according to him, is the "essential aim of the literary work," but while the literary work is seldom faithful to that ambition, drawing is the domain of unknowing and spontaneity, contrasting with the written, the domain of the discursive, of experience, of "art."

This opposition sanctions overturning the values defended by the academic critics, but to a certain extent it rests on an academic premise itself. First it defines an ideal of spontaneity and "supernaturalism," then it establishes "the hierarchy of the work" (this expression is used) according to how it conforms to that ideal. Picon goes so far as to write, "The true drawings are those of which Hugo could say, as he did of the one dating from 1865: 'Drawn with no light at five o'clock in the evening: what I see on the wall' ... ," which amounts to discounting four fifths of his graphic work as insignificant accidents!

It is possible now to envisage a more rounded and possibly more balanced approach to the subject. It is no longer a question of taking sides but of apprehending the totality of the phenomenon. We must start by drawing up a catalogue, involving some three thousand items, and then establish their chronology, from objective information where possible. This hard task is at an advanced stage today. Putting the drawings into a chronological perspective clarifies the relationships between Hugo's graphic work and his literary work over the course of time. For example, during 1850, when the poet was inactive, we see drawing taking over and partially taking on the functions once assumed by poetry, then we see Hugo's graphic creativity decreasing in 1852–53, years of intense literary productivity. During the summer of 1866 Hugo was working simultaneously on two series of works, graphic (the three *Lighthouses* [see fig. 12] and other large-format drawings) and written (the first chapters of *The Laughing Man*) that complement and illuminate one another. A complex mechanism is at work here, spread over a period of time, in which each variety of expression has its reason for being – and makes any hierarchical classification ineffectual.

Other research has attempted to shed new light by an historical approach to the subject. It has confirmed the eccentric position of Hugo's drawings in relation to the major part of contemporary output, but at the same time links them to other traditions, long ignored or despised, study of which has made great progress during recent years. For a long time nineteenth-century art was considered only under its public or even official aspects. The work of compilation since made in art history means that it is now possible to survey a more complete panorama. Studio collections, drawn cartoons, albums of prints initially intended to be shown only to a chosen few, illustrations, theater sets, dioramas, even ladies' handiwork and party games form a disparate mass of greatly varying quality and purpose which, however, should properly be taken into consideration, because at that time it was part of shared experience. This imagery was not impervious to high culture; sometimes it is no more than a clumsy reflection of it. It also has its own conventions. But it constitutes a treasure store on which many artists have drawn, especially those who like Hugo set out to be independent of Art with a capital A. It has been shown, for example, how the silhouette view characteristic of many drawings and cutouts by Hugo is a constant mode in 'popular' imagery. The central position of Hugo's drawings in a certain "1860s Romanticism" has also been pointed out. Thus, gradually, a whole marginal culture, long suspected, is gradually coming into view, centered on one exemplary case. One may add that certain fundamental strands of twentieth-century art proceed directly from that culture. It is essential to study it to gain a clear idea of the interplay of associations and reactions that constitute the history of modern art.

Generally speaking a rather simplistic interpretation of Hugo's drawings prevails, drawing heavily on the Surrealist aesthetic, and intoning the word 'mystery' frequently. This is not the most satisfactory aspect of Hugo's critical 'fortune,' and it is to be hoped it can be modified in this exhibition and book. Hugo himself kept his distance, as when introducing the drawings in the Chenay album: "They will make their way as best they can in the light of day for which they were never intended; critics now have rights over them that make me tremble for them; I abandon them to the critics"

This essay is a slightly adapted translation of Pierre Georgel's article, 'Les avatars du "peintre malgré lui,"' in *La Gloire de Victor Hugo*, exhib. cat., Paris, Galeries nationales du Grand-Palais, 1985; the original French article contains all the bibliographical references not found here.

Victor Hugo, a Precursor *a posteriori*

FLORIAN RODARI

It has often been said that throughout his life Victor Hugo struggled to have his drawings accepted as purely personal experiments of no significance, "these things [... that] amuse [me] between two verses." It was at his friends' insistence that he gradually allowed himself to be persuaded to make public this facet of his creative work, initially shown only to those closest to him. Many reasons have been put forward to justify the writer's distrust of the artist. All are partly true, and explain one aspect or another of an imagination which is still regarded as one of the most productive and complex of the nineteenth century. In selecting the works for this exhibition, however, we have concentrated on one in particular of these many motivations: the special, intense, and very modern relationship Victor Hugo had with the medium in which he chose to express himself.

Hugo is both consistent in his choice of drawing and varied in the way he exploits it. He worked at the table, with pen, ink and paper as his only instruments; the work hardly differed from the gestures he used as a writer, and the distance between the eye and the paper was more or less the same. There was no painterly ritual, no expert preparation in the studio, no thick, slow-drying oils, virtually no color – only drawing, used to convey rays of light and shadows, as an extension of writing, preparing for it or continuing it, never completely detached from it.

The practice of drawing was part of Victor Hugo's life from beginning to end, taking on a variety of functions according to the period, from simple relaxation to supplanting his poetic imagination when, for lack of time, it could not find an outlet in words. Hugo's drawings served several objectives in turn: from adolescence, his pen provided the weapons for caricature, piercing his victim with a shaft even steelier than a cruel epithet or metaphor. Later on, and into old age, his pen amused children and described the countries he had traveled through, showing the nobility of a landscape, the venerability of buildings, their precious charm. Sometimes his drawings include a marginal note of a detail for a book in progress, outlining a situation or projecting a decorative scheme. Sometimes drawing could aid one of the many struggles that were dear to the poet's heart, for example his lifelong campaign against the death penalty. In that particular case the conviction of the drawing was immediately and powerfully apparent: the dis-

tribution of an engraving of the wash drawing entitled *The hanged man* (fig. 8; see cat. 77) rallied more doubters to the cause that Hugo had always supported than his written advocacy had ever previously done. Did the eloquent power of the image ever worry the poet? Of course not. The author of *The Last Days of a Condemned Man* may occasionally have felt a passing irritation at the excessive speed with which some of his friends, who had nothing to say on reading his written works, expressed enthusiasm for his drawings, but Hugo never regarded this aspect of his creative work as seriously competing with his writing. He loved too much the magic of words – with their power to name what cannot be depicted – to think of letting drawing take their place. On the other hand, at the right time drawing enabled him to get near to the "sound preceding words," that secret part of existence – and of the blind senses, wild with emotion – that disappears with words.

Finally, in Hugo's work there is a hesitant, feverish, questioning way of using the pen that has produced some dark, beautiful images, and this group intrigues us today even more than the rest because of a syntax that appeals to our current sensibility. These works form the core of the present exhibition. Their daring procedures as often as not convey uncertainty of time and indeterminacy of space; in them the extremes of light and shade alternate; they evoke the soaring movements and bottomless falls that the writer described at the same period in his poems – and today it is sometimes forgotten how far those poems go in expressing mental distress and in penetrating the mysteries of the soul.

In Hugo's lifetime the praise lavished on his graphic work came more from writers than painters. Public knowledge of the drawings was ensured by names as prestigious as Théophile Gautier, Charles Baudelaire and Philippe Burty. Even if most contemporary critics acclaimed above all the descriptive or visionary qualities of Hugo's drawing, some did not fail to highlight the novelty of the graphic treatment. Gautier was among them: in the preface he wrote in 1862 for a collection of engravings after Hugo's drawings, he marveled at the "vagaries of the unknowing hand" and the way the poet could let himself be almost unconsciously manipulated as he drew. This alternation of praise first for the subject, then for the way it was produced, continued beyond Hugo's death: after Edmond de Goncourt, in 1888 Emile Verhaeren drew attention

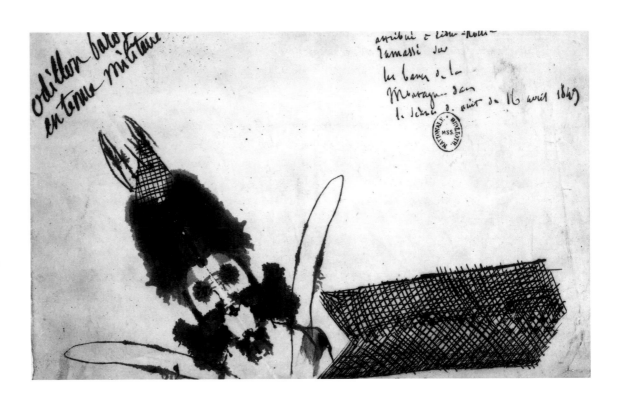

FIG. 15 Victor Hugo, *"Odillon Barot en tenue militaire"* (Odillon Barot in military uniform), *ca.* 1849, pen and brown ink, elaborating on a *tache* obtained by folding, 4⅝ × 7¹⁄₁₆" (117 × 180 mm) Paris, Bibliothèque nationale de France

to "images conveying dramas, storms, witchcraft, brawls, bloody mysteries." In 1890 Huysmans again admired "these painted torments, albeit far inferior to the tempest of his words, and [I] compare them to the sea scenes evoked in *Toilers of the Sea* and *The Laughing Man.*"

It was not until the art critic Henri Focillon analysed Hugo's drawings in 1914 that this parallel activity was accorded its true value and proper place. In a sober, pertinent study just a few pages long Focillon hailed the modernity of these "magnificent improvisations [which] are among the rarest, most beautiful works ever spawned by the imagination of a seer." He described their disconcerting effect on our habits of seeing, the constant transgression of the laws of lighting and perspective, the audacity of the procedures, the plunge into the unconscious, the pull of the infinite. This seminal text not only distinguishes between the various periods now recognized in Hugo's graphic output – before, during and after his exile from 1851 to 1870 – but also links the graphic experimentation to his other interests, in particular his liking for etching, his collector's curiosity and his passionate enthusiasm for interior decoration. All subsequent interpretations of his oeuvre owe a debt to this first clarification, reprinted in Paris in 1919 in a collection entitled *Technique et sentiment.*

In spite of that remarkable exegesis, public knowledge of Hugo's drawings grew at a trickle in the first half of the twentieth century. Isolated exhibitions and a few books, including Raymond

Escholier's *Victor Hugo, artiste* in 1926, were far from enough to make the graphic artist as celebrated as the writer. Poets were still his most fervent admirers: in 1928 in *Positions et propositions* Paul Claudel recognized that Victor Hugo's drawings had the power to give a direct view of his soul, "that maleficent chemistry of black with white, those submerged sites in which a livid, shapeless light is decanted only to reveal an incongruous jumble of objects that have lost their purpose, a past beyond redemption, ruins escaping from the opacity of an accursed world haunted by monsters and ghouls." Some years later, in an article devoted to Oscar Dominguez written in 1936, André Breton identified systematic explorations in the poet–artist's work which he paralleled with the Surrealists' deliberate abandonment of consciousness in their quest for freedom and exaltation (*"vertiges"*).

Interest in Hugo's drawings did not really intensify until the beginning of the 1950s, with the presentation of a selection of drawings in Geneva in 1951, the exhibition celebrating the 150th anniversary of his birth at the Bibliothèque nationale a year later, catalogue essays, and studies by Raymond Journet and Guy Robert on three albums belonging to the Bibliothèque nationale. Hugo's work began to be investigated more systematically and in a more objective light. In 1963 a lavishly illustrated volume entitled *Victor Hugo dessinateur* (Victor Hugo the Draftsman), with an intelligent preface by Gaétan Picon, was published by Editions du Minotaure. That was a turning-point: a few years later, in 1967 and 1969, the com-

plete works in two volumes, produced under the editorial supervision of Jean Massin, listed two thousand drawings, with a classification that was partly chronological and partly thematic. In these volumes Pierre Georgel embarked on a series of essays that have been crucial in appreciating Hugo's drawings, and in the following decade he followed these up with numerous articles. The diversity of Hugo's work was revealed in exhibitions curated by Georgel, held at Villequier and Paris in 1971 and in London in 1974. The centenary of the poet's death in 1985 was marked by a great many events, in which the role played by drawing was not neglected: the exhibition splendidly entitled *Soleil d'encre* (Ink sun) at the Petit-Palais under the aegis of Roger Pierrot, Judith Petit and Marie-Laure Prévost finally revealed to the public at large the scope and modernity of Hugo's graphic vision. In 1987 Harald Szeeman assembled a small selection of significant works at the Kunsthaus in Zurich and in 1993 Jean-Jacques Lebel presented a remarkable panorama of his art in the Galleria d'arte moderna of the Ca' Pesaro in Venice: in giving it the title *Victor Hugo peintre* (The painter Victor Hugo) Lebel rightly attempted to set his experiments in the context of contemporary attitudes.

A good many of the drawings included in this exhibition were completely unknown to the poet's contemporaries. Their daring went so far beyond what was acceptable at that period that their creator himself took fright. Nonetheless, he refrained from throwing all of them away. It took over fifty years – during which time our way of looking at the world and of depicting it changed completely – for people to allow these enigmas that had been jealously guarded in cardboard boxes finally to be deciphered. Hugo's instinct had been right: no less than his novelist's visions and his political hopes, the inventions conjured up by the artist's brush as he dreamt over his paper have withstood the test of time.

Of course, even though Hugo's graphic art appears revolutionary with regard to its period, it failed to have a concrete impact on the course of history. The avant-garde movements of the early twentieth century knew nothing of his example, nor at a later stage did the European exponents of the abstract art known as *tachisme* or *art informel*. There were too few exhibitions, and those that occurred were too little known, so this aspect of Hugo's art remained restricted predominantly to literary circles. Apart from the Surrealists, who were aware of the existence of this "means of setting down moments of exaltation [*vertiges*]" (André Breton) from the early 1930s, few artists who participated in the art revolutions of the twentieth century knew about these strange images with their suggestion of new approaches. We cannot therefore speak of influence. Even so, it is surprising to find the procedures commonly used by Victor Hugo recurring so often in the works of the

creative artists who launched the revolution in the way we look at things. We are made to realize that in this field, too, Hugo can in some way be said *a posteriori* to have been a precursor.

This modernity which is seen in Hugo's drawings is obviously recognized today because of the space that time has opened up between an earlier sensibility and our own. However, Hugo did not in fact invent any of the techniques he used. They existed and had been tried out before him, often by great artists. He himself did not see them as heralding a new manner of self-expression through painting, let alone claim that they did. Nonetheless, his freedom from artistic tradition and convention, his curiosity about the materials he used and the reactions they mutually exerted, his liking for experiment, his playfulness, too (fig. 15), and not least a kind of detachment he shows in the execution of his drawings, put him fairly and squarely on the track of twentieth-century art. Certainly he was less inhibited than in writing, at which he excelled, but where his own judgment weighed on every word: in making his wash drawings he preserved an open, carefree attitude which in all kinds of gestures and procedures presages the freedom consciously claimed by twentieth-century artists.

It is as well to recall that the first blows against the old order were struck by poets. Transformations relating to language were crucial to the questioning of accepted norms that shattered the modes of expression in Europe at the beginning of the twentieth century. In addition to the examples so often cited, Mallarmé's *Coup de dés*, Rimbaud's *Sonnet des Voyelles* and Lautréamont's *Maldoror*, perhaps we should add a few verses from the descent into hell written by Hugo in *La Fin de Satan*, or listen again to the doubts and fears that plague the pages of that huge, unfinished journey which he named *Dieu*. These texts ushered in a new way of seeing and reading in which the poetic norms of the day were redefined by the range of the questioning and the anguish of a response that never seems quite capable of being uttered; Hugo's prosody forces the reader who wishes to enjoy to the full the disturbing nature of this splendid yet worrying vision to participate almost physically in the torment that carries his lines along. Nevertheless, even as all his poetic art strained to convey by the most appropriate word, in the first place, what his appalled eye had seen, with all the aids of meter, tricks of assonance and flights of metaphor at his command, at the same time Hugo did not fail to take an interest in the support that carried his testimony: in his eyes paper was not a neutral surface, it reacted to the advances of the ink and could become an active agent in the image. Its format, the cut-outs that could be made from it, its thickness and its resistance became part of the aesthetic balance, determining rhythms and directions. Still more, the words themselves sometimes seem to seek to escape from their function as

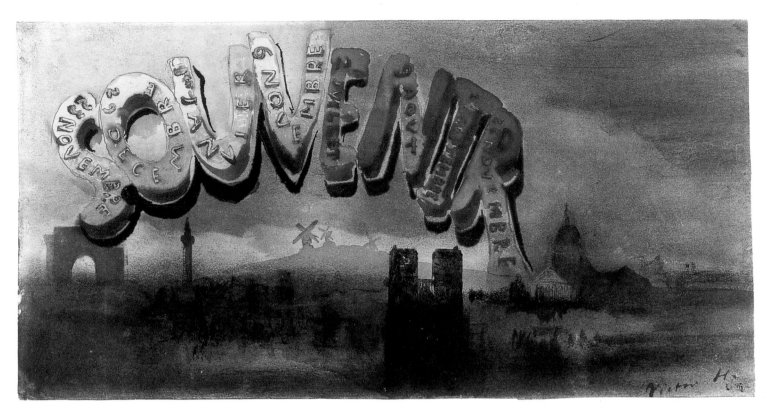

FIG. 16 Victor Hugo, *"Souvenir," ca.* 1853?, pen and brown-ink wash, charcoal, pencil, colored inks and stencil, 6 × 11⅝" (153 × 296 mm) Paris, Maison de Victor Hugo

bearers of meaning, and to acquire an autonomous existence, empty of significance, purely formal. Several drawings in this exhibition show this aspiration of letters or even whole words towards monumentality, and their tendency to mingle with the elements of landscape (fig. 16; cats. 54 and 59). Thus Hugo emerges as one of the most acute sensibilities of his time, involuntarily responsible, alongside Mallarmé, for encouraging this confrontation between the bare page and the letter, or word, and then between them and the architecture of the sheet, or even the whole book. This productive contrast imperceptibly led to the kernel of the meaning being separated from its physical envelope, disjoining the once undisputed relationship between signified and signifier: a few years later analogies and slippages of meaning of this kind would preoccupy not only the Cubist artists in Guillaume Apollinaire's circle, but the Futurists, too, and soon the Dadaists, the Suprematists in Russia, and all the writers, painters, publishers or theater directors anxious to dismantle the order that had prevailed until then.

The attraction Victor Hugo experienced for the instrument he used every day is of course not uncommon in writers. What is exceptional in his case is the intensity of the questioning he directed at the sheet of paper and the ink. His frequent switches from writing with the point of the quill pen to drawing with its barb are more than a simple love of paradox, or harmless amusement. Although the man making them pretended otherwise, they indicate a desire to reach a depth on the whiteness of the paper where words are no longer enough or cease to be viable. And the poet's vision, feasting on all the sights of nature and on the innumerable convulsions that make up its disorder, quite naturally led the graphic artist to induce dramatic metamorphoses in the material he used. Ink in his eyes was a marvelous reservoir of values and forms; all that was needed was a little push – using all sorts of expedients and mixtures – and it would come up with lots of unexpected responses and be complicated by an infinite number of movements and inflections revealed in its transparency or its process of drying.

Time and time again Hugo found new ways of proceeding on the sheet, using swabs, rags, *pliages* (foldings) or stencils, mixing it all up with powdered charcoal or crushed fragments of greasepaint. The mixtures are so odd and the instruments are used in such an unusual way that it is sometimes hard to ascertain how he set about it. A few eye-witnesses have spoken about these preparations, including Georges Hugo, the poet's grandson, who provides the most convincing account:

I sometimes saw him drawing: they were only quick little sketches, landscapes, caricatures, profiles drawn at a single stroke, which he made on any little scrap of paper. He scattered the ink haphazardly, crushing the goose quill which grated and spattered trails of ink. Then he sort of kneaded the black blot which became a castle, a forest, a deep lake or a stormy sky; he delicately wet the barb of his pen with his lips and with it burst a cloud from which rain fell down onto the wet paper; or he used it to indicate precisely the mists blurring the horizon. Then he finished off with a wooden match and drew in fine architectural details, putting flowers on the pointed arches, adding a grimace to a gargoyle, turning a tower into a ruin, and the match between his fingers became a burin.

This is eloquent testimony to the attitude of the artist towards his material and the formal propositions that arose from it as the hand explored and aroused the constituent parts of the image. It inevitably reminds us of the experiments carried out by artists younger than Hugo, using other fluids than mere paint, manhandling their support, rummaging in the material in search of buried secrets, cobbling together as best they could breaches opened up in the fabric of the visible. In particular one is forcibly reminded of that plunge into limitless, wild space ventured by another seer, the poet Henri Michaux, from the early 1930s, demanding from paper washed with watercolor that he should be freed from the straitjacket of words that were too precise, unbearable and always wide of the mark.

All kinds of formal solutions capable of responding to the secret stirrings that the poet observed everywhere were born from this tireless investigation by the eye and the hand, which would start up again as each advance was made: watery transparencies, suspensions, evaporations, crystallizations, sudden stiffenings of the material. These explorations are particularly apparent in the large compositions dating from around 1850 (see p. 104f.): in them Hugo exhibits an entire 'materiology,' a swarming of atoms and fragments that accumulate and collapse, mixtures endowed with life that are unceasingly decanted into one another. Quasi-genetic manipulations of this kind effected in the fabric of the forms, variations in the pulsation of the blacks and the whites, would doubtless have delighted Jean Dubuffet, if he had known of them: Dubuffet's earth impressions and his lattices, 'texturologies,' topographies and other fields of action are amazingly reminiscent of the works of the author of *The mushroom, Town beside a lake* or certain landscapes such as the *Landscape with bridge* (cats. 73, 67 and 34).

The interventions of chance occupy a vital place in this attention to the possible transformations of the element under his gaze.

Instead of hiding the suggestions of chance by retouching them with his pen, Hugo chose on the contrary to insist on letting them happen, and whenever he could took advantage of the disruptions that occurred. From this point of view, too – which radically overturned the perceptual order that had prevailed since the Renaissance – Victor Hugo inadvertently anticipated many twentieth-century pictorial and poetic initiatives.

The ink-blots (*taches*) which he allows to invade the paper, following their wayward tracks with an amused and attentive eye, the ink impressions which he uninhibitedly uses his fingers to make, the runs set off by the water content and halted by drying, the way he turns the support upside down, are all in a spirit that is comparable to that of an artist like Hans Arp, strewing shreds of torn paper at random over the white page so that splendid, precarious constellations are born of chance. Similarly the transfers, foldings, rubbings and other tooling applications carried out by Hugo presage the 'magic' works of artists such as Schwitters or Ernst who expected the wonder of the naked, elemental, primeval thing to emerge from the clash of the materials and the short-cuts of collage. This manner of acting – or rather of not acting, since formal initiatives are entrusted to a material supposed to be inert – is in line with the preoccupation Hugo displayed several times in his writing: that of reaching the moment preceding formulation, the infancy of expression from which unintelligible murmurs, cries or incantations arise. The same passion for the raw and unfinished again pushed him to linger in many equivocal places where forms have not yet been definitively fixed and set – fringes, verges, river banks, mists and twilight in which differences cancel one another out, contrasts lose their clarity, and the tangible gives way to the unreal; one senses he is haunted by the closed and definitive, which accords with the fascination Hugo felt for the deformed and for 'incomplete' individuals who had not yet been polished by apprenticeship to society, in whom he could find roughness, spontaneity and the primitive. Hence the transparencies of the ink, the ambiguities between vapor and water, plant life confused with indentations of stone; hence the specters and the monsters, the illusions in the foam, the reflections that mask meaning, and Hugo's interest in scribbles, graffiti, the grotesque and caricature (fig. 17 and cat. 84).

It is on these boundaries that Hugo's heroes dream, and through this permeable enclosure that the unknown appears to them; here, on the margins of sleep, at the onset of night or the ocean, contemplation gives access to other realities, allows other languages to be read. This assiduous frequenting of thresholds likewise explains the interest Hugo took for several months in table rapping in 1852. The fact that he succumbed to the fashion for spiritualism, and even contributed to the morbid atmosphere of these séances

LEFT FIG. 17 Victor Hugo, *Grotesque four-headed character, ca.* 1856, pen and brown ink, 3¾ × 6" (95 × 153 mm)
Paris, Bibliothèque nationale de France

ABOVE FIG. 18 Victor Hugo, *"Spiritus Malus"* (Evil spirit), pencil drawing from a 'spirit sketchbook' dating from Spring 1854, 11⁸⁄₁₆ × 16⁹⁄₁₆" (292 × 420 mm), Paris, Bibliothèque nationale de France

in Jersey by his deliberately dramatic interventions, matters very little when all is said and done. The crucial point about these experiments lies in their being attuned to the world beyond, in the receptivity of his unquiet being to voices from elsewhere that had long been silent or could not be believed. These phenomena of suggestion – by which he was in fact only half convinced – renewed and reinforced within him the dialogue with the abyss. Yet again, curiosity won the day with Hugo: he felt the need to venture into the dark that frightened him, not to titillate his senses, but with the object of exploring the world that lay behind the door, and enriching his mind with the knowledge of other realities. In this journey toward a world-in-between, in which "strange animal creatures ... terrible or smiling livid apparitions ... floating forms in the dark" draw near to the waking sleeper (figs. 17 and 18), Hugo would be joined a few years later by Max Ernst, a confirmed somnambulist, one of the few painters who had the opportunity to see and admire some of Hugo's drawings. Not only was Ernst endowed with a visionary power comparable to Hugo's, with an equal capacity to intensify his imaginative faculty by staring at a detail for a long time, but in both cases the images often oscillate between two planes, the real and the imaginary, unsure of the threshold separating them, engendering in the viewer a sense of *déjà vu*, of a country that is known but cannot be reached.

The mind's acquiescence to the unconscious forces summoned up by descent into one's own inner self leads quite naturally to a relaxation of the hand and an abandon of acquired skill in favor of spontaneous impulses and outside influences. However, there is nothing to suggest that Hugo ever succumbed to the kind of practices which result in a loss of control, of which the successes are as freakish as the failures are disappointing. However near the poet went to the gulf, he never completely lost his balance. Something stronger held him at the edge, in spite of a persistent attraction to being submerged beneath the waters or dazzled in an excess of light. He never ceased to observe the ink-blots on his page, and the convulsive movements of his pen, especially in the series of so called bizarre or grotesque drawings, always remain linked to the figure, if only distantly.

On the other hand, we may legitimately see his experience of controlled drift as similar to the experiments and research carried out by the artists who in the 1950s devoted themselves to *art informel*. There can be no doubt that gestural painting has its origins in examples that have no historical association with Hugo's drawings, and it would be a gross error to see the author of *Les Misérables* as the "father of modern painting," as one journalist mistakenly did in 1963. Nonetheless, when looking at some of Hugo's pages, brushed over by a careless pen, as if responding only to the dictates

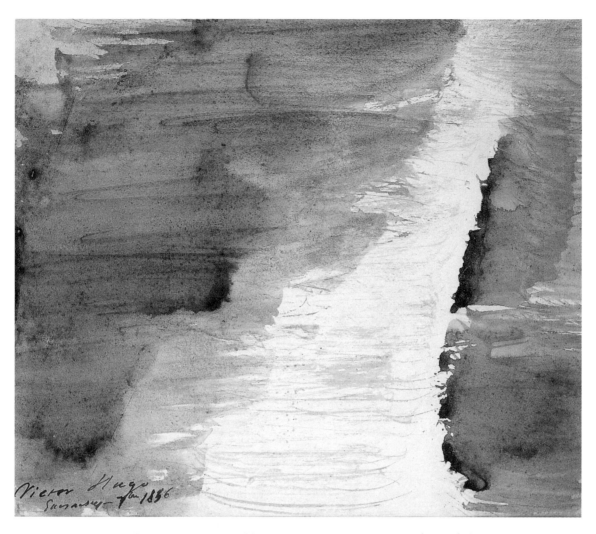

FIG. 19 Victor Hugo, *Seascape*, 1856, pen and brown-ink wash on stiff paper, 10¹⁄₁₆ × 11¼"
(255 × 286 mm), signed bottom left *Victor Hugo/Guernesey – 7bre 1856*, Private collection

of an inner voice (fig. 19), we can only wonder. The incredible novelty of these compositions that go back to his years of exile in the Channel Islands does not lie mainly in the disappearance of all figurative references; what is really surprising is that, as in the work of the most talented abstract artists, the space is quite definitely no longer of the kind that can accommodate Euclidean geometry: in the absence of a true center and of any firm attachment with the edges, our gaze floats undecidedly between depth and surface, top and bottom, the right and the wrong way around.

In the middle of the nineteenth century Victor Hugo did not discover fortuitously what would later be called abstraction – a term that is very far from conveying the richness and diversity of the visual experience in question. In his case the buried reality of the visible was sited in his eye, it was the product of his searching gaze questioning the unknown. It was his desire that summoned up the dark side of things. In his behavior, no less than in his literary and graphic work, he felt a continual need to draw near to dizzy exaltation, to pass through chaos. He went as far as to say, "Exaltation is a tremendous lucidity" (*Le vertige est une lucidité formidable*), adding more specifically, "particularly an exaltation carrying you simultaneously towards day and night, composed of two eddies turning into opposite directions. One sees too much and not enough. One sees everything, and nothing." He revels in the whirlpool that blinds and disorientates him. This feeling of panic mingled with terror, this way of directing his gaze, without preconceptions, without safety barriers, into the heart of chaos, yet again links Hugo's experience to the art of our century: a similar confidence in the void, a similar exalted excitement toward excess,

is believed to have gripped painters like Jackson Pollock, Willem De Kooning, Mark Tobey or Franz Kline when they abandoned themselves to the trepidation of space and the impetuous flux of colors. One difference, though, between Hugo's vision and the visions of these contemporary artists is that they confronted loss of reference-points with a sort of serenity acquired through years of struggling against traditional representation, whereas the author of *Toilers of the Sea* threw himself into the water alone, not knowing if he would be able to get out.

There are many more instances of the complicity between Hugo's gaze and ours, as the perceptive register of his eye was so huge, capable of all forms of creation. His obsession with hoarding, his voracious collector's eclecticism, his love of the discarded fragment placed in a new context, are not so far removed from several devices used by European artists both at the end of the First World War and a few decades later. In the small theaters that his ink washes represent, one can also see certain visual ambiguities and detours of meaning engendered by the kind of false perspectives, reflections or breaks in logic that were the delight of the Dada movement and its countless heirs. One could mention random landscapes, tracks leading nowhere, and flux. We could continue this little game for a long time, and we would not be completely wrong, but perhaps we would miss the main point. Looking at a drawing by Victor Hugo is not a question of lining up references or weaving parallels between two centuries. In the final analysis we must allow the drawings to remain silent, allowing their profound originality to express itself in its own irreducible language. This is the intention in the catalogue that follows.

This is not to deny that half a century of radical transformations has not altered our perspective, and that as a result we may read the secret of these drawings differently and may perhaps extract even more riches from them. Indeed, the ability to withstand the test of time, to be susceptible to different angles of approach and to provide plentiful food for new interpretations is the mark of a great work. Pietro Sarto, a painter who admired Hugo passionately and illustrated his fragmentary poem *Le Rhin* (The Rhine) a few years ago, has remarked that Hugo's creative work was "fractal." By that he meant that everything in his oeuvre is indissolubly linked, and concentration on one aspect of it can never obliterate the whole. Each fragment contains and reconstructs the total vision. A certain line written at the end of Hugo's life sheds light on a poem written at the start, a certain early motif reappears months, years later and fits ideally in the place evidently intended for it, grafting itself seamlessly into the network of images Hugo is busy weaving. The drawings do not explain a drop in Hugo's literary output, they take their place naturally within it – carrying on where it leaves off by means of different rhythms, coming face to face with the unknown along a different path. They will never replace the poet's prodigious vitality, the inexhaustible inventiveness of his words, the terrible nocturnal beauty of the images he builds up from words, as some people may have believed. But, on occasion, they speak more directly than Hugo's writing, buried underneath the weight of too much fame, and therefore dust. So it is to be hoped that looking at the drawings will encourage the public to go back and reread the works of this excellent poet. A detour via the meanders of the wash drawings would then lead back, after a necessary intermission – an intermission necessary so that we can rediscover the means of reading it more deeply – to the unceasing splendors of Hugo's writing.

CATALOGUE

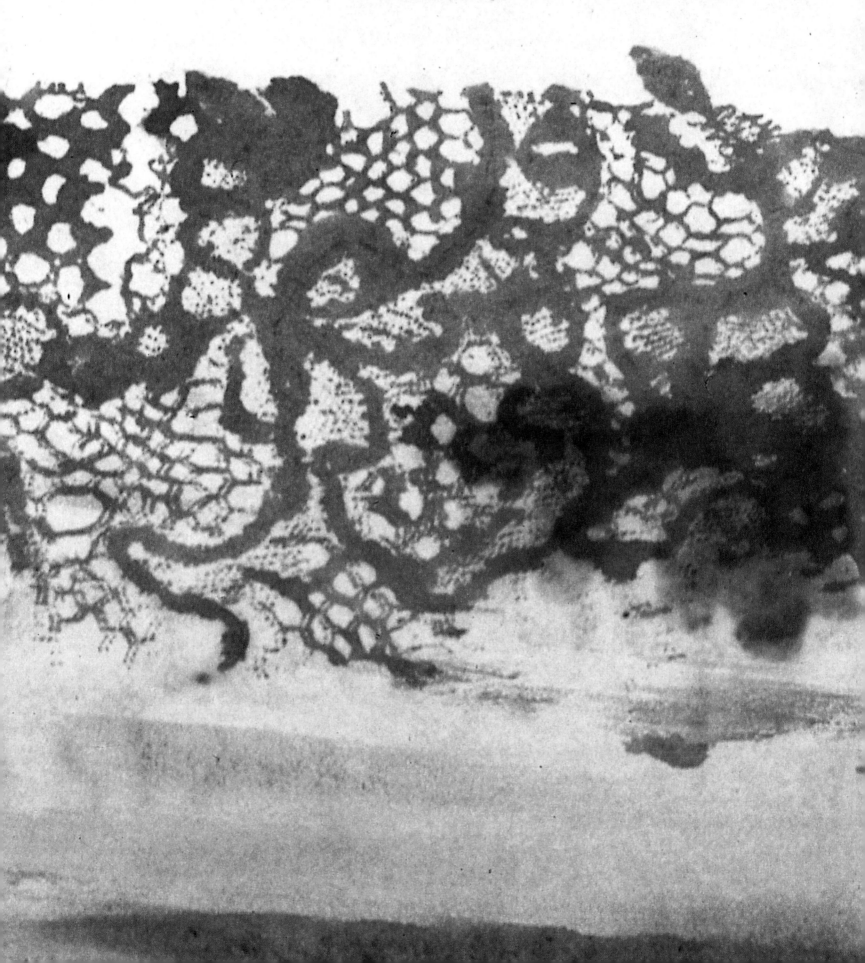

PART I: TECHNIQUES

The selection of drawings presented in this catalogue does not cover all Victor Hugo's graphic work, which numbers nearly three thousand items. Certain aspects of his oeuvre have deliberately been ruled out, such as drawings too obviously connected to manuscripts and the numerous caricatures he "didn't want," along with travel notes and sketches of buildings; instead, we have concentrated on that part of his work which intrigues contemporary artists and audiences by virtue of its liberty and inventiveness.

The hundred or so drawings selected here are not arranged in strictly chronological order, though care has been taken to respect shifts in style and theme relating to events in Hugo's life. Hugo's activities as a draftsman only began in earnest in 1830 and came to a close in 1871. The drawings that interest us are spread out, broadly speaking, between 1847 and 1865. These were Hugo's most fertile years as a draftsman, both for the interest he took in the craft and for the depth of vision he achieved facing the ocean, amid the landscapes of the Channel Islands where he lived out his exile between 1852 and 1870.

The first part of the catalogue considers separately the principal materials and techniques that form Hugo's drawing vocabulary. This classification should not, of course, appear restrictive: more often than not, a drawing will combine two or more techniques. We thought it less important to give precise descriptions of techniques – the real secret of which is nearly always elusive – than to try to understand Hugo's reasons for choosing them and the effects they enabled him to achieve.

All these experiments with different media attest to the exceptional curiosity of Hugo's gaze. His eye simply recorded the spectacle of the world in a passive way, but continually questioned the forms of nature, realigning axes and adjusting focal lengths so as to invent new relationships. In many respects, in his quest to put his vision down on paper, Hugo forces the eye of the spectator, in its turn, to become engaged in the process of seeing; and, in what was a novelty for his time, to forsake the dominant position of its gaze in favor of immersion in the random and disorderly swarm of things.

EDITORIAL NOTE

Unless devised by Hugo himself (in which case they are given in quotation marks), the titles of the drawings are derived from the catalogues of Jean Massin (Massin, I, 1967 and Massin, II, 1969) or from *Soleil d'encre* (Paris 1985).

Entries signed MLP were written by Marie-Laure Prévost. Unsigned entries are by Florian Rodari.

The Techniques of a Poet–Draftsman

MARIE-LAURE PRÉVOST

"I'm very happy and very proud that you should choose to think kindly of what I call my pen-and-ink drawings. I've ended up mixing in pencil, charcoal, sepia, coal dust, soot and all sorts of bizarre concoctions which manage to convey more or less what I have in view, and above all in mind. It keeps me amused between two verses," wrote Victor Hugo to Baudelaire on April 29, 1860.

According to several other descriptions, too (some of which have already been quoted in the preceding essays), Hugo's drawing techniques were highly unusual. Accounts of them go back at least to 1842. One of the fullest is by his son, Charles Hugo:[1]

"Once paper, pen and ink-well have been brought to the table, Victor Hugo sits down and without making a preliminary sketch, without any apparent preconception, sets about drawing with an extraordinarily sure hand not the landscape as a whole but any old detail. He will begin his forest with the branch of a tree, his town with a gable, his gable with a weather vane, and, little by little, the entire composition will emerge from the blank paper with the precision and clarity of a photographic negative subjected to the chemical preparation that brings out the picture. That done, the draftsman will ask for a cup and will finish off his landscape with a light shower of black coffee. The result is an unexpected and powerful drawing that is often strange, always personal, and recalls the etchings of Rembrandt and Piranesi."

Richard Lesclide claimed to have seen Hugo making use of mulberry juice, burned onion and cigar ash, while Paul Meurice stated that Hugo "poured a little ink over part of the sheet; then, with infinite patience and marvellous skill, gently, carefully scratched away, scratched obstinately away"[2]

In actual fact, Hugo seems to have made only occasional use of coffee and other unusual materials. Restoration work required by the drawings has revealed that generally the poet employed metallogallic ink.[3]

Hugo's account books are an invaluable source of information.[4] They show him – in Guernsey and during his travels, as well as after his return from exile – buying, like any artist, pencils, "colors" [*i.e.* paints], India ink, iron nibs, bottles of ink, paintbrushes, "sketch pads," red ink, drawing paper, a bottle of drawing gum, a box of watercolors in tubes, sepia, lithographic pencils, "tubes of white [paint]," niello paints. Other materials turn up less

frequently: books of gilt leaf, silver leaf, a press and copying ink (but were they used for drawing?), a copper plate

His correspondence is likewise useful, as can be seen from this letter to Meurice: "Would you then call in at Susse's and buy me a dozen cakes of English sepia (which, being English, can't be found in England), [and] a dozen fat black crayons known as lamp blacks?" (February 5, 1856).

Meanwhile spectrographic analysis carried out by the French Centre National de la Recherche Scientifique on certain drawings has proved that, for the frontispiece he drew for *Toilers of the Sea*, Hugo employed a green paint made from "blue ash" that was of exclusively English manufacture in the nineteenth century.

What is striking, however, is the astonishingly inventive use Hugo made of all these materials: highlights of gold leaf have been applied to the composition called *Les Orientales* (fig. 3 on p. 11), while a drawing examined under magnification reveals the use of crushed graphite (Massin, II, no. 971). As Meurice pointed out, Hugo used scraping (*grattage*) to depict cloudy skies, notably in compositions dated, or datable to, 1847. This practice is constant throughout his graphic work, however, as can be seen from the drawings made during his trip to Luxembourg in 1871, for example (see Massin, II, no. 411).

TACHISM

One favorite technique of Hugo's was to develop a drawing from an ink-blot or blots or from stains (*taches*), hence the term 'tachism.' He used 'tachism' from before his time in exile (1852) through to his last years as a draftsman (cats. 16–30), though examples appear to date mostly from the last ten years of his exile (1860s). By about 1855 he had adopted the characteristic habit of spreading the ink across the sheet in streaks. Equivalent to "the whirl of elements" of the ocean on which he gazed from Guernsey, tachism, as Jean Gaudon and Pierre Georgel have observed, could give graphic expression to the inchoate ideas of *Dieu* and *La Fin de Satan*, the major literary works on which he was busy at the time. An inscription Hugo made on a drawing – "*toujours en ramenant la plume*" [always bringing the pen back round] (cat. 1) – and certain remarks of his recorded by Jules Laurens sum it up: "Ah! you're familiar with my daubings? They are not, I would say, at

too presumptuous a remove from my main line of work, since I make them with the two ends of my only instrument, that is to say by drawing with the nib of a goose quill and painting with the bristles of the barb."[5]

PLIAGES

Taches could also be brought about by *pliage* (folding), as can be seen in cats. 64–71. The practice of obtaining symmetrical *taches* in this way seems to have been constant throughout Hugo's work; examples can be found from even before his time in exile (cat. 36). Experiments stepped up around 1856, however, after Hugo tried his hand at 'table turning,' and Judith Petit has drawn a parallel with the German Romantic poet Justinus Kerner,[6] who, like Hugo, was fascinated by spiritualism and would similarly see specters in splashes of ink – the approach taken by Hugo in cat. 32.

LACE IMPRESSIONS

Hugo's applications of plant fragments and, above all, pieces of lace (*dentelles*) likewise date from his time in Guernsey (1855–70). Most were made with pieces of late eighteenth-century wire lace of the kind used to decorate gowns at court.[7] A calling card dated January 1, 1856, features an impression of this kind and, given the unlikelihood that it was used for long, suggests that the works in question can be dated to late 1855. A note by Hugo in his account books for 1863–64 shows that he retained a liking for lace-work of this kind: "Suzanne has bought me forty-five ells of braid, and gold and silver lace (tawdry, old-style)."[8]

Lace is a network, as Judith Petit has stressed:[9] "Musing on these impressions as their author urges us to do, we may ... recall that text and textile have the same common origin, and that ever since antiquity – see Plato's *Politicus* – the interweaving of threads has been compared to that of words." She then links Hugo's experimentation of this kind to the poem '*Ce que dit la bouche d'ombre*' [What the shadow's mouth says], with the line "Everything in the infinite says something to someone." Likewise, in the drawing *Les Orientales* (fig. 3 on p. 11), Hugo used a lacework application for the sky in what is probably an evocation of the "fire of heaven" (*Les Orientales*, VII):

> *Le ciel à l'horizon scintillait étoilé,*
> *Et sous les milles arceaux du vaste promontoire,*
> *Brillait comme à travers une dentelle noir*

[The sky on the horizon glittered with stars,
And under the thousand arches of the vast headland
Shone as if through black lace]

CUT-OUTS AND STENCILS

As Pierre Georgel has remarked,[10] Hugo began making paper cut-outs very early on for his children. He made cut-outs throughout his career. He would use both the cut-out and the 'negative' from which it had been cut, and the two parts thus broken up can sometimes be reconstructed today. A drawing, preserved at the Bibliothèque nationale de France (Massin, II, no. 950), for example, was cut out from *Recollection of Belgium*, now in a private collection. A fragment that originally formed part of *Octopus with the initials VH* (cat. 25) is also known, and a cut-out belonging to the Bibliothèque nationale was partially reconstructed for the exhibition *Soleil d'encre* (Massin, II, nos. 920 and 940).

Hugo first began using cut-outs as stencils about 1850, for example employing circular cut-outs to mask off a sun or moon against dark backgrounds. A stencil was also used for the silhouette of a cockerel in a drawing today preserved at the Bibliothèque nationale and for *Gallia* at the Maison de Victor Hugo. There is every reason to believe that Hugo also used a stencil for *Mushroom* (cat. 73). He resorted to such stencils again in 1854, at which point they acquired considerable importance in his work. They again grew scarce about 1860, as Hugo resumed his travels.

From 1853, Victor's sons, Charles and François-Victor Hugo, had been devoting their energies to photography,[11] setting up a photographer's studio at Marine Terrace, the Hugo family's home in Jersey. It comes as no surprise that Hugo should have been influenced by photographic negatives: in the compositions he made at this time the stencil is to the image taken from it what the negative is to the photograph. Jersey was also a center for pottery decorated with stencils, and Hugo, who used quantities of china for the decorations of Hauteville House in Guernsey, may have taken an interest in the craft from the moment he settled in Jersey.

It may again have been the availability of new materials in the Channel Islands that prompted Hugo to make stenciled compositions; another was 'drawing gum,' which he seems to have used, among other things, to sign in resist certain drawings from this period (for example, cat. 77). The purchase of a bottle of gum is mentioned in one of his notebooks.[12]

For the stencils themselves Hugo used all sorts of papers – concert programs, cardboard, wrapping paper, old envelopes, even a stamp (where the stencil becomes a collage). These are of great importance: a concert date discovered beneath the ink with the aid of infra-red photography, or the mention of an address in Guernsey on an envelope, have made it possible to date many of these stencils (in general the compositions appear to have been made from recently acquired materials). Cut-outs would be used once,

occasionally twice (once with pencil, once with ink), seldom more than three times.

As a rule the cut-out papers would be used in their entirety; that is to say that Hugo would apply to his compositions both the cut-out motif and the surround from which it was taken. The stencil of a castle with three towers, for example, was used for a composition usually called *Castle lit up in the night* (cat. 50), in which the silhouette of the castle is masked off against a dark background, while the sheet of paper from which the cut-out was made was used in a composition called *Dusk*, in which the same castle is dark and stands out against a light background.

The motifs of Hugo's stencils are, usually, architectural. The earliest stencils (Massin, II, nos. 862, 861 and 864) are rooted in reality, the atmosphere being conjured up by a cloudy sky. Subsequently, the elements become separated from their context and are transferred to a wholly unfamiliar or imaginary landscape. As a result of this pictorial alchemy, the rock of the Jersey Hermitage (see cat. 78) changes, some years later, into *Recollection of Switzerland, sentinel of William Tell*.

Only one animal silhouette, entitled *Heraldic eagle* (cat. 45), features in the group of stencils that have come down to us; the bird is similar in style to the fantastical drawings made between 1856 and 1857. Seascapes for which stencils have been used are scarce, perhaps not surprisingly. Hugo also made cut-outs for his initials; see for example *Les Orientales* (fig. 3 on p. 11).

It is interesting to consider the intended destination of the stencil drawings. Some were offered either as gifts to visitors or as New Year cards to friends; others, relating to Hugo's literary work, may be projects for a frontispiece – this was probably the case with the drawings *"Les Orientales"* and *La Légende des siècles* (fig. 3). Finally, nearly all the drawings entitled *"Souvenir"* (see fig. 16 on p. 24 and cat. 51),[13] which were hung in the billiard room at Hauteville House, bear the imprint of stencils. All these stencils, whether addressed to friends or exhibited in the billiard room, were therefore destined to lead a more or less public existence.[14]

Might this explain why Hugo made use of stencils – as a kind of fair copy? Gaétan Picon is probably not correct, then, to regard the techniques employed by Hugo as "first and foremost ... substitutes for artistic means he had not had time to learn, the gestures and ploys of impatience, of the spur of the moment."[15]

Preserved among Hugo's papers along with his literary remains, these stencils remained virtually unknown for decades. In presenting a large selection of them, first Roger Cornaille and Georges Herscher in *Victor Hugo dessinateur* in 1963, then Pierre Georgel in the exhibition held at Villequier in 1971, broke new ground. It is surely in these cut-outs that one finds one of the keys to Hugo's aesthetic and to his compositions in "ink, that blackness which engenders light."[16]

NOTES

1. Extracts cited by Pierre Georgel, 'Histoire d'un "peintre malgré lui,"' in Massin, II, pp. 13–80.

2. *Ibid.*

3. Paris 1985, pp. 16–17.

4. Bibliothèque nationale de France, Mss, NAF 13441–13486.

5. J. Laurens, *La Légende des ateliers*, 1901, pp. 675–76, quoted in Georgel 1973, p. 54.

6. Paris 1985, pp. 118–19.

7. *Ibid.*, no. 11.

8. Bibliothèque nationale de France, Mss, NAF 13456, fol. 57.

9. Paris 1985, p. 39.

10. Georgel 1974, pp. 24–32.

11. Françoise Heilbrun and Philippe Néagu, 'L'Atelier de photographie de Jersey,' in *Victor Hugo et les images*, edd. Madeleine Blondel and Pierre Georgel, Dijon 1989, pp. 184–95.

12. Bibliothèque nationale de France, Mss, NAF 13456, fol. 26.

13. Jean Gaudon, 'Souvenir de ... ,' in *Victor Hugo et les images*, cit., pp. 152–67.

14. Pierre Georgel, 'Pour l'intimité,' in *Usages de l'image au XIXème siècle*, Paris 1992, pp. 184–95.

15. Quoted in Georges Herscher, 'Papiers découpés de Victor Hugo,' *L'Œil*, November 1963, pp. 34–39.

16. See Venice 1993, pp. 41–44.

Wash

The wash of black, violet or brown ink (or ink that has faded to brown over the years) is Hugo's basic medium as a draftsman. The transition from the writing pen to the drawing pen is negligible, and in many respects a Hugo drawing is first and foremost a script – a hand moving excitably across the paper (see cat. 2), scribbling away energetically (see cat. 3), wandering at will. Another advantage of wash is that it can be applied either by holding the pen or penholder like a pencil, or by grasping the instrument at the other end and using it like a brush or stick. Hugo made wide use of the barb of the quill; he twisted it on its axis in a rotating movement (see cat. 1). One can start with a line and end up with tonal value. Lines can be deliberately blurred, contours transformed into surfaces. From there to spilling the ink directly onto the paper is a short step which Hugo, who was fond of games and lucky surprises, was quick to take. The result was the famous *tache* (ink stain), to which the second subsection of this catalogue is devoted (see p. 48).

The fluidity and transparency of wash makes it a medium almost as directly responsive to Hugo's vision as handwriting. Ink, according to its dilution, application and drying time, makes possible infinite variations in atmosphere, light and apparent hour of day. Wash is essentially a medium of abrupt shifts and transitions, of ambiguities of light and weather. Like air filled with water in sus-pension, like lands rendered ethereal by distance, the consistency of a wash drawing is a function of the density of pigment or the invasiveness of water. Disappearance versus appearance, sudden descents into the depths of night or of human consciousness, subterranean journeys, fog, drownings, death and resurrection into the light are themes that haunt Hugo's novels and for which equivalents are readily found in his wash drawings. The ambiguous pallors of wash are ideally suited to a writer with a predilection for twilights, for wandering alone in marine or urban no-man's-lands, for uncertain forms and blurred frontiers.

By virtue of its ductility on paper and smooth handling, wash also helps create a sense of movement – the movement of time even more than movement through space. Hugo's drawings are sometimes fast, sometimes slow. At times, a pen-stroke will accelerate things, even provoking, when acute, a sense of violent illumination; at others, the spreading transparencies of ink will make everything seem interminably slow. If the outlines of his figures lack firmness on occasion, if he often reveals a poor mastery of perspective, Hugo nevertheless takes full advantage of the pictorial possibilities contained in the graphic technique he adopted for most of his compositions.

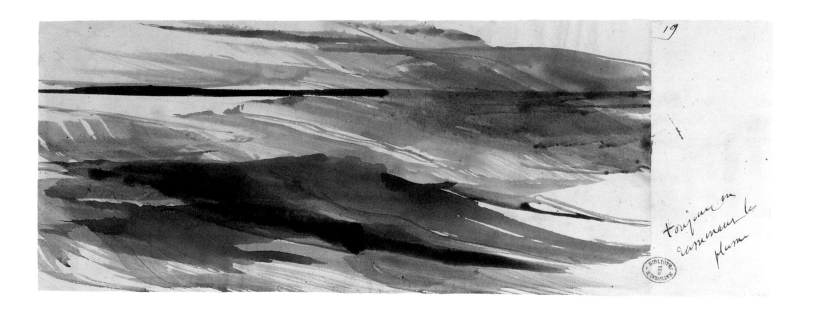

1 *"Toujours en ramenant la plume"*
(Always bringing the pen back round)
ca. 1856

Web of quill, brown ink and wash on cream paper
5⅞ × 11″ (150 × 280 mm)
Inscribed *"toujours/ en ramenant/ la plume"* in pen and
brown ink at bottom right
Paris, Bibliothèque nationale de France, Mss, NAF
13351, fol. 19
EXHIBITIONS Bologna 1983, no. 28; Paris 1985,
no. 206; Venice 1993, no. 49
LITERATURE Journet and Robert 1963, pl. 3;
Cornaille and Herscher 1963, no. 153; Delalande 1964,
p. 67, fig. 82; Massin, II, 1969, no. 896; Lafargue 1983,
p. 117 (printed upside down without comment);
Picon and Focillon 1985, no. 151

This is a fine example of the wash technique
which first appeared in Hugo's work *ca.* 1856
and was apparently still being used in certain
late drawings made after his return from exile
in 1870. MLP

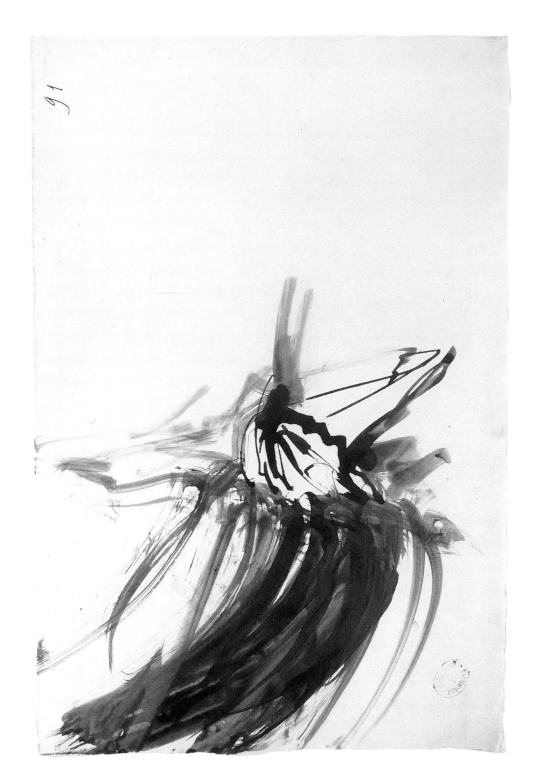

2 *Sailing ship in a storm*
ca. 1866–69

Pen (or short stick), brown ink and wash on cream
paper (no. 35 of *Le Théâtre de la Gaîté*)
8¾ × 5¾″ (222 × 145 mm)
Paris, Bibliothèque nationale de France, Mss, NAF
13355, fol. 91
EXHIBITIONS Marseille 1985, no. 51; Paris 1985,
no. 216; Zurich 1987, no. 31; Venice 1993, no. 54
LITERATURE Journet and Robert 1963, p. 53;
Massin, II, 1969, no. 983

The paper employed in this drawing dates it to
ca. 1866–69. Note the way the lines of the boat
and wave clash, suggesting an image of man's
struggle with the elements, a theme that is also
treated in *Toilers of the Sea* (cf. *The vision ship*,
cat. 89). MLP

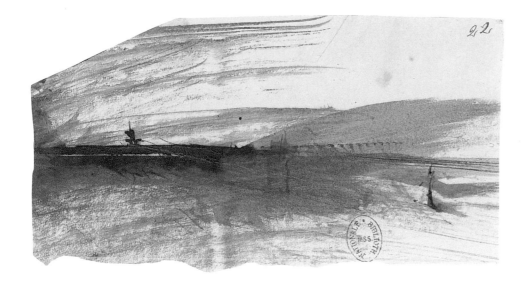

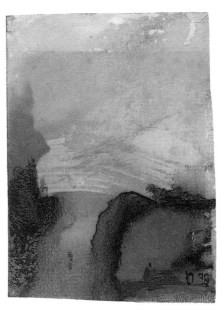

3 *Seascape*

ca. 1855–56

Pen and brown ink on irregularly cut blue paper
2⅝ × 4⅞″ (68 × 125 mm)
Paris, Bibliothèque nationale de France, Mss,
NAF 13351, fol. 22
EXHIBITIONS Paris 1985, no. 209
LITERATURE Journet and Robert 1963, p. 28;
Cornaille and Herscher 1963, no. 156; Massin, II, 1969,
no. 507; Picon and Focillon 1985, no. 157

Journet and Robert date this wash to before
Hugo's exile in 1852, basing their argument on
the appearance of a windmill in the distance,
on the left. The technique used, however,
suggests that the drawing dates from the time
of his exile. MLP

4 *Estuary*

ca. 1855?

Pen and brown-ink wash on laid paper
3 × 2⅛″ (76 × 55 mm)
Paris, Maison de Victor Hugo, inv. 856
EXHIBITIONS Paris 1930, no. 770
LITERATURE Sergent 1934, no. 136; Sergent 1957,
no. 151; Cornaille and Herscher 1963, no. 158; Massin,
II, 1969, no. 908; Seghers 1983, p. 32; Picon and
Focillon 1985, no. 159; Maison de Victor Hugo 1985,
no. 856

This tiny drawing is an excellent example of
Hugo's ability to draw out the possibilities
contained in wash: he makes very skillful use
of the drying speeds and thicknesses of ink, of
the degree to which the pigment has been
diluted in the liquid and of its subtle
differences in transparency. Guided by his
materials, he relies entirely on the movements
of the ink to define space. This drawing seems
to have lost all reference to perspective or
scale, blending the various elements into a
single, weightless reverie: light rises on all
sides. The form is created by the rhythms of
the wash rather than by any attempt at
imitation.

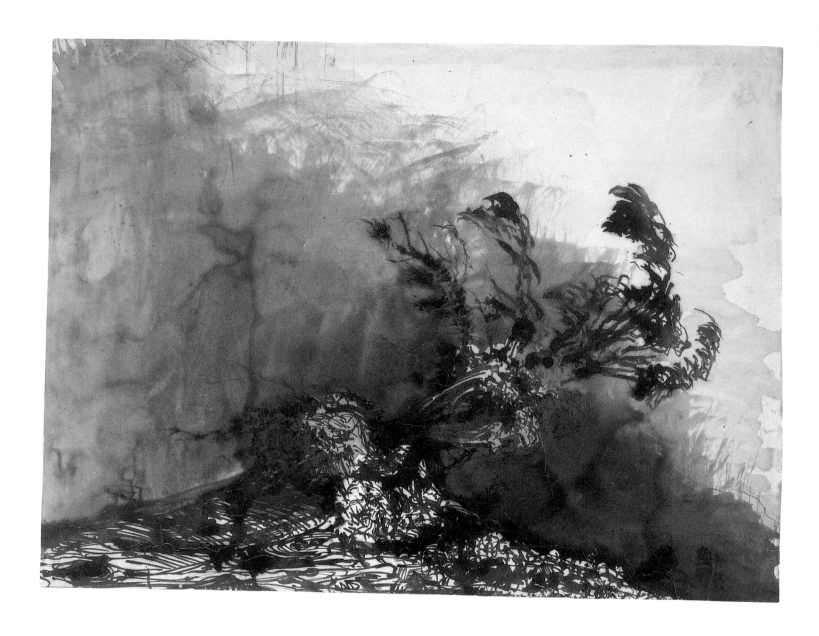

5 *Tree flattened by wind*

Pen and brown-ink wash on stiff vellum paper
8⁹⁄₁₆ × 11⁷⁄₁₆″ (218 × 290 mm)
Paris, Maison de Victor Hugo, inv. 177
EXHIBITIONS Paris 1930, no. 1034; Geneva 1951,
no. 79
LITERATURE Album Méaulle 1882, pl. 34;
Alexandre 1903, p. 147; Sergent 1934, no. 155; Sergent
1957, no. 169; Massin, II, 1969, no. 748; Lafargue 1983,
p. 39; Maison de Victor Hugo 1985, no. 177

Characteristic of Hugo's work, this fine
drawing displays a rather casual treatment of
surfaces and is painted hastily. Handled
confidently, it is sketched with quick, wiry
pen-strokes and renders to good effect the gust
of wind and flurry of leaves. Hugo's use of his
cleverly selected instruments gives the picture
powerful contrasts, evoking the fury of the
elements and glorifying this solitary force
withstanding the brutality of the storm. The
turbulent air is rendered by fluid splashes of
wash, while the mound of earth and the
branches of the tree that have taken root there,
both drawn with a pen, are buffeted by a
feverish script.

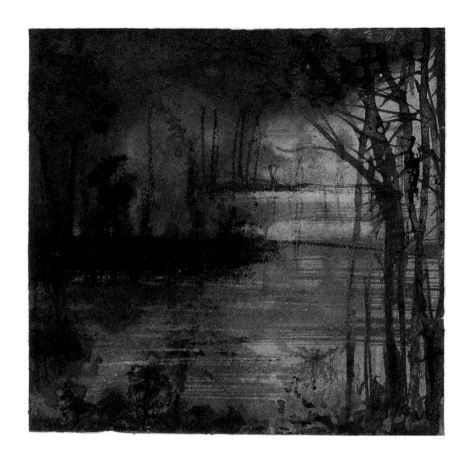

6 *The pond*
ca. 1847

Pen, brown-ink wash and black crayon on vellum
paper, partly rubbed or scraped
4¼ × 4⅜″ (108 × 112 mm)
Paris, Maison de Victor Hugo, inv. 912
PROVENANCE Collection Lefèvre-Vacquerie;
acquired by M. Salles-Girons, Algiers, 1935
EXHIBITIONS Paris 1935, no. 419; Geneva 1951,
no. 63
LITERATURE Sergent 1934, no. 868; Sergent 1957,
no. 196; Massin, II, 1969, no. 527; Maison de Victor
Hugo 1985, no. 912

As opposed to the previous drawing, the use
of wash here underwrites a calmer vision.
Applied with a rag to a thicker, more
absorbent sheet of vellum paper, and dotted
with tiny shadows of the kind typically made
by a reed pen, the ink wash gives off a gentle
light that is diffused throughout a slowly
deepening space by means of very subtle
transitions. The stagnant water of the pond
abolishes contours and mingles together
foliage, shadows and reflections in a blended
mass that is reminiscent of certain Chinese
paintings, dependent for their effects on a
skillfully applied brush lightly filled with ink.

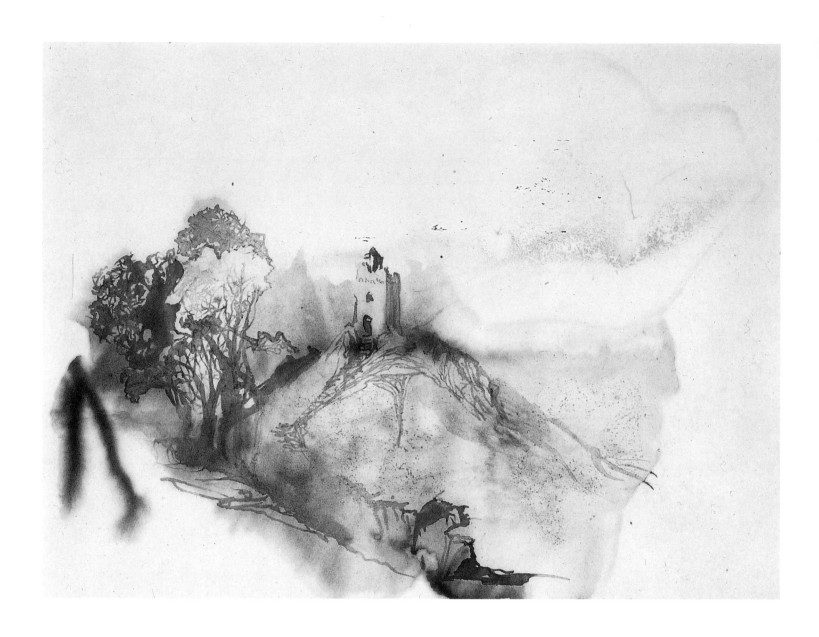

7 *Landscape and tower*

Pen and brown-ink wash on vellum paper
6½ × 8¾″ (165 × 222 mm)
Galerie Jan Krugier, Ditesheim & Cie, Geneva,
inv. 3439
PROVENANCE Hugo Family Estate; Collection
François Hugo
EXHIBITIONS New York and Geneva 1990–91,
no. 18; Valencia 1996, no. 24
LITERATURE Cornaille and Herscher 1963, no. 170;
Massin, II, 1969, no. 538; Krugier 1983, no. 10

Over an extremely faint, transparent wash,
possibly an accidental wet mark, Hugo has
built up a motif from random forms and
shadows. A powerful sense of unreality is
created by his juxtapositions of line with the
fluctuating, evanescent smudges of the wash.

As often in Hugo's graphic work, it is
difficult to judge the original tones of the
drawing: the inks have faded, the paper has
altered, and transparencies have come into
play which throw the drawing into a different
light.

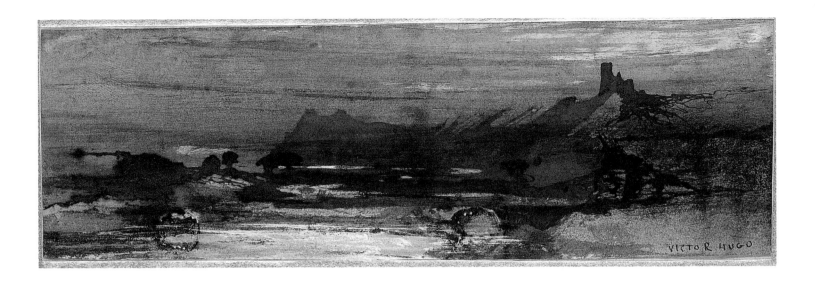

8 *The Upper Rhine*
1855

Pen, brown-ink wash, watercolor, highlights of white
gouache and fingerprints on beige paper
2⅜ × 7½" (60 × 190 mm)
Gilt-paper border, vellum-paper backing, 8¹⁄₁₆ × 12"
(205 × 305 mm)
Signed bottom right *VICTOR HUGO*
Inscribed on mount *Le Rhin supérieur / offert aux beaux
yeux de / Madame Préverault* [*sic*]/ *Victor Hugo/ 1ᵉʳ
janvier 1855 – Jersey* (The Upper Rhine/ offered to the
beautiful eyes of/ Madame Préverault [*sic*]/ Victor
Hugo/ January 1, 1855 – Jersey
Galerie Jan Krugier, Ditesheim & Cie, Geneva,
inv. 4211
PROVENANCE Mme Préveraud
EXHIBITIONS Zurich 1987, no. 19; New York and
Geneva 1990–91, no. 11, p. 87; Venice 1993, no. 6,
p. 215
LITERATURE Massin, II, 1969, no. 892

This vision of a landscape was drawn from
memory. It shows great freedom of handling,
and the artist had no qualms about executing
his image in a somewhat informal manner,
combining various techniques: he blurred the
inks, covered them over and dabbed away at
the mixture, leaving his fingerprints. This
extraordinarily offhand approach to his
medium adds a sense of momentaneity or
impatience to Hugo's art.

The drawing is inscribed to Mme
Préveraud, who was also exiled with her
family in Jersey, then in Guernsey where she
followed the Hugos. Mme Préveraud received
a second New Year missive the following year
(see cat. 61).

9 *Stormy sky*
1856

Pen and brown-ink wash over graphite, watercolor and gouache on paper
1⅝ × 4¾" (41 × 120 mm)
Signed and dated at bottom *Guernesey. Victor Hugo. 1856*
Galerie Jan Krugier, Ditesheim & Cie, Geneva, inv. 5116
PROVENANCE Private collection, France

The ductus of the pen alone – now sharp, now slack – suggests the movement of water and its various states: lowering clouds, driving rain, wind-swept sea, waterlogged land. Highlights of watercolor and gouache serve to indicate distance and provide pointers in a blurred weather-map where islands may be outward-bound ships or sails may be steeples.

10 *Cart drivers in a storm*
1854–55?

Pen and brown-ink wash with highlights of gouache on paper
1¹⁄₁₆ × 5⅛" (27 × 130 mm)
Signed bottom left, in gouache *VICTOR HUGO*
Collection Jan and Marie-Anne Krugier-Poniatowski
PROVENANCE Collection Auguste Vacquerie, Paris
EXHIBITIONS New York and Geneva 1990–91, no. 21 (illus.)

As is often the case in Hugo's work, the contrasts in scale here are highly effective. Because of the small format, one takes in the details of this stormy atmosphere in a single glance. The horizon is suggested by a single thin line of white gouache.

11 *Seagull in the wind*
ca. 1856

Violet–black-ink wash and stencil (?) on laid paper
with the watermark *G*
7¼ × 4⅜″ (185 × 110 mm)
Private collection
PROVENANCE Hugo Family Estate

For several years, but chiefly during his stay in
the Channel Islands, Hugo made many
drawings in which he experimented with the
random and the reversible, allowing the
rivulets and puckerings of ink to draw for
themselves an elusive world in the throes of
dissolution, a world where poles shift, and can
even be reversed, from one moment to the
next. A drawing like this, rather than enclose
us within a classical vision in which the
object's distance, orientation or limits are
determined by a point of view, projects us into
a space which offers no guarantees, where we
must force openings and find our own way
forward without necessarily knowing if we
will end up on solid ground. The bird is an
emblematic figure that turns up several times
in drawings from this period (see cat. 79), and
whose flight unites the contrary forces of
water, air and gravity.

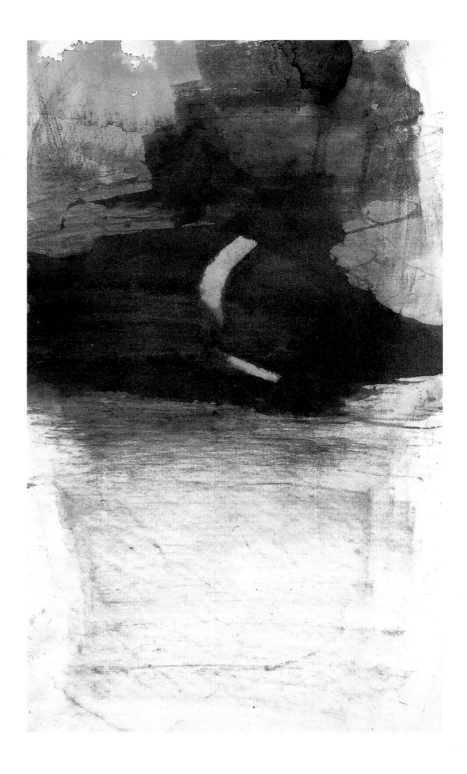

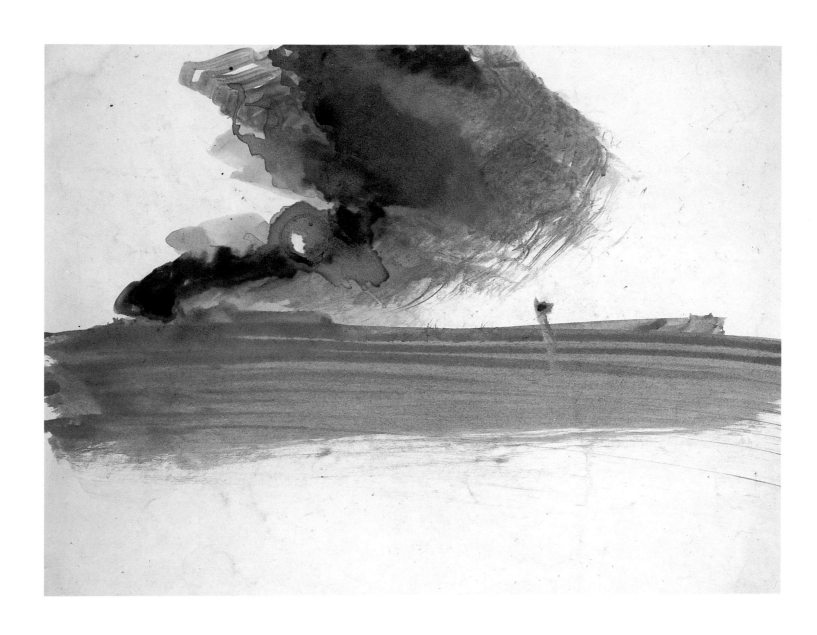

12 *Cloud over a field*
ca. 1854–56?

Brush and brown-ink wash on beige paper
8½ × 11¼" (215 × 284 mm)
Private collection
PROVENANCE Hugo Family Estate
EXHIBITIONS Paris 1972, no. 29
LITERATURE Massin, II, 1969, no. 698

13 *Landscape*
ca. 1854–56

Brown-ink wash on beige paper
8¾ × 5¾″ (222 × 146 mm)
Private collection
PROVENANCE Hugo Family Estate

Whether sketches, abandoned experiments or
executed as intended, Hugo's drawings
frequently appear unfinished. It seems futile,
often, to try to find titles for them, but clouds
are recurrent motifs in Hugo's drawings –
emblematic in their capacity for
transformation, their potential to cast
threatening shadows, and their power to
induce daydreams.

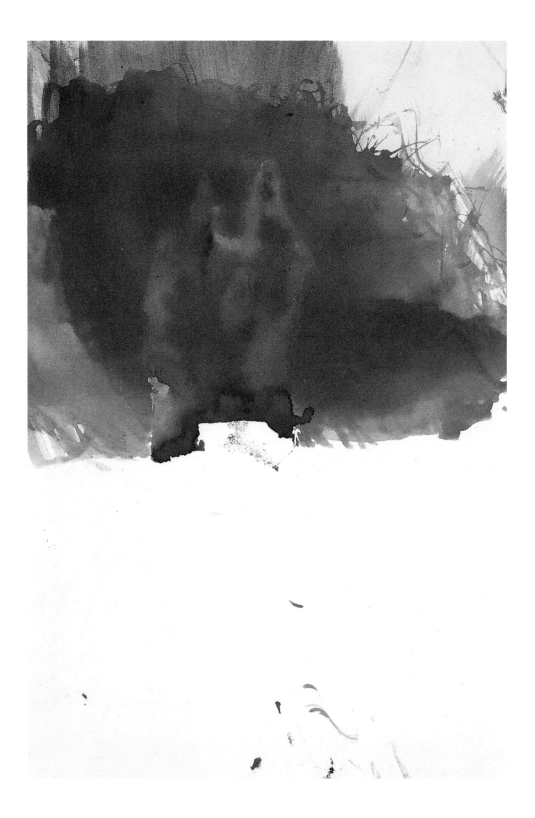

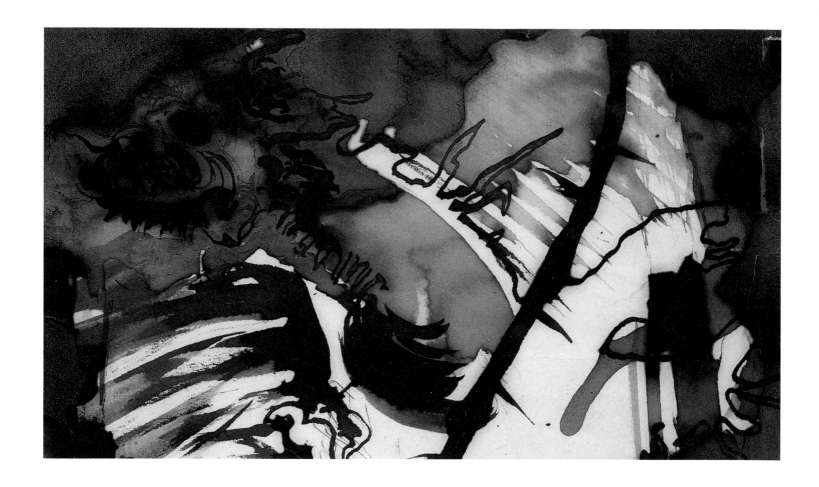

14 *Abstract composition (monstrous animal) ca.* 1856?

Pen and brown-ink wash with highlights of gouache (?) on beige paper
4½ × 7¾″ (116 × 197 mm)
Private collection
PROVENANCE Hugo Family Estate
EXHIBITIONS Paris 1972, no. 40; Monaco 1981, lot no. 35
LITERATURE Massin, II, 1969, no. 995 (illus.)

Despite its poor condition, this drawing remains a remarkable illustration of the range of expression Hugo could obtain from wash. The halting and indiscriminate pen-strokes, characteristic of a group of drawings from 1856 (see cat. 80), are here blended with the much broader, open rhythms of diluted wash. The play of transparency, density and contrast defines an extraordinarily complex space where clear tones are counterbalanced by deep, dark tonalities. The modern viewer is almost inevitably reminded of the early abstract work of Wassily Kandinsky.

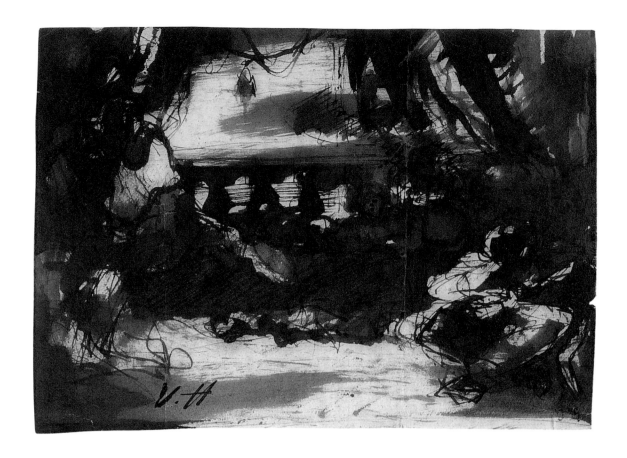

15 *Five-arched bridge*

Pen and brown-ink wash on vellum paper marked
by two vertical folds
$4\frac{3}{8} \times 5\frac{7}{8}$" (110 × 149 mm)
Bottom left, in brown ink *V. H.*
Paris, Maison de Victor Hugo, inv. 924
PROVENANCE Louis Barthou bequest (1935)
EXHIBITIONS Paris 1935, no. 410; Geneva 1951,
no. 75
LITERATURE Sergent 1934, no. 880; Sergent 1957,
no. 197; Massin, II, 1969, no. 621; Maison de Victor
Hugo 1985, no. 924

In this drawing, the eye cannot establish a
clear idea of scale. Is the space in question
limited or boundless? Without or within? We
are not so much present at a performance as
steeped in an atmosphere – caught in time
rather than carried forward by a narrative.

Over a sketch that is classical, almost
Poussinesque, in style and composition, in
which tonal values are indicated by freely
applied splashes of wash, the artist has drawn
in a few figures and trees, with lively pen-
strokes that do little more than hint at forms.

Ink *Taches*

Hugo always took full advantage of his chosen material, studying it from every possible angle, even scrutinizing its defects. Just as in his writings he would hound the French language into the darkest corners, so as a draftsman he would seek to exhaust the expressive possibilities of the ink wash. One of the main risks run by anyone drawing in ink, as schoolchildren are well aware, is that of making a *tache* or blot. Hugo had no qualms about making *taches*, dirtying his sheet of paper or smearing his drawing. The *tache*, however, is more than just a way of acknowledging one's freedom; as painters have known ever since Leonardo da Vinci, it also enables one to tease out forms hidden in nature and take advantage of odd and unpredictable discoveries. Hugo pondered on the possible resemblances and analogies provided by chance. Either he allowed the *tache* to expand by itself, modified only by the quantity of water, the quality of paper and the obstacles it encountered in the course of its haphazard journey; or he guided it deliberately, steering it along paths opened up by chance more or less intentionally in the direction of recognizable forms or suggestive scenes.

As anyone fond of scribbling on bits of paper will know, one of the forms to emerge most naturally from the manipulated *tache* is that of the many-tentacled cephalopod (see cat. 25). When one recalls the importance this monstrous octopod has in Hugo's literary works, one cannot fail to be struck by the image one finds of it in several drawings (intertwined, moreover, with his initials). Symbolically elusive and omnipresent, this "sinister apparition," as Hugo called it, this "rag," glides underwater, spurting out ink and adding its cloudy liquid to the foaming and chaotic ocean.

Most of the manipulations to which Hugo subjected the hazards of the *tache* resulted in landscapes or figures. Excess water caused the *taches* to expand, suggesting new solutions, new ways forward for the eye. This is what the artist liked; he would oversee the different possibilities. He liked the wet ink which, in the course of drying, forms a sediment swarming with animalcules; he liked suggestive imprecisions, diving into a mist from which suspended, fragile and endangered forms, isolated highlights, gradually emerge. Whole continents are contained in the meanderings of the ink, which Hugo then peopled with a few additional strokes of the pen. Splashes, smudges, fingerprints, marblings made by pressing two sheets of paper together, transfers, rubbings, dabbings, wiping the ink away with care or, on the contrary, causing it to pull, were among the many formal possibilities open to him. Among the fascinating structures that manipulations of this kind created, one can make out plants, fleeting crystallizations, monsters from the deep, shiftings of sand and water.

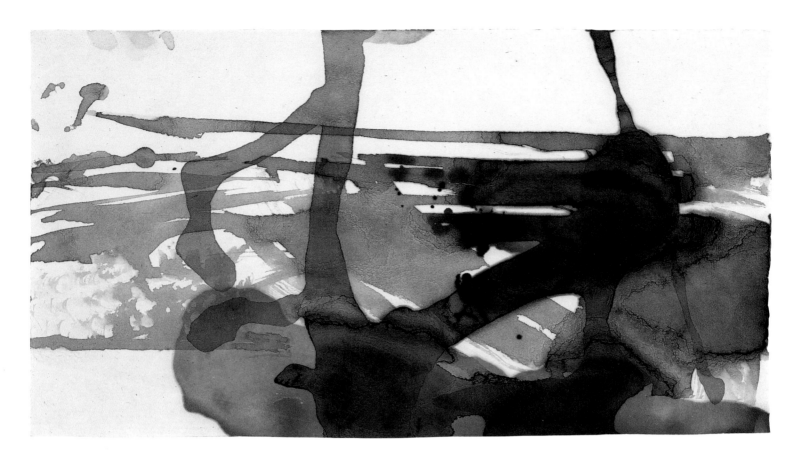

16 *Abstract composition*

Brown-ink wash on vellum paper
5⅜ × 9⅝″ (157 × 243 mm)
Paris, Maison de Victor Hugo
PROVENANCE Collection Jean Hugo; private
collection, New York; Galerie Jan Krugier, Ditesheim
& Cie, Geneva
EXHIBITIONS New York and Geneva 1990–91,
no. 33; Valencia 1996, no. 33

This abstract composition is a perfect example
of manipulation of the accidental: after letting
the ink take the initiative, Hugo intervened in
the process by tilting the paper slightly and
allowing the separate strands to run together
again. It is less the artist's will than the
different capillary qualities, the accidental
superimpositions, the duration and extent of
drying that are important here.

A *tache* becomes a landscape, transparencies
and fluidities create depth. All sense of
classical perspective has been banished, all
active participation abandoned in favor of total
immersion in the oceanic flux.

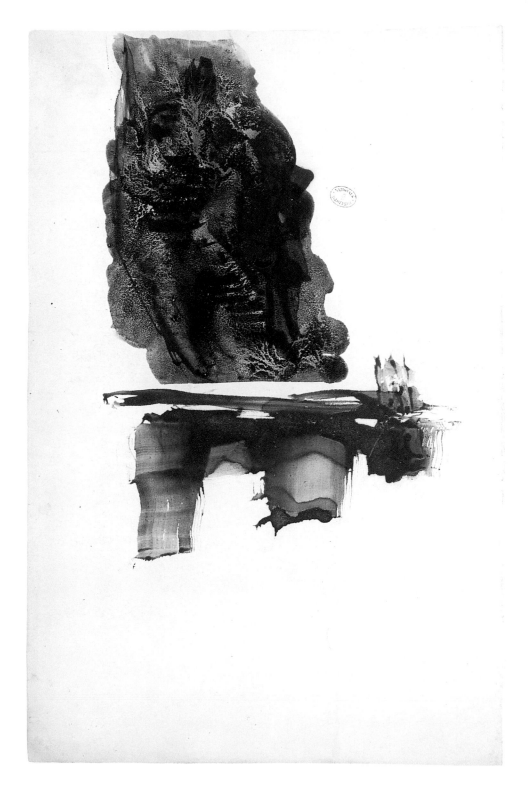

17 *Taches*
ca. 1866–68

Pen (?), crushed graphite, brown ink and wash
on cream paper
14⅛ × 9¼" (360 × 235 mm)
Paris, Bibliothèque nationale de France, Mss,
NAF 13355, fol. 111
EXHIBITIONS Paris 1985, no. 316; Venice 1993,
no. 41
LITERATURE Journet and Robert 1963, pl. 14;
Cornaille and Herscher 1963, p. 143; Massin, II,
1969, no. 961; Picon and Focillon 1985, p. 143

18 *Taches with fingerprints*
1864–65

Brown ink and wash spread with fingers on cream paper
10¼ × 7⅝" (260 × 195 mm)
Paris, Bibliothèque nationale de France, Mss, NAF 13345, fol. 28
PROVENANCE From a sketchbook, NAF 13345
EXHIBITIONS London 1974, no. 65; Paris 1985, no. 288; Venice 1993, no. 38
LITERATURE Cornaille and Herscher 1963, no. 247; Massin II 1969, no. 982; Picon and Focillon 1985, p. 236

This composition comes from a sketchbook Hugo used in 1864–65. MLP

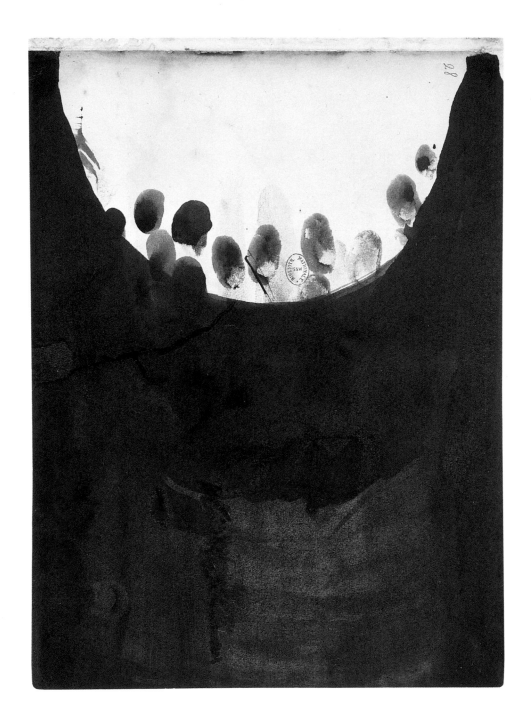

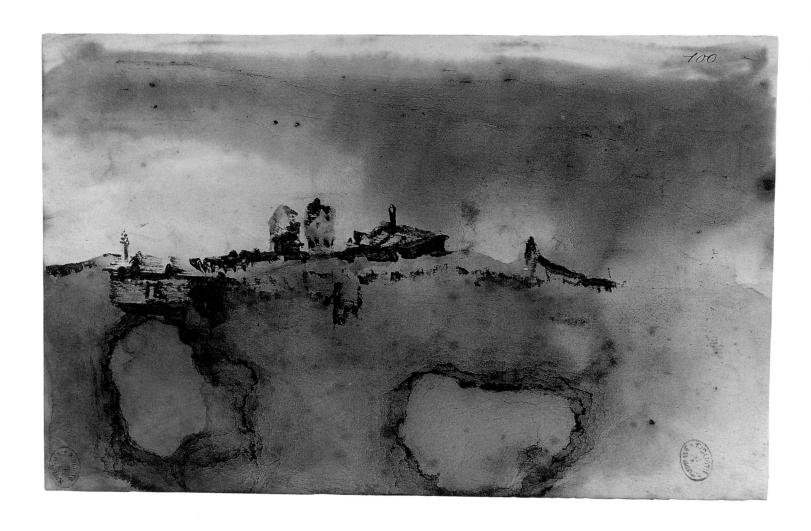

19 *Taches*
ca. 1855–56

Pen, brown ink and wash with faint highlights of
gouache on paper
5⅝ × 8⅝" (142 × 220 mm)
Paris, Bibliothèque nationale de France, Mss, NAF
13355, fol. 100
EXHIBITIONS
Paris 1985, no. 204; Marseille 1985, no. 53; Zurich
1987, no. 22
LITERATURE
Journet and Robert 1963, p. 53; Cornaille and
Herscher 1963, no. 168; Massin, II, 1969, no. 911; Picon
and Focillon 1985, p. 166

After the paper was entirely soaked in wash,
the resulting *taches* were drawn over in ink
and highlights of gouache added, giving the
impression of a city perched dangerously on a
strange, porous massif and reflected in the
water. MLP

20 *Tache*

ca. 1865?

Pen and brown-ink wash on vellum paper folded
in two
Drawing 15 × 9½″ (380 × 243 mm)
Paper 15 × 19″ (380 × 483 mm)
Paris, Maison de Victor Hugo, inv. 978
PROVENANCE Bought from Jean Hugo (1971)
LITERATURE Massin, II, 1969, no. 964; Maison de
Victor Hugo 1985, no. 978

Whether Hugo rejected this drawing or not,
or wanted it to be preserved in its unfinished
state, no one can say for sure. In reality, it is of
no great importance, we today make sense of
it, recognizing in this 'assisted' *tache* a familiar
respiration of white space, a conjunction of
force and surrender, of aggression and retreat,
in which years of *art informel* and Abstract
Expressionism have educated us.

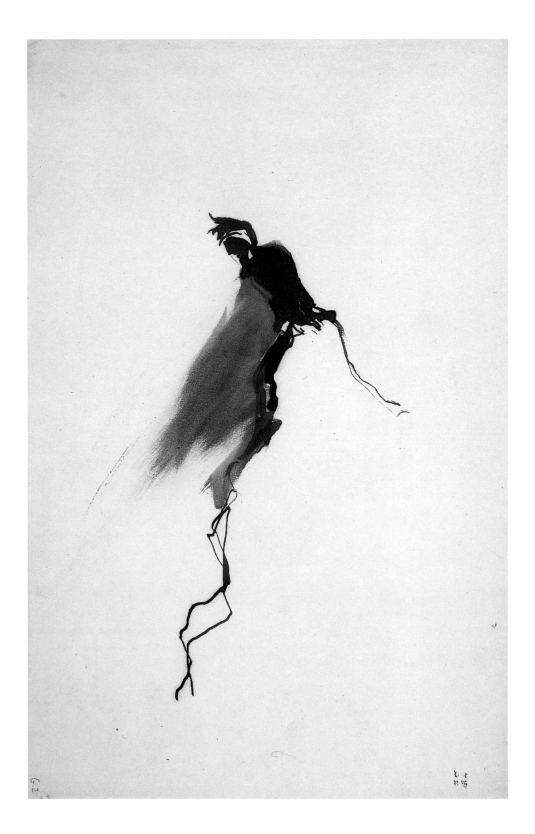

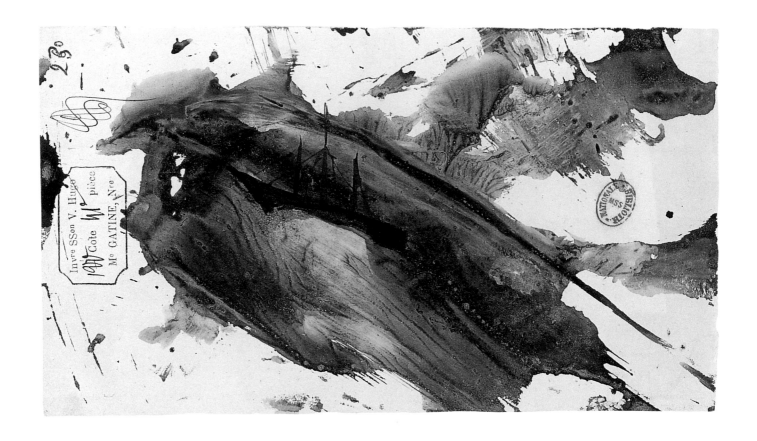

21 *Taches*
ca. 1866

Black ink and wash on cream paper
4 × 7⅛″ (103 × 181 mm)
Paris, Bibliothèque nationale de France, Mss,
NAF 24810, fol. 230
EXHIBITIONS Paris 1985, no. 423; Zurich 1987,
no. 67; Venice 1993, no. 96
LITERATURE Massin, II, 1969, no. 702

Judging in particular by the type of ink
employed, this drawing may be dated to the
later years of Hugo's exile. As before, the sea
was a source of inspiration to him in his
graphic work as in his writing. But from this
period onwards his *tachiste* compositions take
on a dream-like appearance contrasting with
his earlier seascapes. MLP

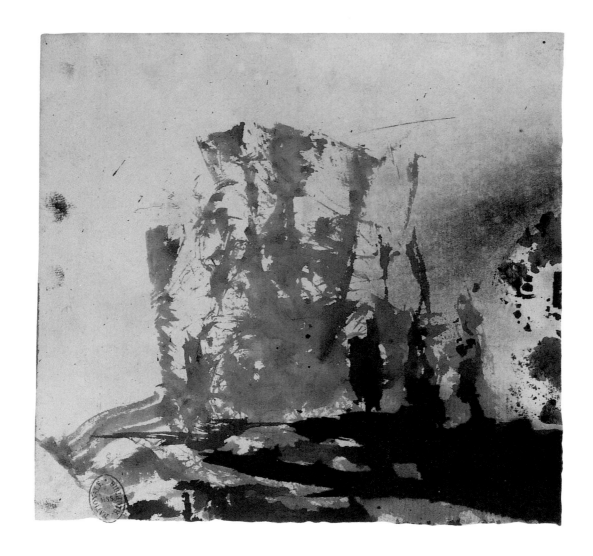

22 *'Sail' taches*

ca. 1862

Charcoal, web of quill, stencil, brown ink and wash
on cream-colored laid paper
5⅛ × 5½" (130 × 140 mm)
Paris, Bibliothèque nationale de France, Mss, NAF
13351, fol. 20
EXHIBITIONS Bologna 1983, no. 32; Paris 1985,
no. 210; Venice 1993, no. 51
LITERATURE Journet and Robert 1963, pl. 4;
Cornaille and Herscher 1963, no. 144; Massin, II,
1969, no. 965; Lafargue 1983, p. 1129; Picon and
Focillon 1985, p. 141

This drawing is similar in technique to one
dated 1862 in the Maison de Victor Hugo (inv.
163), and was probably made around the same
time. The abstract beauty of the composition
goes hand in hand with great inventiveness in
the choice of techniques: rubbed charcoal, the
barb of the quill, stencil work and *taches*.
MLP

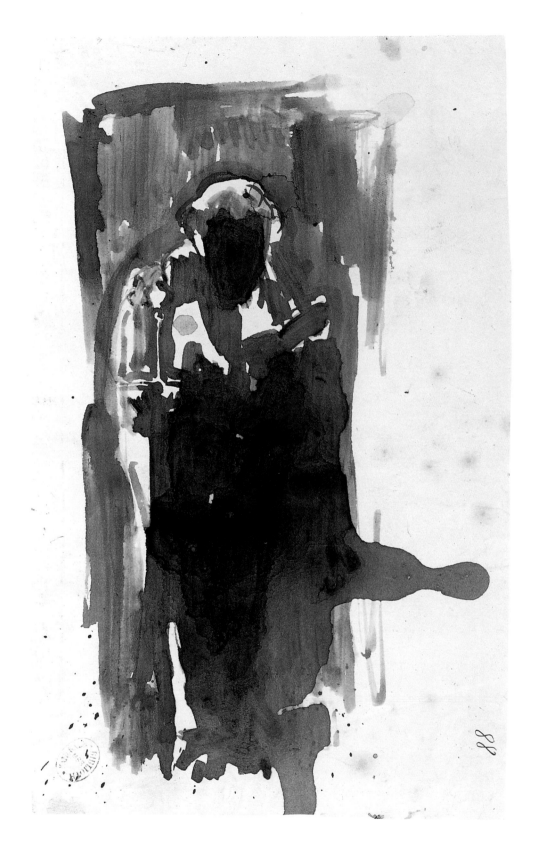

23 *'Figure' taches*
ca. 1866–69

Brown ink and wash on cream paper
8⅛ × 4⅞" (205 × 125 mm)
Paris, Bibliothèque nationale de France, Mss,
NAF 13355, fol. 88
EXHIBITIONS Paris 1985, no. 315; Venice 1993,
no. 46
LITERATURE Journet and Robert 1963, pl. 7;
Massin, II, 1969, no. 981

Hugo created this figure by shaping the forms
of the *taches* with a short stick. MLP

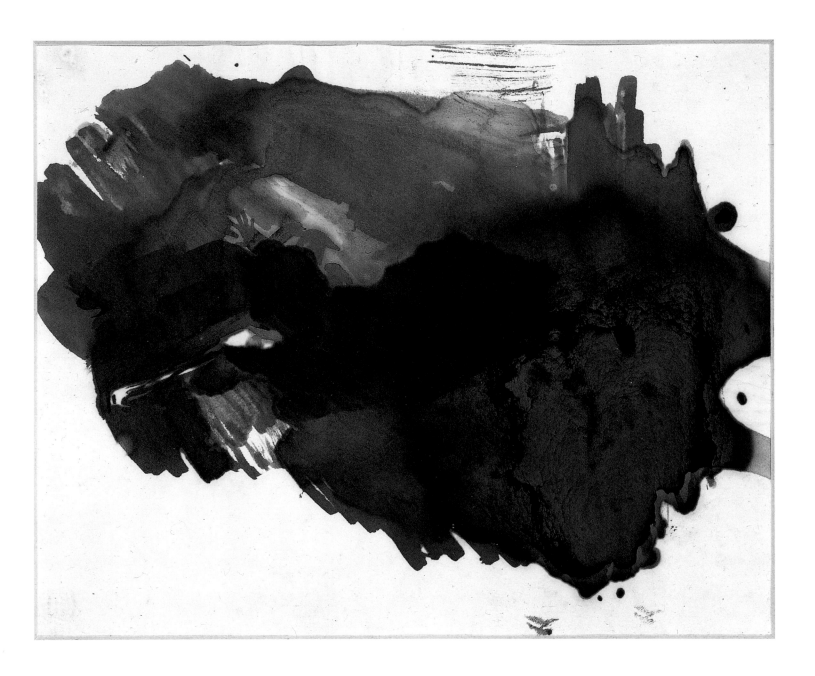

24 *Castle on a hill*
ca. 1854–59

Brown-ink and black-ink wash on London Superfine
vellum paper
7¹⁄₁₆ × 8⅝″ (180 × 220 mm)
Galerie Jan Krugier, Ditesheim & Cie, Geneva,
inv. 3539
PROVENANCE Hugo Family Estate; Sotheby's,
Monaco, 1981, no. 9
EXHIBITIONS Monaco 1981, no. 9; Zurich 1987,
no. 16; New York and Geneva 1990–91, no. 31; Venice
1993, no. 47

This drawing is usually known as *Castle on a
hill*, which is perfectly justified if one reads the
large splash of ink horizontally and views the
twin protuberance at top right as the silhouette
of a tower or castle, a theme dear to Hugo. But
one has only to rotate the image through
ninety degrees or turn it the other way up to
make evident its abstract qualities.

25 *Octopus with the initials VH*
ca. 1866

Pen, brush, brown ink and wash on cream paper
14 × 10¼″ (357 × 259 mm)
Paris, Bibliothèque nationale de France, Mss, NAF
24745, fol. 382
PROVENANCE Mounted on a second sheet of paper
(16⁷⁄₁₆ × 11¹³⁄₁₆″ [417 × 300 mm]) and inserted at the
end of *Toilers of the Sea* (II, iv, 2)
EXHIBITIONS Paris 1952, no. 341; Paris 1985,
no. 348; Venice 1993, no. 64
LITERATURE Album Méaulle 1882, pl. 48; Cornaille
and Herscher 1963, no. 264; Massin, I, 1967, no. 486;
Picon and Focillon 1985, no. 253; Georgel 1985, no. 31

Hugo pasted this drawing into his own
manuscript of *Toilers of the Sea*, where it
corresponds with the following text:

"At night, however, and particularly in the hot
season, she becomes phosphorescent. This
horrible creature has her passions, she awaits
her submarine nuptials. She adorns herself,
setting herself alight and illuminating herself;
and from the height of some rock she may be
seen in the deep obscurity of the waves below,
expanding with a pale aureole – a spectral sun.
(*Toilers of the Sea*, Part II, Book IV, ch. 2)

The entire sheet has been washed over, as if
the monster were indeed submerged in water;
the body and tentacles of the cephalopod have
been shaped from a single *tache*. The original
drawing was even larger; a fragment from the
bottom part is today in a private collection
(unpublished). Note that the tentacles of the
octopus form the letters V and H, the author's
initials. MLP

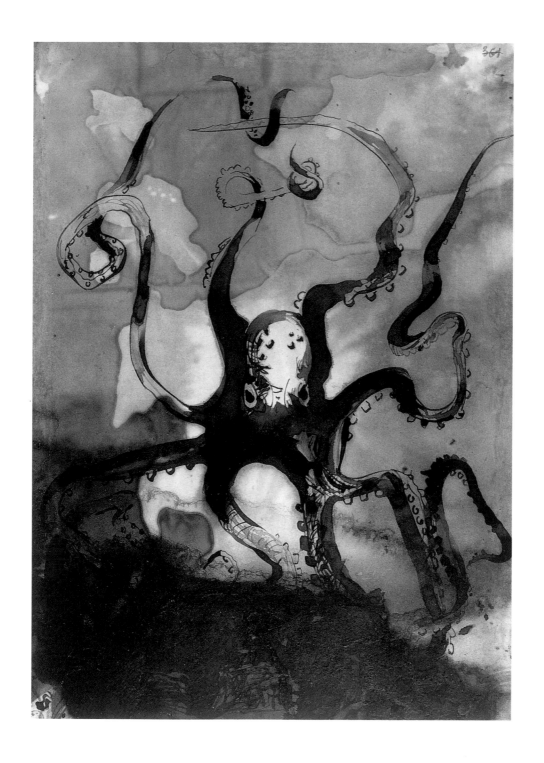

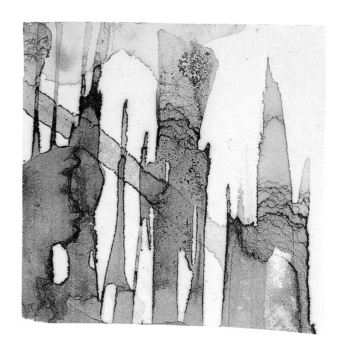

26 *Tache*

ca. 1856?

Heavily diluted brown-ink wash on prepared paper
3½ × 2″ (88 × 50 mm)
Private collection
PROVENANCE Hugo Family Estate
LITERATURE Massin, II, 1969, no. 974

As with many of the drawings in this series, the impression one gets here is of an almost laboratory-style experiment: the paper serves as a test site for new labors and semantic solutions.

BELOW

27 *Tache*

ca. 1856

Brown-ink wash on beige vellum paper
2½ × 4⅛″ (64 × 104 mm)
Inscribed on mount *G.53*
Private collection
PROVENANCE Hugo Family Estate

28 *'Steeple' taches*

ca. 1856?

Brown- and blue-ink wash with highlights of white gouache on beige paper
3⅛ × 3⅛″ (80 × 80 mm)
Private collection
PROVENANCE Hugo Family Estate
LITERATURE Cornaille and Herscher 1963, no. 141; Massin, II, 1969, no. 967; Picon and Focillon 1985, no. 139

The delicacy of the wash and the small scale of this drawing make it an invaluable example of Hugo's practice during his exile. To his eye, the veins in a stone, the variegations of lichen, the patterns of foam were as complex as a mentality. One has only to glance at such forms to discover new things, unforeseen developments, amusing, grotesque or fearsome analogies. The aim of Hugo's drawings is not so much to depict things as to prompt discoveries and embark on little adventures of this kind.

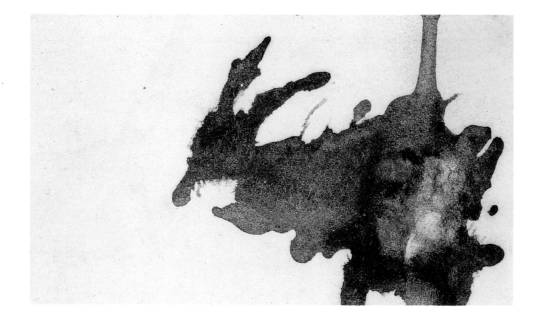

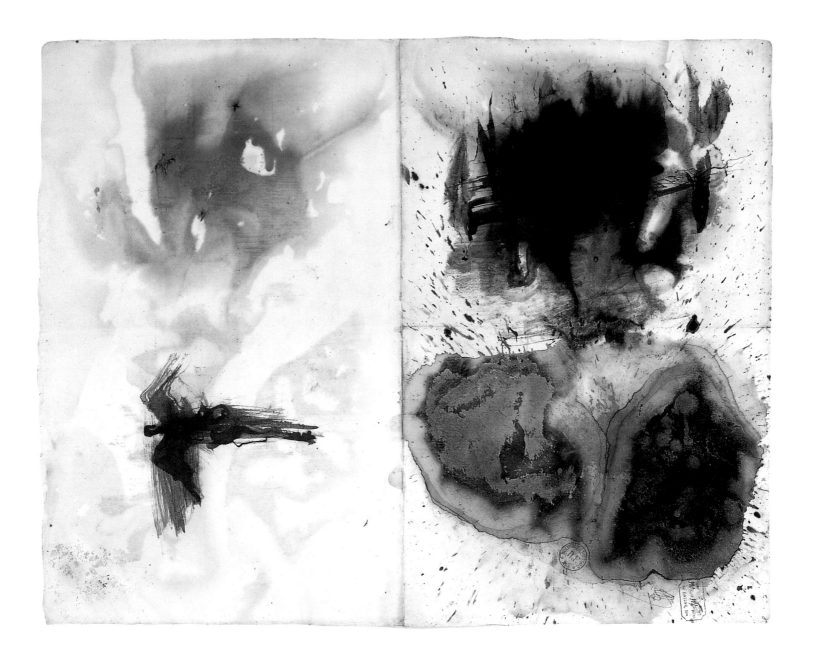

29 *Composition with taches*
ca. 1875

Wash of bluish ink on cream laid paper with the
watermark *DAMBRICOURT FRERES*, folded in two
17½ × 21⅜" (443 × 548 mm)
Paris, Bibliothèque nationale de France, Mss, NAF
24807, fols. 41–42 verso
EXHIBITIONS Paris 1985, no. 425; Zurich 1987,
no. 66; Venice 1993, no. 97
LITERATURE Journet and Robert 1963, pl. 189;
Massin, II, 1969, nos. 958, 957

30 *Planet*

ca. 1854

Pen, brown-ink wash and black ink over rubbed
charcoal with highlights of gouache on paper
12³⁄₁₆ × 14⅝″ (310 × 372 mm)
Collection Jan and Marie-Anne Krugier-Poniatowski
PROVENANCE Hugo Family Estate; collection
Valentine Hugo
EXHIBITIONS Paris 1952, no. 471; Villequier and
Paris 1971–72, no. 60; Paris 1972, no. 26; Neuchâtel
1952, no. 26; London 1974, no. 27; Monaco 1981, no. 8;
New York and Geneva 1990–91, no. 30; Berne 1996,
no. 64
LITERATURE Cornaille and Herscher 1963, no. 275;
Picon and Focillon 1985, no. 265

This particular meditation on the smudgings
and effusions of ink paved the way for a series
of works remarkable in both size and theme.
These 'planet' *taches* (*taches-planètes*), as they
are sometimes called, first appeared in the
early 1850s and combine the transparencies
and fluidities of wash with the use of a circular
stencil, or paper or cardboard cut-out (see cats.
43–51), to represent nebulae. These images
have rightly been compared to various poems
written by Hugo around the same time. The
collection *Les Contemplations*, for example,
contains poems which evoke "globes opening
their sinister pupil/toward the immensities of
eternal dawn" (*les globes ouvrant leur sinistre
prunelle/ vers les immensités de l'aurore éternelle*),
or "Saturn! enormous sphere! star with
mournful airs!/Heaven's penal colony/
Jailhouse with the gleaming basement
window" (*Saturne! sphère énorme! astre aux
aspects funèbres!/ Bagne du ciel! prison dont le
soupirail luit!*). Similarly the opening of *La Fin
de Satan* is startlingly reminiscent of the
lugubrious wash drawing at Dijon (see cat. 96).

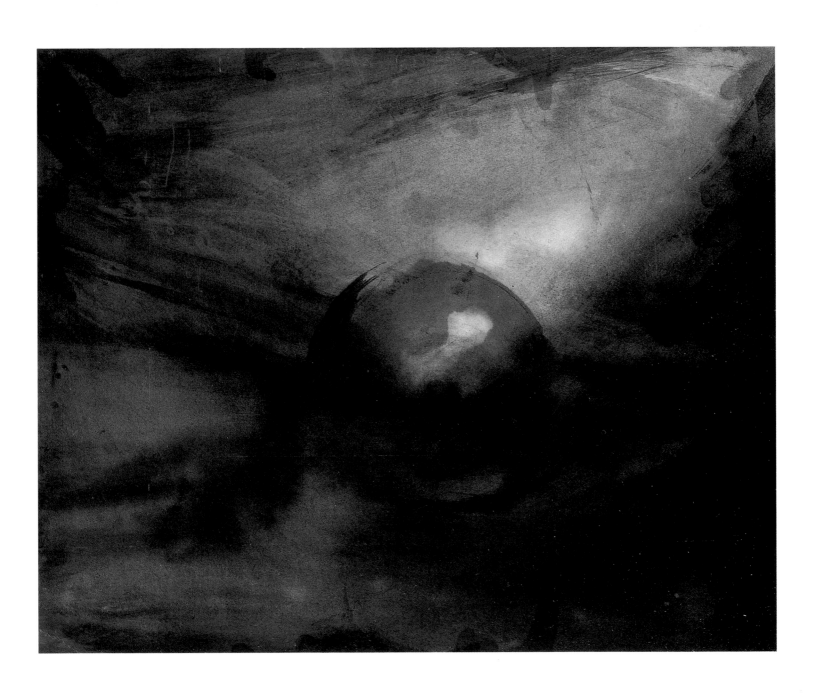

Pliages

Hugo was always looking for alternatives to the more traditional forms of drawing and was quick to discover the technique known as *pliage* (folding). Examples can be found from before his exile, and the practice of making symmetrical *taches* by folding seems to have been an enduring one. Nevertheless, his experiments in this direction stepped up some time around 1856, after his experience of table-turning. In *pliage*, chance is 'assisted,' as Duchamp would put it; the results, however, still come as a surprise. Through *pliage* Hugo explored the pastimes of childhood, finding solutions which overlapped with his concerns as a poet.

What Hugo was searching for in these drawings were signs that would stimulate his imagination and suggest directions for his pen. Hugo interpreted these foldings, not for psychological purposes like the Swiss physician Hermann Rorschach with his famous tests introduced in 1921, but like a seer. He developed the symmetry, discerned resemblances, discovered figures and carried out all kinds of permutations. Reversal (or, better still, reversability), metamorphosis and fusion were themes so firmly rooted in Hugo's praxis that one commonly finds in his compositions a landscape reflected in water or a figure that reads equally well either way up.

The symmetries created by folding might also be compared to the decorative reflections, repetitions, inversions and interlacings that form ornaments in architecture. In addition to his many other activities, Hugo had a mania for collecting and designed the decorations and furniture for his home at Hauteville House in Guernsey.

31 *Rosette*

ca. 1856

Pen and brown-ink wash on vellum paper folded
twice
8¾ × 7⅛" (226 × 180 mm)
Villequier, Musée Victor Hugo, inv. 2660
PROVENANCE Hugo Family Estate; Sotheby's,
Monaco, 1981, lot 33
EXHIBITIONS Paris 1972, no. 12; Paris 1985, no. 146;
Venice 1993, no. 36
LITERATURE Cornaille and Herscher 1963, no. 149;
Massin, II, 1969, no. 894; Chirol 1982, no. 28; Picon
and Focillon 1985, no. 147

This image was made by folding the paper
two, or possibly three times. Look at it long
enough and its purely decorative aspect starts
to appear strange and mysterious: the slightly
imperfect symmetries attract and fascinate the
mind.

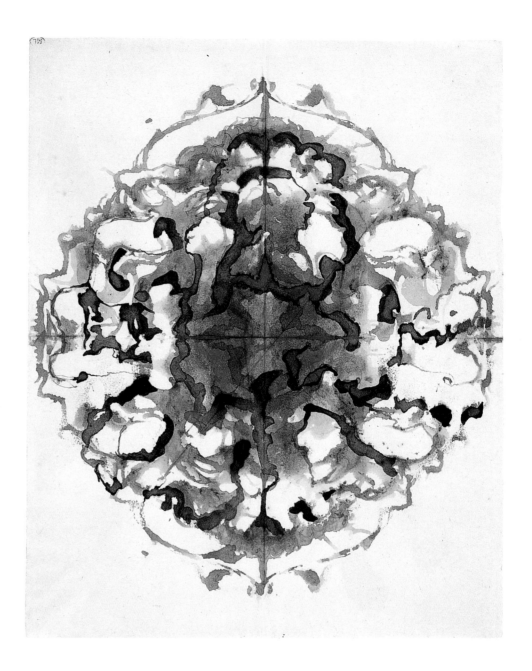

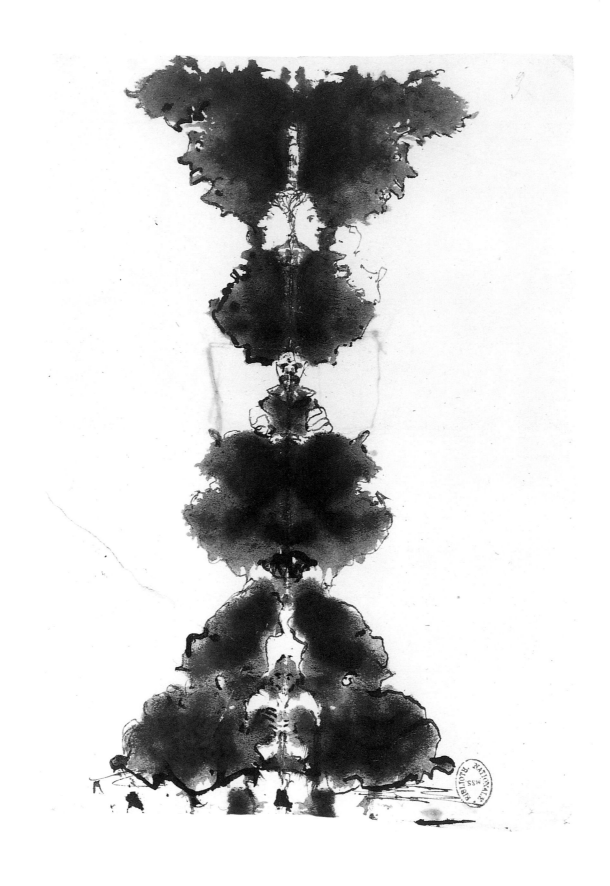

LEFT 32 *Ink tache slightly reworked on folded paper*
ca. 1856–57

Pen, brown ink and wash on cream paper with folds
(pen marks on verso)
8 × 5⁹⁄₁₆″ (202 × 142 mm)
Paris, Bibliothèque nationale de France, Mss, NAF
13351, fol. 28
EXHIBITIONS Paris 1985, no. 145; Venice 1993,
no. 35
LITERATURE Journet and Robert 1963, p. 6;
Cornaille and Herscher 1963, no. 148; Massin, II, 1969,
no. 886; Bory 1980, p. 97; Picon and Focillon 1985,
p. 145

This composition was made by folding the
sheet twice. Giving free rein to his
imagination, Hugo then interpreted the *pliages*
by highlighting certain contours with a pen.
Journet and Robert see them as caricatures
("Chinamen"), but they could equally well be
candelabra, like those made in earthenware in
Urbino in the sixteenth and seventeenth
centuries. The two profiles underlined in the
upper part of the drawing suggest analogies
with the 'fantastic' compositions of 1856–57
made while Hugo was in Guernsey. The
composition is also very similar to another
tache Hugo made with a folded envelope
(stamped *FE-26/1857*). MLP

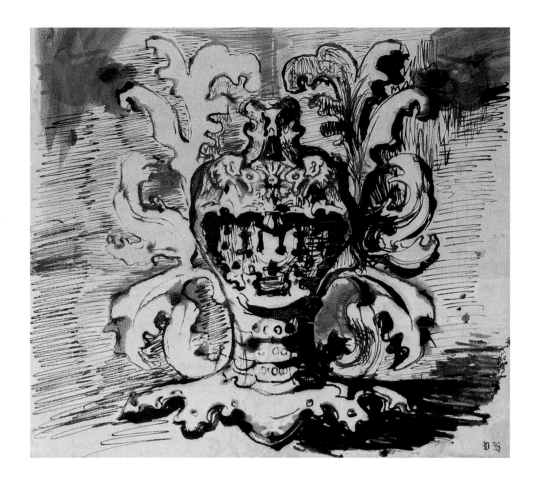

33 *Heraldic crest*

Pen, brown-ink wash and black ink on thick, pale
gray-blue vellum paper folded down the middle
9 × 7⅛″ (229 × 180 mm)
Paris, Maison de Victor Hugo, inv. 906
EXHIBITIONS Geneva 1951, no. 135
LITERATURE Sergent 1934, no. 290; Sergent 1957,
no. 338; Massin, II, 1969, no. 887; Maison de Victor
Hugo 1985, no. 906

This figure was obtained by folding the left-
hand side of the paper over a drawing made
on the right-hand side. The details have been
reworked with a remarkably sure hand in
abrupt, wiry, yet confident pen-strokes.

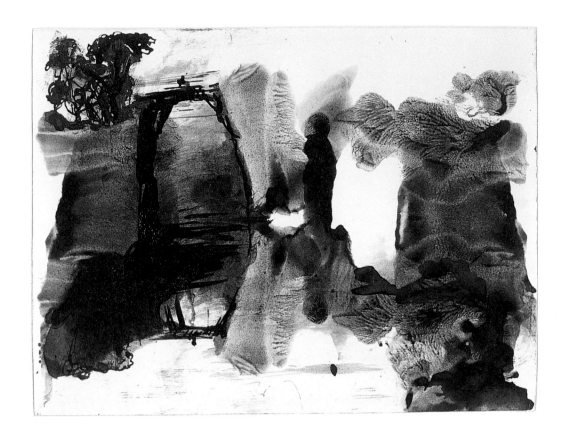

34 *Landscape with bridge*
1855–56

Pen and India-ink wash on beige paper
4 × 5¼" (102 × 135 mm)
Dijon, Musée des Beaux-Arts, Donation Granville,
inv. DG 623
PROVENANCE Hugo Family Estate; Valentine
Hugo
EXHIBITIONS Villequier and Paris 1971–72, no. 100
LITERATURE Cornaille and Herscher 1963, no. 146;
Georgel 1971, no. 13; Donation Granville 1976,
no. 149

Here, the effects of folding are combined with wash to form the outline of a landscape. The veins and marblings created when the paper was separated from the wet ink make the surface shimmer, while the smudges and irregularities left by evaporation bring out depth. Developing a *tache*, Hugo then added the detail of a delicate footbridge, creating a perspective.

35 *Chandelier*

ca. 1850

Pen and brown-ink wash on verso of a letter folded
down the middle

10¾ × 8⅛″ (262 × 205 mm)

Recto: stamp and estate mark of Maître Gâtine, with
(*Un ancien ami ?) et admirateur de Monsieur Victor/
Hugo, après une longue absence à l'étranger, désire lui/
présenter ses hommages, et lui/ demander un billet
d'entrée/ pour l'Assemblée Nationale/ Son tout obéissant et
dévoué Charpentier* ([An old friend?] and admirer of
Monsieur Victor/ Hugo, after a lengthy absence
abroad, wishes to pay his respects and to/ request an
entrance ticket/ to the Assemblée Nationale/ from
him. His obedient and devoted Charpentier)

Galerie Jan Krugier, Ditesheim & Cie, Geneva,
inv. 3417

PROVENANCE Hugo Family Estate

EXHIBITIONS Villequier and Paris 1971–72, no. 49;
Zurich 1987, no. 25; New York and Geneva 1990–91,
no. 29

LITERATURE Cornaille and Herscher 1963, no. 150;
Massin, II, 1969, no. 892

Made by folding the right-hand side of the
paper over the left-hand, where the brown ink
was still wet, this study of a chandelier testifies
to Hugo's taste for decorative detail. His pen
clearly revels in arabesque, in the sheer
pleasure of form.

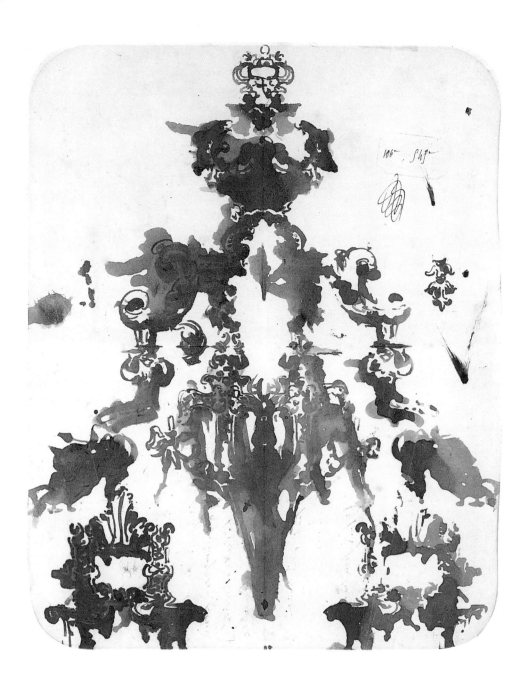

36 *Landscape with river*
ca. 1837–40

Pen, brown ink and wash on cream paper
4¾ × 7⅛" (120 × 180 mm)
Paris, Bibliothèque nationale de France, Mss, NAF
13355, fol. 61
EXHIBITIONS Paris 1985, no. 142; Venice 1993,
no. 34
LITERATURE Journet and Robert 1963, p. 49;
Massin, II, 1969, no. 891

Hugo composed this landscape from an ink *tache* drawn out lengthwise by folding; the symmetrical image obtained resembles a riverside view. The trees reflected in the water have been reworked with a pen. To the right, the line of the riverbank is reminiscent of the drawings Hugo made during his voyages on the Rhine and through Spain, and lends itself to the same interpretations as certain sketches he made of rocks in 1843:

"… the mountain, molded and weathered by wind and rain and sea, is peopled by the sandstone with a crowd of stone inhabitants, dumb, motionless, eternal, almost terrifying.

There is a hooded hermit, sitting with arms outspread on the top of an inaccessible rock at the entrance to the bay, who, according to whether the sky is blue or stormy, appears to bless the sea or warn the sailors. There are bird-beaked dwarfs, monsters in human form with two heads, one laughing, the other crying, close to the sky, on a deserted plain, in deep cloud, where there is nothing to make you either laugh or cry. There are giants' limbs, *disjecti membra gigantis*: here the knee, there the torso and the shoulder blade, further on the head … ."
(*Voyage aux Pyrénées*) MLP

70

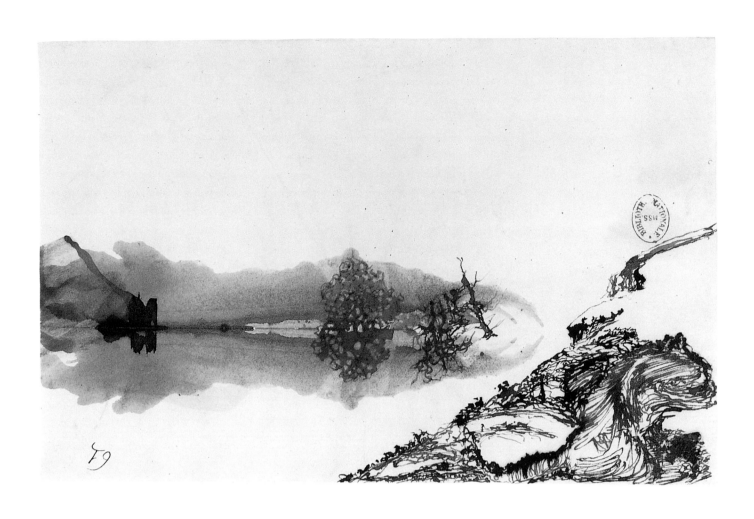

Lace Impressions

One of Hugo's experimental drawing techniques was the application of ink-soaked lace to paper. He probably used the same fragment of metallic lace to make these impressions, achieving a particular graphic effect. Nevertheless, he experimented with different colored inks and papers (see cats. 37–39). He also tested a wide range of possible reactions by varying the quantity of ink employed or the pressure with which the wire-mesh was applied to the paper, combining the results with other techniques. The delicate structures resemble ghostly apparitions left behind by the open-work of the lace, like patterns of foam on a beach. One also thinks, of course, of the splendid descriptions of marine life in *Toilers of the Sea*, that

endlessly mobile world of salt-water phantoms where silhouettes of plants merge with networks of rock crystal. Lace, in Hugo's graphic universe, is a kind of flotsam placed delicately on the surface of things but is in no way gloomy; a threshold where life throbs, albeit indistinctly. These fragments of lace were often used in mementos the exiled poet sent to his friends – New Year cards, words of thanks, tributes (see cats. 61 and 62). The tact and intimacy of Hugo's gesture restores some of the femininity and erotic power the material will originally have possessed. Often integrated into landscape, the open-work veil places a faint screen between eye and paper.

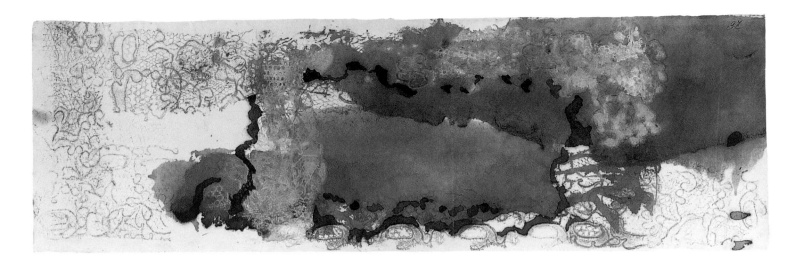

37 *Lace impression*

ca. 1855

Application of lace soaked in brown ink, with wash
and highlights of white gouache on cream paper
4¾ × 14¾″ (120 × 378 mm)
Paris, Bibliothèque nationale de France, Mss, NAF
13351, fol. 37
EXHIBITIONS London 1974, no. 41; Paris 1985,
no. 15; Zurich 1987, no. 13; Venice 1993, no. 25
LITERATURE Journet and Robert 1963, pl. 13
(bottom); Cornaille and Herscher 1963, no. 133;
Massin, II, 1969, no. 884; Picon and Focillon 1985,
p. 128

This impression was made by pressing a piece
of lace between two sheets of paper. On this
sheet the spindly lace combines and
intertwines with the mass of a large ink *tache*.
The second of the two impressions, formerly
belonging to Valentine Hugo and today in a
private collection, was presented at exhibitions
in Villequier and Paris 1971–72 (no. 74) and
London 1974 (no. 40). MLP

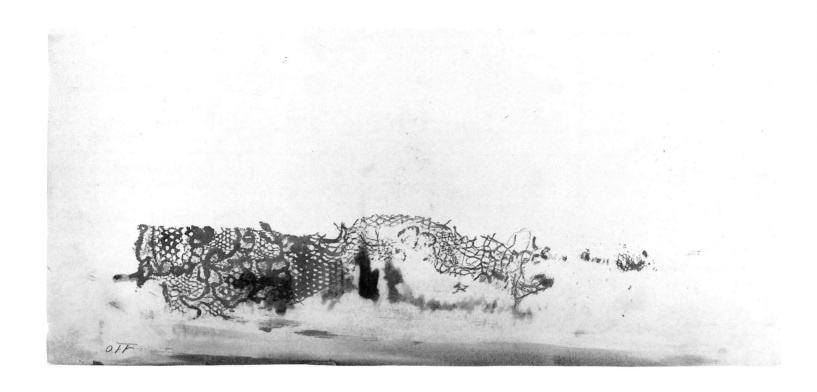

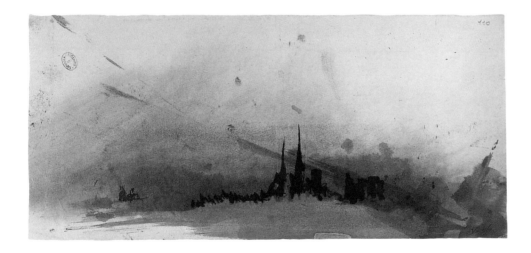

38v

38 *Lace impressions*
ca. late 1855

Recto: application of lace soaked in brown ink on
cream paper
Verso: charcoal, brown ink and India ink
6 × 12⅞″ (153 × 327 mm)
Paris, Bibliothèque nationale de France, Mss, NAF
13355, fol. 110
EXHIBITIONS Paris 1985, no. 12; Venice 1993, no. 23
LITERATURE Journet and Robert 1963, pl. 13 (top);
Massin, II, 1969, no. 880

Hugo often made use of both sides of the
paper. Either he made the paper transparent
so that the motif on one side was also visible
from the other – like the drawing known as
Odalisque (in the manuscript of *Chansons des
rues et des bois*) or the profiles of the *Théâtre de
la Gaîté*, which can be looked at from either
side – or he used the same sheet to depict two
very different compositions, as is the case here.
MLP

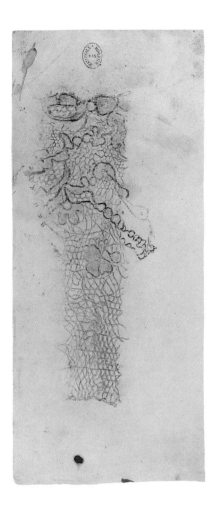

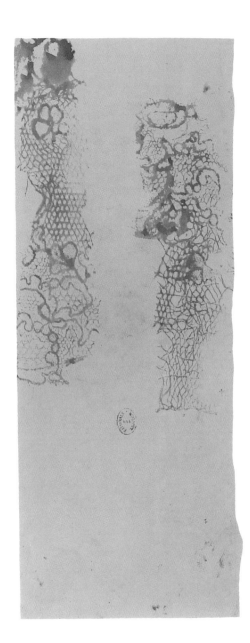

39 *Lace impressions*

ca. late 1855

Two lace impressions in a single frame
Paris, Bibliothèque nationale de France, Mss, NAF
13351, fol. 27a and b
Left: Application of lace soaked in brown ink, rubbed
charcoal and highlights of brown ink on cream paper
8⅝ × 3¾" (220 × 95 mm)
Right: Application of lace soaked in brown-ink wash,
on blue paper similar to that used for part of *Les
Châtiments*
11 × 4⅛" (280 × 105 mm)
EXHIBITIONS Paris 1985, no. 13 (a and b); Venice
1993, no. 24
LITERATURE Journet and Robert 1963, p. 29;
Cornaille and Herscher 1963, p. 134; Massin, II, 1969,
nos. 881–82

Like the previous example, these two
compositions closely resemble the original
pattern of the lace. Hugo added only a few
marks to bring out the network of lines.
MLP

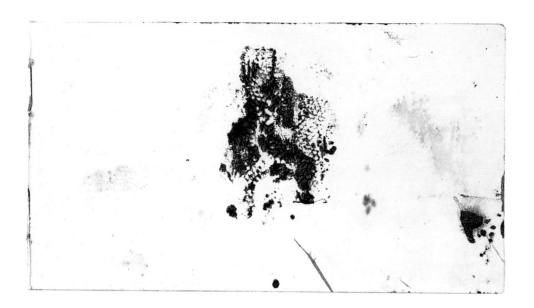

40 *Lace impression*
1856

Application of lace soaked in brown ink on white paper
3⅜ × 5¾″ (85 × 147 mm)
Villequier, Musée Victor Hugo, inv. 93–20
PROVENANCE From one of Hugo's notebooks, June 17–late August 1856, fol. 39
EXHIBITIONS Paris, Aittouarès, n.d.; Venice 1993, no. 33

A similar lace-work impression turns up on several pages of a sketchbook from 1856. From the same motif, Hugo derived in turn the head of a young girl (*La Jolie Cauchoise*, Villequier, Musée Victor Hugo) and that of an old woman (see right).

41 *"En revanche la vieille avait l'air formidable"* (The old lady, on the other hand, looked wonderful)
1856

Application of lace soaked in brown ink, reworked with brown-ink wash, pen and brush on white paper
5¾ × 3⅜″ (147 × 85 mm)
Inscribed at top *elles étaient à l'église assises dans les vieilles stalles de la nef* (they were sitting in church in the old stalls of the nave); at bottom *en revanche la vieille avait l'air formidable*
Villequier, Musée Victor Hugo, inv. 93–21
PROVENANCE From one of Hugo's notebooks, June 17–late August 1856, fol. 40
EXHIBITIONS Paris, Aittouarès, n.d., no. 19; Venice 1993, no. 33

From this lace impression Hugo creates the profile of an old peasant woman sitting in church. Hugo's ability to interpret a detail glimpsed in a form is the very foundation of his poetics. Short cuts, synecdoches, similarities, confusions and analogies nourish his poetry and his draftsmanship.

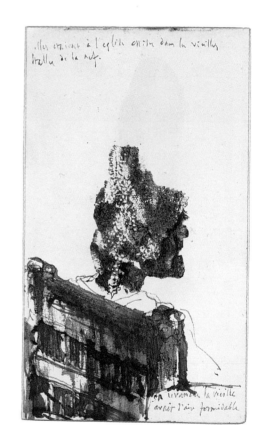

42 *Lace impressions*

ca. 1855–56

Application of lace soaked in black ink, with splashes
of brown ink on beige paper (right-hand corner cut
away)
Maximum 10¾ × 9⅛″ (275 × 230 mm)
Private collection
PROVENANCE Hugo Family Estate
EXHIBITIONS Paris 1972, no. 31; Paris 1985, no. 17
LITERATURE Massin, II, 1969, no. 885

Like the previous examples, this drawing
shows the experimental artist engaged in pure
research. Hugo combines the lace impressions
and *taches* by trial and error, speculating on the
tonal values of ink and paper and seeking to
create effects of weight and transparency.

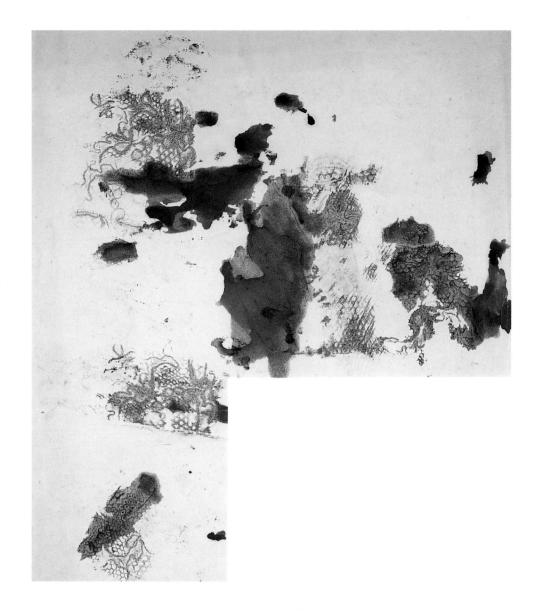

Stencils and Cut-outs

A stencil allows one not only to repeat the same motif as a pattern, but to isolate a form from the overall treatment (with wash, for example). The motifs to be masked off were cut out in a material which stood up to repeated use, such as aluminium or stiff cardboard. Many cut-outs of this kind made by Hugo have been preserved. Alongside architectural motifs, of which there are large numbers, figure decorative initials (see cat. 52), entire words (see cat. 51) and heraldic designs (see cat. 45), made along the lines of those available commercially at the time.

Hugo, who mainly used stencils between 1852 and 1858, often employed the technique when sketching the first part of a drawing, notably in his views of castles, where the use of a cut-out gives a certain depth to the outline of a turret (see cat. 68). Hugo used the stencil's power to break the graphic continuity of the drawing to remarkably good effect. The reserve created by the stencil leaves a trace that affects our reading with a sense of unreality; what one has before one's eyes is not so much the image of the object itself, as the 'halo' of the image of that object – its echo. The drawings made using this technique reveal a powerful characteristic of reserve: contrasts of *chiaroscuro* are heightened, or, alternatively, an even greater ambiguity of distance, movement or time of day is created.

43 *Silhouette of a castle*
ca. 1856

Wash with stencil made from ledger paper on beige
paper
1⅝ × 4⅞″ (40 × 125 mm)
Private collection
PROVENANCE Hugo Family Estate
EXHIBITIONS Villequier and Paris 1971–72, no. 83;
Paris 1972, no. 33
LITERATURE Massin, II, 1969, no. 878

This stencil has been cut out from the same
ledger paper used for a drawing datable 1856.

44 *Silhouette of a tower*
ca. 1865

Brown-ink wash and stencil on paper
On verso, in Hugo's hand *Ch. de Mouy*
5⅜ × 2½″ (135 × 62 mm)
Private collection
PROVENANCE Hugo Family Estate

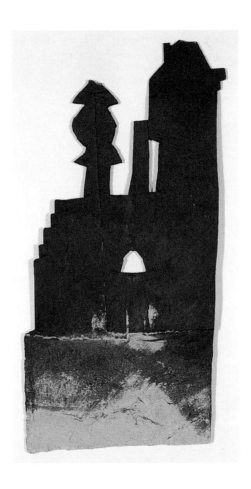

Charles de Mouy was born in 1834 and was a
gifted literary critic. From 1862 to 1865, he
worked for *La Presse*. There exists an exchange
of letters between Hugo and de Mouy dated
1864 and 1865. That the name of the journalist
has been written in Hugo's hand on the back
of this cut-out (made from a scrap of paper or
an old envelope perhaps) suggests that it dates
from the mid 1860s.

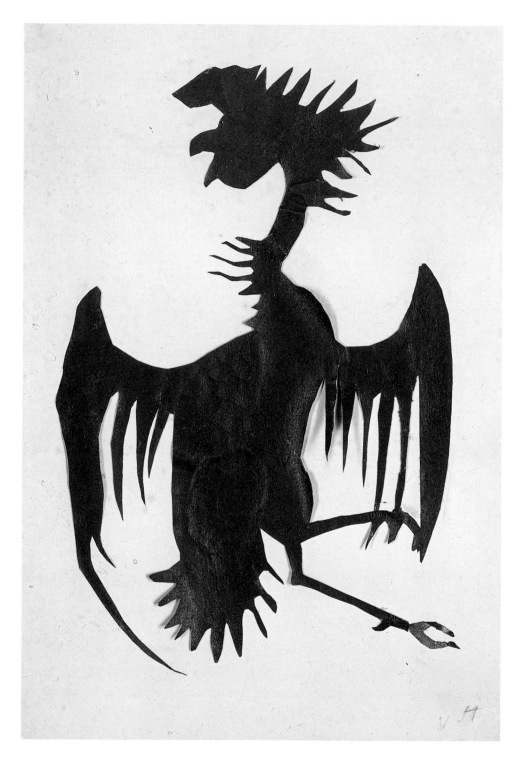

45 *Heraldic eagle*

ca. 1855

Cut-out made from black, laid paper and mounted on vellum

7¹¹⁄₁₆ × 5¼″ (195 × 133 mm)

Monogram on mount *V. H.*

Galerie Jan Krugier, Ditesheim & Cie, Geneva, inv. 4574

PROVENANCE Collection Paul Meurice; Collection Ozenne-Meurice; Collection Georges Hugnet

EXHIBITIONS Villequier and Paris 1971–72, no. 76; New York and Geneva 1990–91, no. 36

LITERATURE Cornaille and Herscher 1963, no. 129; Bory 1980, p. 125; Georgel 1985, p. 491

This remarkable cut-out was used to make the drawing opposite. Drawn with a firm hand, the eagle was then cut out with a pair of scissors from shiny black paper (traditionally used since the eighteenth century for silhouettes and cut-outs).

46 *Study of an eagle for a coat of arms*
ca. 1855

Soft charcoal, stencil, pen, brown-ink wash, black ink,
blue ink and application of lace on vellum paper
11¾ × 9″ (297 × 229 mm)
Paris, Maison de Victor Hugo, inv. 182
EXHIBITIONS Paris 1930, no. 949 or 1037; Geneva
1951, no. 133; Bologna 1983, no. 35; Marseille 1985,
no. 44
LITERATURE Simon 1904, p. 54; Planès 1907,
no. 253; Escholier 1926, p. 119; Sergent 1934, no. 288;
Sergent 1957, no. 335; Cornaille and Herscher 1963,
no. 130; Massin, I, 1967, no. 281; Picon and Focillon
1985, no. 125; Maison de Victor Hugo 1985, no. 182

Hugo began by tracing the silhouette of the
cut-out in soft charcoal. Once the image had
been made in reserve he worked over it with
brown and blue ink, at the same time
integrating a lace impression which is all but
illegible today. The colors, probably brighter at
the time of execution, must have emblazoned a
design that resembled a family coat of arms.

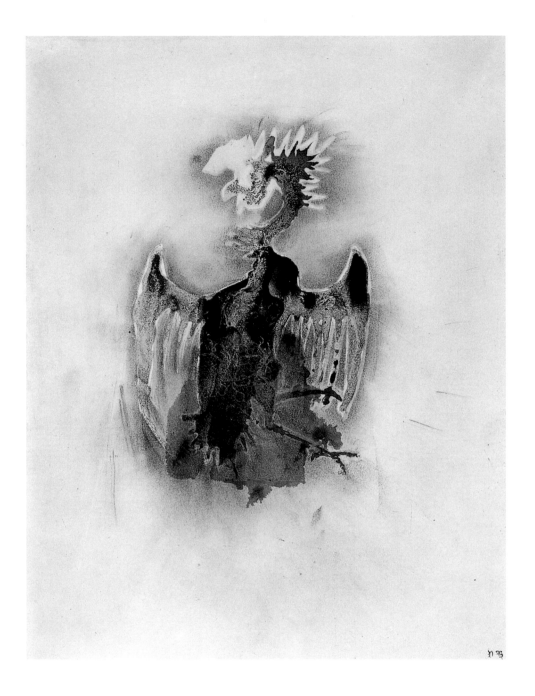

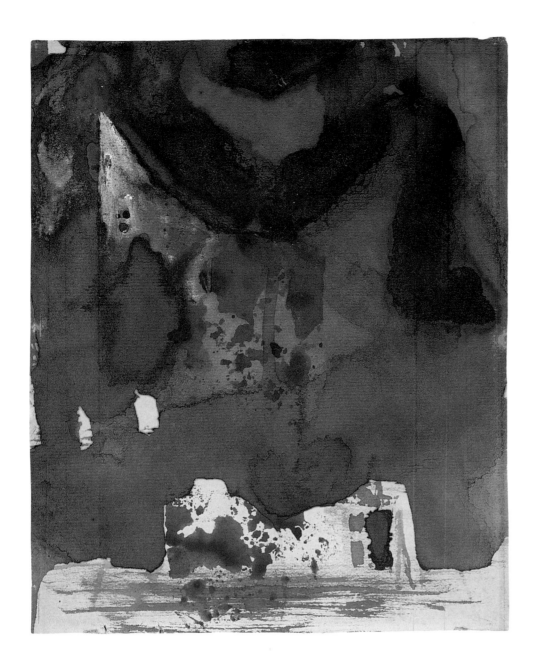

47 *Ghost castle*

ca. 1865

Brown-ink wash and stencil with highlights of white
gouache on ledger paper
9⅜ × 7½″ (237 × 191 mm)
Private collection
PROVENANCE Hugo Family Estate
EXHIBITIONS Paris 1985, no. 277
LITERATURE Cornaille and Herscher 1963, no. 166;
Massin, II, 1969, no. 999; Picon and Focillon 1985,
no. 164

The castle shown in this large wash drawing
was made with a stencil. The dissolution of
forms seems to have been brought about by
dampening the paper beforehand. Note how
the faint vertical lines of the ledger paper
heighten the sense of distance.

48 *Ruins and castle in moonlight*
ca. 1865

Pen, brown ink, gouache and stencil on drawing
paper
10 × 6⅝" (255 × 168 mm)
Private collection
PROVENANCE Hugo Family Estate
EXHIBITIONS Paris 1985, no. 276
LITERATURE Cornaille and Herscher 1963, no. 167;
Massin II 1969, no. 997; Bory 1980, p. 81; Picon and
Focillon 1985, no. 165

The perfectly round reserve used for the full
moon helps to underline the extraordinary
chaos of the night, evoked by wash mingled
with thin trails of ink. Contours have ceased to
exist. Stones, clouds, shadows, reflections –
everything has been caught up in a current in
which reality is dissolved and geography
abolished.

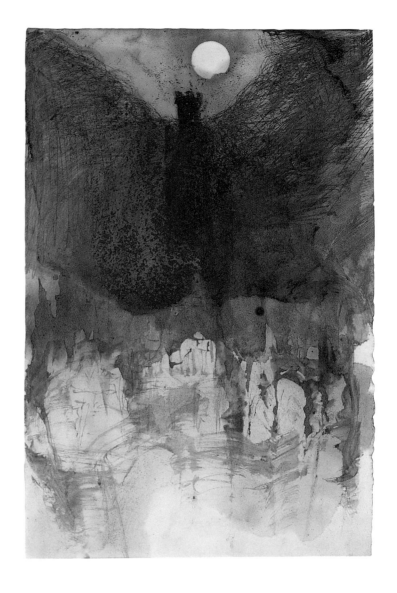

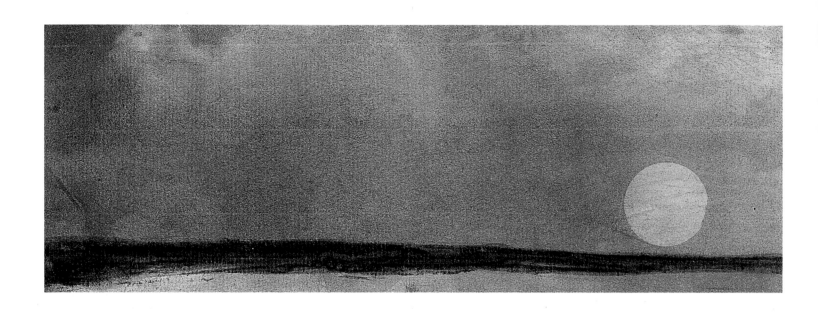

49 *Sunset by the sea*
ca. 1852–55
Gray-ink wash and stencil on gray-tinted paper
3⅜ × 9⅛" (86 × 231 mm)
Villequier, Musée Victor Hugo, inv. 1675 II 45
EXHIBITIONS Besançon 1985, no. IX (printed
upside down)
LITERATURE Chirol 1982, no. 24

This is a fine drawing, at once sober and
sensitive, with a quiet horizontality that gives
even greater breadth and tragic mystery to
the sun's descent into the sea. It exhibits a
remarkable economy of expressive means: a
pale-gray wash for sky and shore, and a few
brushstrokes to define the sea that divides
them. The stencil used creates that "dismal
and slowly ruined" star "of sinister
roundness" conjured up in *La Fin de Satan*.

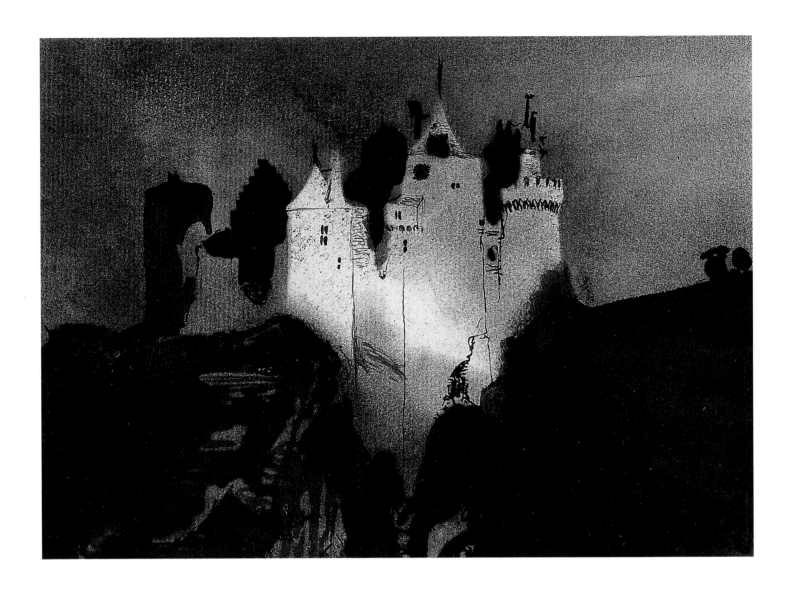

50 *Castle lit up in the night*
1856

Pen, brown-ink wash and black ink over rubbed
charcoal on laid paper
5⁷⁄₁₆ × 7⅜″ (138 × 188 mm)
Signed bottom right *1856/ Victor/ Hugo*
Inscribed on a piece of paper glued onto mount [*Aux
pieds*?] *de Madame Louise Colet/ Guernesey—5 août
1856/ Victor Hugo* ([At the feet?] of Mme Louise
Colet/Guernsey—August 5, 1856/ Victor Hugo)
Villequier, Musée Victor Hugo, inv. 57
PROVENANCE Collection Louise Collet; Collection
Lucien-Graux; Hôtel Drouot, Paris, December 13,
1957, lot 155

EXHIBITIONS Villequier and Paris 1971–72, no. 98;
London 1974, no. 43; Bologna 1983, no. 41; Paris,
Maison de Victor Hugo, 1985, no. 95; Paris 1985,
no. 176
LITERATURE Massin, II, 1969, no. 558; Georgel
1971, no. 16; Bory 1980, p. 50; Chirol 1982, no. 27

The cut-out used for this picture is today in the
collection of the Bibliothèque nationale de
France (NAF 13351, fol. 34³). The blurred
outline and luminosity of the area left in
reserve give a sense of unreality to Hugo's
vision of a castle looming up out of the night.
The color balance is extremely fine. The blacks
are deep and smooth near the bottom of the
picture, allowing the sudden burst of
moonlight to sparkle even more forcefully on
the towers of the castle. The thinly applied
wash somewhat muffles the light reflected by
the laid paper, the delicate structure of which
is visible beneath.

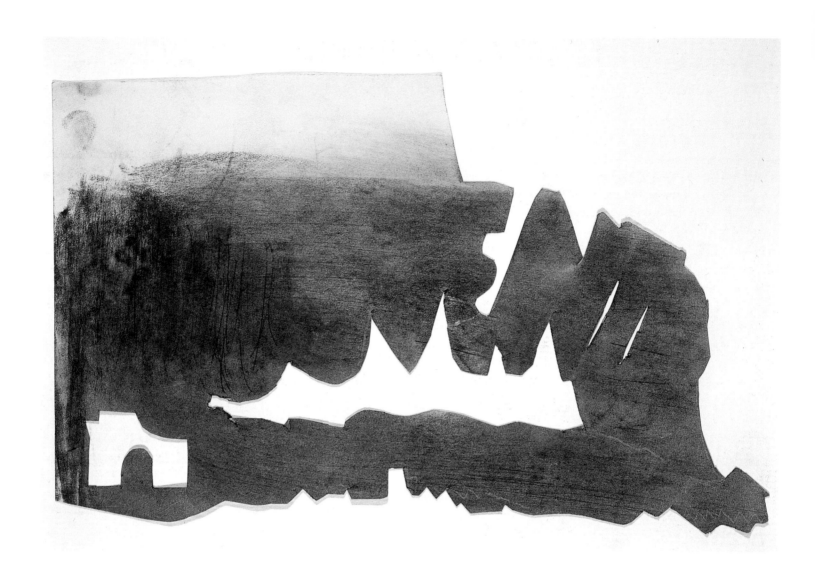

51 *"Souvenir"* (Memento)
ca. 1851

Cut-out, charcoal and traces of ink on paper
5⅜ × 8¾" (137 × 223 mm)
Private collection
PROVENANCE Hugo Family Estate

This cut-out was used to form the word
'*souvenir*' (memento) which appears in the sky
above Paris in a fine drawing belonging to the
Maison de Victor Hugo (see fig. 16, p. 24). In
each letter, outlined with a stencil and then
reworked with a pen, appears the date of an
anniversary, relating to Hugo's love affair with
Léonie d'Aunet.

PART II: THEMES

The drawings assembled in the second part of the catalogue were for the most part made during, or just before Hugo's exile (from 1851), and are distinguished either by their large formats, or by a use of mixed media in which reliance on chance is increasingly frequent. This new trust in occult, unconscious forces which trace vague outlines on the paper, breaking up forms and dispersing them, is not unrelated to the experiments Hugo made with table-turning between 1853 and 1855. If the table can speak, it follows that paper, ink and taches can too. Thus Hugo's 'spirit drawings' were an important stage in his development of complete freedom in both the materials he used and the way he used them.

The example of the ocean, contemplated daily from the islands of his exile, was, of course, essential: its fecundity, its conflicting and destructive ebb and flow, its absurd and unpredictable fits of rage, acted as examples for the artist's eye and hand. Under its sway, the theme of shipwreck comes to haunt Hugo's work as both poet and draftsman. Combining the techniques described in the first part of this catalogue, Hugo developed a vision of space that sought to rival the inventions of writing.

The unknown for which Hugo searches in these drawings has as its starting point all kinds of uncertainties concerning solid and liquid states, and a remarkable capacity for metamorphosis. Reveries on nature find expression in conflicting boundaries, inexplicable disappearances, and a pervasive sense of ambiguity. To make anything out in these drawings one must stare into fog, scrutinize dream-like forms and fragile materials, and only after insistent contemplation and relentless questioning of the visible will the clouds sometimes disperse and a fleeting unity be restored to the scattered fragments.

In these drawings, then, the major themes of Hugo's writings resurface, examined by other means but no less powerfully expressed. The various forms of Necessity weighing so heavily on human destiny are present here, though it is the clash between mankind and nature that is particularly stressed. One can find in these pictures the rhythms of prose and the fervor of poetry, accumulations of descriptive detail, grotesque disproportions, sudden reversals of situations and rents in the fabric of logic – in short, that extravagance born of spiritual restlessness that may plunge mankind into the foulest darkness or lead up to mystical illumination.

Initials

For Hugo letters were more than just an instrument for composing words or expressing ideas. His graphic work contains no end of forms towering up like gigantic, isolated initials in the landscape (see cats. 54 and 55) or concealed, like elements in a rebus, in a piece of architecture (see cat. 53). Frequently, the initials are Hugo's own. If the V of Victor seldom appears on its own (though its lively, pointed outline often punctuates the contours of a castle), the H, on the other hand, with its massive stability, haunts a great many drawings. The resemblance of this powerful initial to the two towers flanking the façade of the cathedral of Notre-Dame in Paris has often been noted. Several of Hugo's drawings openly suggest the association. Likewise, the two rocks of Douvres, rising up in the middle of the sea and united horizontally by the wreck of the *Durande* that has been flung there by a storm, form, as the author of *Toilers of the Sea* himself describes it, "a sort of gigantic capital H … . It resembled a gate. What good is a gate in this open expanse that is the sea?" Rising up alone in the middle of the sea, at once an impregnable bastion and a breach open to all kinds of devastation, the letter has enormous symbolic resonance. It is the author's initial, of course, but it is also that of *Homme* (Man), *Héros* (Hero) and *Humanité* (Humanity), all major themes in Hugo's work. It is also, to a lesser extent, that of his residence in Guernsey, Hauteville House, where it repeatedly crops up like an insignia – on chimney-pieces, over doors, and in decorations for the furniture, frames and curios devised by their owner.

Other drawings contain whole words: book titles, recollections of places visited, captions and, above all, the name Victor Hugo written out in full. It is the formal value, rather than the circumstantial significance or psychoanalytical import, of these inscriptions on paper that needs to be considered here. Once again, the poet displays astonishing freedom, inflating the letters as they move through space and effortlessly combining them with the arabesques of drawing. In this respect, he can be compared to late nineteenth-century poster-artists and to a whole host of early twentieth-century graphic artists who took almost as much interest in the character of the letter as in the theme depicted.

52 *Intertwined initials*

ca. 1856

Cut-out paper stencil (?) and brown ink on stiff
paper
5 × 3⅝″ (128 × 92 mm)
Private collection
PROVENANCE Hugo Family Estate
EXHIBITIONS Paris 1972, no. 37; Paris 1985, no. 191
LITERATURE Massin, II, 1969, no. 1007

The H of Hugo is represented only once in
these intertwined initials, at bottom right. No
further trace has been found in the poet's
drawings of this monogram, which was cut
out from the wrapping paper that Hugo used
for manuscripts dating from 1856.

53 *Project for the dining-room chimneypiece*
at Hauteville House
1857

Pen and black ink on green-tinted paper (verso of a
brochure)
11 × 9" (278 × 228 mm)
Private collection
PROVENANCE Hugo Family Estate
EXHIBITIONS Villequier and Paris 1971–72, no. 101;
London 1974, no. 49; Paris 1985, no. 226
LITERATURE Massin, II, 1969, no. 805

This is a project for a nook in the large
fireplace of the dining-room at Hauteville
House which seems to have been completed in
fall 1857. The capital H made with
earthenware tiles to decorate the poet's
Guernsey home (bought on May 16, 1856 with
royalties from *Les Contemplations*) is twice
justified. Not only did Hugo design the
decorations for the rooms, he also supervised
the way in which they were arranged, with an
intelligence, as various authors have stressed,
that should be seen in relation to all his other
creative activities. He even went so far as to
remark: "I've missed my vocation. I was born
to be a decorator." Visiting Hauteville House is
an astonishing experience to this day, such is
the accumulation of objects, inscriptions and
ornamental designs one finds there, bearing
out the writer's declaration in *Post Scriptum de
ma vie*: "I'm not prudish in the presence of art
and nature. I accept it … I like it all; I have no
preferences in the ideal and the infinite; I'm
not fussy; I'm not hard to please; I don't turn
my nose up at it; I'm the Gargantua of
beauty." A fine drawing from the Maison de
Victor Hugo (fig. 20) is further testimony to
Hugo's vision: the architectural mass looms up
out of dense, mysterious shadow; the
verticality and oblique lighting of the
chimneypiece turn it into a cathedral as much
Buddhist as Gothic, a monument dedicated
more to its own monumentality than to any
function it may serve. It is like something seen
in a dream. Contemplate this image long
enough and a sort of magnification of space

occurs, a proliferation of detail, as though it
had been placed under a magnifying glass. The
powerful H formed by the uprights and the
architrave of the chimneypiece further
reinforces the symbolic significance of this
fusion of architecture and alphabet. Hugo's
dream-vision leads from the letter to the book,
from the book to the cathedral, and, if one
recalls the poet's novels, to the splendid lesson
contained in the chapter 'This Will Kill That'
(*Ceci remplacera cela*), in *Notre-Dame de Paris*.

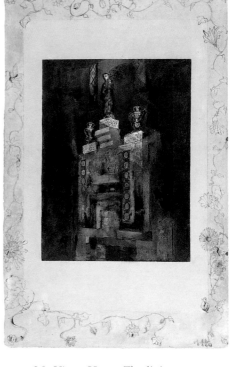

FIG. 20 Victor Hugo, *The dining-room
chimneypiece of Hauteville House*, 1857, pen
and brown-ink wash over graphite, black
ink, charcoal, soot (?), gouache, watercolor,
blue ink (?), rubbed areas, 18¾ × 13¹¹⁄₁₆"
(477 × 347 mm), Paris, Maison de Victor
Hugo

BELOW
FIG. 21 *The dining-room on the ground floor
of Hauteville House*, photograph, Paris,
Maison de Victor Hugo

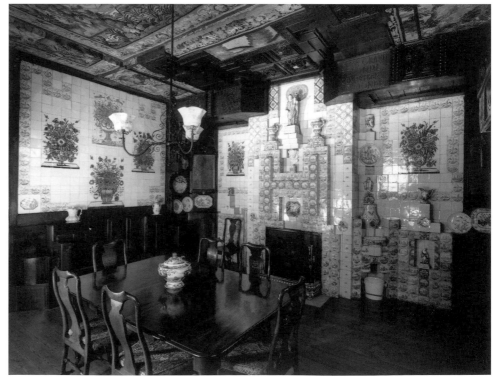

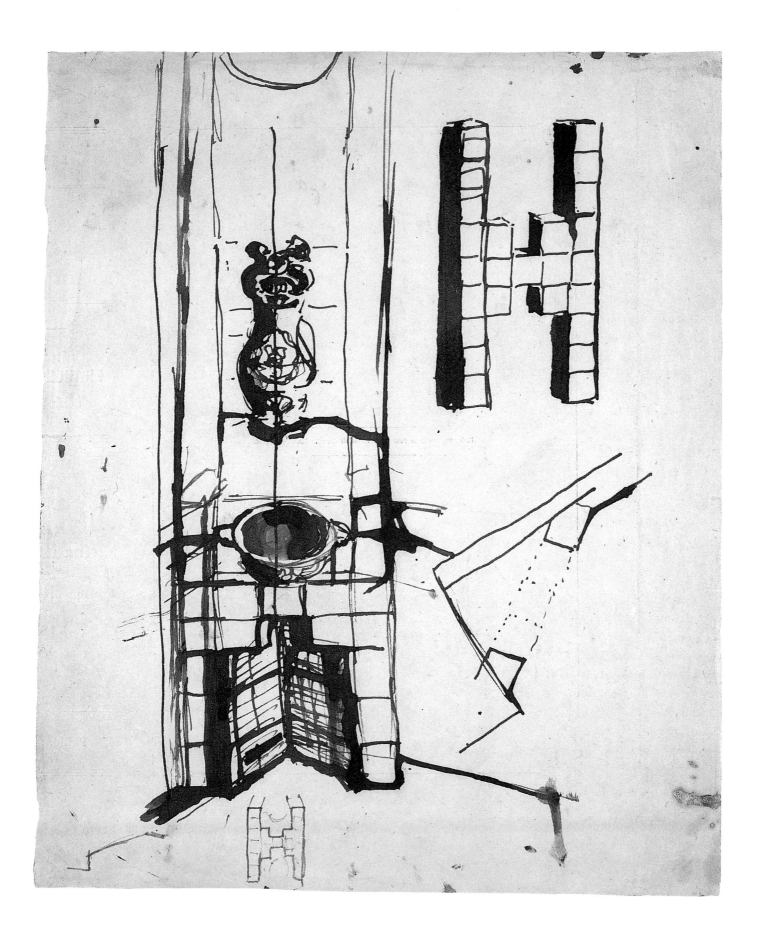

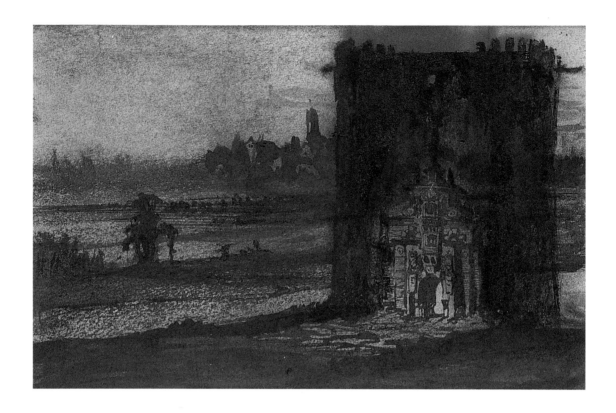

54 *A tower at dusk*
ca. 1845

Pen, brown-ink wash, charcoal and graphite on
vellum paper, partly rubbed
3¾ × 5¾" (97 × 146 mm)
Galerie Jan Krugier, Ditesheim & Cie, Geneva,
inv. 4482
PROVENANCE Collection of Mme Biard (Léonie
d'Aunet)
EXHIBITIONS New York and Geneva 1990–91,
no. 19; Valencia 1996, no. 26

As is often the case with Hugo's drawings, it is
only after looking at the image for some time
that one notices how strange it is. On a first
reading one admires the skill with which the
ink and pencil have been rubbed, giving a
sense of fullness to the space. Little by little,
though, the shadow of that massive, solitary,
blind tower bears down on the countryside,
opening it up to unreality. Its strange
proportions and excessively ornamental Gothic
or plateresque portal make it seem outlandish.
Before long, an immense H appears, steering
the entire image in the direction of allegory
and suggesting a melancholy meditation on
the remains of day.

OPPOSITE **55** *Two castles in a landscape*
1847

Brush, brown ink and wash over black crayon and
graphite, with shellac, on laid paper
10½ × 18¼" (267 × 464 mm)
At bottom, on mount *Debout l'un devant l'autre ils
semblent/ Deux noirs géants prêts à la lutte/ Victor Hugo*
(Standing facing one another they resemble/ Two
dark giants ready for the fight/ Victor Hugo)
Diagonally at bottom left *j'avais donné ce dessin à/ mon
vieux compagnon d'exil Kesler;/ je suis charmé de le voir
entre/ les mains de mon jeune et excellent/ ami M. le
Ber/ V. H./ H. H. avril 1870* (I had given this drawing
to my old companion in exile Kesler;/ I am charmed
to see it in/ the hands of my excellent young/ friend
M. le Ber/ V. H./ H. H. April 1870)
Bottom right, on frame *A mon cher et courageux
compagnon d'exil/Kesler/ en souvenir des soins
affectueux pendant ma maladie/Victor Hugo/ Guernesey
1 janvier/1859* (To my dear and courageous
companion in exile/ Kesler/ for the affection with
which he cared for me during my illness/ Victor
Hugo/Guernsey January 1/ 1859)

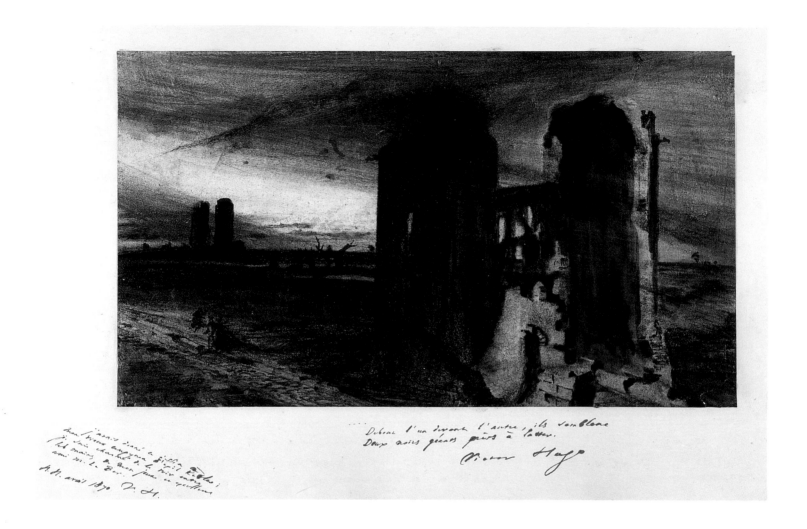

Bottom left, on frame *qu'Hugo prenne la plume ou du pinceau/ c'est la même puissance./ Hugo peint un dessin c'est toujours un joyau/ … C'est la force et élegance/ et partout l'harmonie/ et partout la grandeur prêté au souffle ardent (?) … il … son génie./ Dans les livres au papier (?) sublime créateur/ et donne la couleur et la forme et la vie./ Kesler/ Guernesey janvier 1859* (Whether Hugo takes up pen or brush/ it's the same power./ Hugo paints a sketch, it's always a gem/ … There's force and elegance/ and everywhere harmony/ and everywhere greatness brought to bear on ardent inspiration (?) … he … his genius./ In books on paper (?) sublime creator/ and gives color and form and life./Kesler/Guernsey, January 1859)
The Art Institute of Chicago
PROVENANCE Gift of the artist to Monsieur Kesler, Guernsey, January 1859; gift of Monsieur Kesler to Monsieur Le Ber before 1870; gift of Monsieur Le Ber to the Receiver-General of Alderney (Channel Islands); gift of the Receiver-General of Alderney to Sir Henry Gauvain; thence by descent, France; purchased in 1989

Here Hugo himself urges the viewer's gaze to more than mere acknowledgement. The two buildings are explicitly compared to "two dark giants ready for the fight." The massiveness, darkness and isolation of the two silhouettes, set off against a dramatically lit landscape, prepare the mind for a metaphorical, even allegorical reading. These gigantic structures can also be likened to enormous capital letters sunk like landmarks in the distance, ramparts raised against a deserted, wind-torn plain and the uncertainty of the impending dusk. Though we once again have no difficulty recognizing the author's powerful initial, these colossal stone buildings seem powerless to contain the unsettling approach of night which is already eating into them.

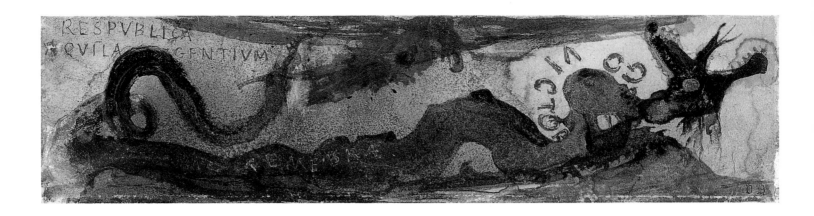

56 *"Respublica, aquila gentium"* (The Republic, eagle of the people)

Pen, brown-ink wash, black ink, blue ink, charcoal (?) and gouache on beige paper, partly scraped
2½ × 9¹¹⁄₁₆" (64 × 246 mm)
At top left, in red ink *RESPVBLICA/AQVILA GENTIVM*
On body of snake, in blue ink *TENEBRAE*
To the right, circular signature in red ink *VICTOR HUGO*
Paris, Maison de Victor Hugo, inv. 869
LITERATURE Sergent 1934, no. 285; Sergent 1957, no. 332; Massin, I, 1967, no. 275; Maison de Victor Hugo 1985, no. 869

The meaning of this allegorical composition becomes clearer (without entirely divulging its secret) once one has spotted the eagle hovering over the reptile-like dragon dying under the blows planted in its body by the letters of Victor Hugo's name. It is the image itself, though, more than the Latin inscription supposed to provide an explanation, that helps us understand the meaning of the picture: the serpent, a baneful, chthonic force, is rendered by a flow of shadowy blue ink of which the limp arabesques bespeak the careless approach. It is not so much the clumsily drawn eagle as the lettering (the blood-red letters of Victor Hugo's name) that lays low evil forces.

RIGHT 57 *"Torquemada"*

Pen and brown-ink wash over graphite, black ink, charcoal and fingerprints on beige paper, partly rubbed
11⁵⁄₁₆ × 18" (288 × 458 mm)
Strip of irregularly shaped laid paper (7¹¹⁄₁₆ × ¹¹⁄₁₆" [196 × 5 mm]) glued onto left edge
Across the top, in large capital letters drawn with a mixture of glue and red pigment *TORQUEMADA*
Paris, Maison de Victor Hugo, inv. 809
PROVENANCE Collection Paul Meurice; gift of Paul Meurice (1903)
EXHIBITIONS Paris 1888, no. 106; Geneva 1951, no. 113
LITERATURE Planès 1907, no. 289; Sergent 1934, no. 225; Sergent 1957, no. 258; Cornaille and Herscher 1963, no. 298; Massin, II, 1969, no. 783; Lafargue 1983, p. 97; Picon and Focillon 1985, no. 287; Maison de Victor Hugo 1985, no. 809

This is the projected frontispiece for *Torquemada*, a play completed in 1869 that had been in Hugo's mind as early as 1859. The drawing is similar in subject and script to one dated 1852–55 depicting the dyke then visible in Jersey. In *William Shakespeare*, Hugo describes it in the following terms:

"To the left could be seen the dyke. The dyke was a line of large tree-trunks built against a wall, planted upright in the sand, dry, bare, with knots, crooks and joints, which looked like a row of shinbones. The musing mind, which willingly puts up with daydreams for the sake of presenting itself with a riddle, might wonder to what men these eighteen-foot-high tibias had belonged."

The drawing, which closely resembles a photograph in Hugo's possession, shifts the subject by 90°, turning, in one of those reversals dear to Hugo, what had been a rampart against the sea into the very disorder of the sea. Water mineralizes plant-life, which in turn shelters figures, eyes, fabulous beasts; sea changes to stone, wood becomes wave, techniques merge, spaces are superimposed, the horizon shifts on its axis. Finally, the poet's hand traces across the raging elements the name of the Dominican inquisitor in beautiful, blood-red capitals, *TORQUEMADA*.

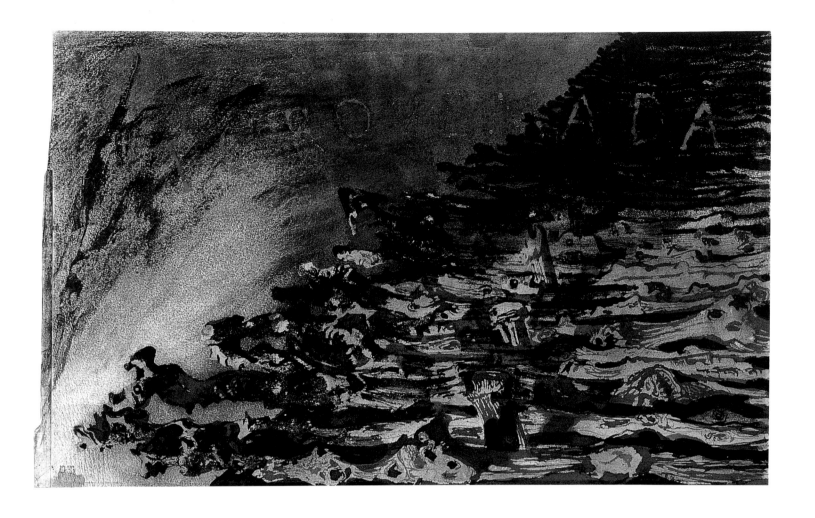

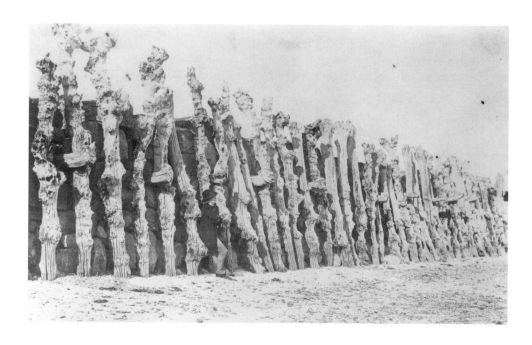

FIG. 22 Charles Hugo, *Victor Hugo at the foot of the Dyke, Jersey*, 1853, photograph Paris, Maison de Victor Hugo

58 *The castle*

ca. 1866

Pen, India-ink wash, watercolor and gouache (?) on
paper
2⅜ × 6¹¹⁄₁₆″ (60 × 170 mm)
In capital letters, in red gouache
GUERNESEY/VICTOR/HUGO
Collection Jan and Marie-Anne Krugier-Poniatowski
PROVENANCE Private collection
EXHIBITIONS Zurich 1987, no. 50, p. 19; New York
and Geneva 1990–91, no. 24; Valencia 1996, no. 32

FIG. 23 Charles Hugo, *Marine Terrace, Jersey*, photograph
Paris, Maison de Victor Hugo

59 *Marine Terrace with initials*
1855

Pen, brown-ink wash and rubbed charcoal with
highlights of gouache on paper
Bottom left *MARINE TERRACE: VICTOR HUGO/
21 mai/1855*
16⁹⁄₁₆ × 13″ (420 × 330 mm)
Private collection, Paris
PROVENANCE Collection Juliette Drouet (?); Paul
Meurice; Mme Albert Clemenceau-Meurice
EXHIBITIONS Paris 1952, no. 368; Guernsey 1954,
no. 32; Villequier and Paris 1971–72, no. 68; London
1974, no. 33; Paris 1985, no. 9
LITERATURE Cornaille and Herscher 1963, no. 103;
Massin, II, 1967, no. 1016; Georgel, *Sources*, 1971, no.
pp. 281–82; Bory 1980, p. 60; Seghers 1983, p. 9; Picon
and Focillon 1985, no. 102

One does not know what to admire most in
this drawing: the powerful combination of the
four claw-like letters holding firmly captive
the initials of Victor Hugo and his mistress,
Juliette Drouet; the daring of this "gigantic
aerial advertisement," as Gaétan Picon calls it;
or the upward momentum which carries the
poet off toward a much-desired apotheosis.
The landscape is handled with remarkable
skill; the silhouette of Marine Terrace, the
house Hugo occupied with his family in
Jersey, seems to have been drawn from a
photograph taken by his son Charles (see
fig. 23). The treatment of the light, typical of
drawings from this period, strongly suggests
as much, for the light sources are both
improbably dispersed and energized by a
narrowing of the aperture that lets in light. As
a result the eye receives a twofold impression
of precariousness and of immense scope. Earth
is hardly more solid than water under this sky
made of scraps of light. The dazzling façade of
Marine Terrace alone resists this all-pervading
pallor, a flat-roofed building facing the sea,
"rectilinear, straight-laced, four-square,
whitewashed with cold, all white." "It was
brick-laid Methodism," added the poet, who
never felt at ease there. "Nothing is as chilling
as this English whiteness. It seems to offer us
the hospitality of snow."

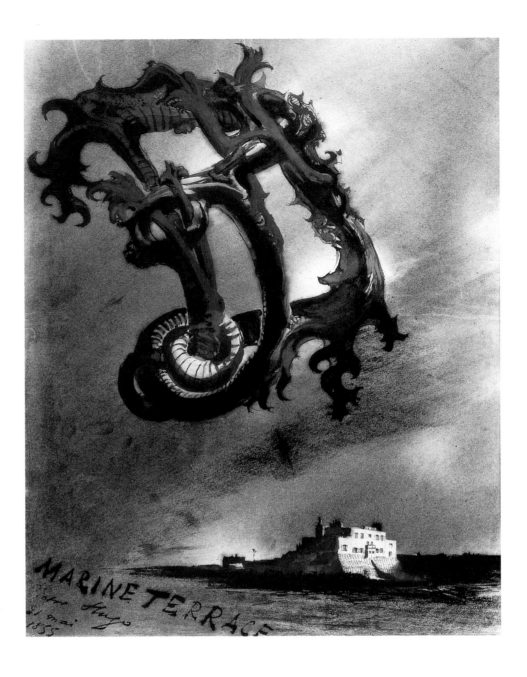

Calling Cards and New Year Cards

In several drawings from the period of his exile Victor Hugo's name is spread over the entire sheet of paper. This has sometimes been taken as a sign of overweening pride. But that is to ignore the destination of these drawings, which were addressed by the exiled poet to friends who had stayed behind on the mainland. The drawings were often sent for the New Year or for anniversaries of one kind or another; in combining his name with a landscape or a composition he had drawn, Hugo was merely perpetuating a tradition that was widespread in exchanges of letters and family celebrations throughout the nineteenth century. The letters which spell his family and Christian names did, it is true, have an appeal for Hugo: he enjoyed intertwining them, superimposing them, trying them out in every possible position and even confronting them with one another in a daring visual palindrome. These calling cards, as Hugo himself described them, are among his most inventive drawings, for he does not feel himself bound by constraints and is clearly eager to have his friends share in his discoveries and the games he plays with his pen. Hence the wide range of formal means (*taches*, stencils, stumpwork, lace applications, collages, embellishings, permutations, mirror-play and a constant use of color, otherwise seldom used in his graphic work) that characterizes these occasional drawings.

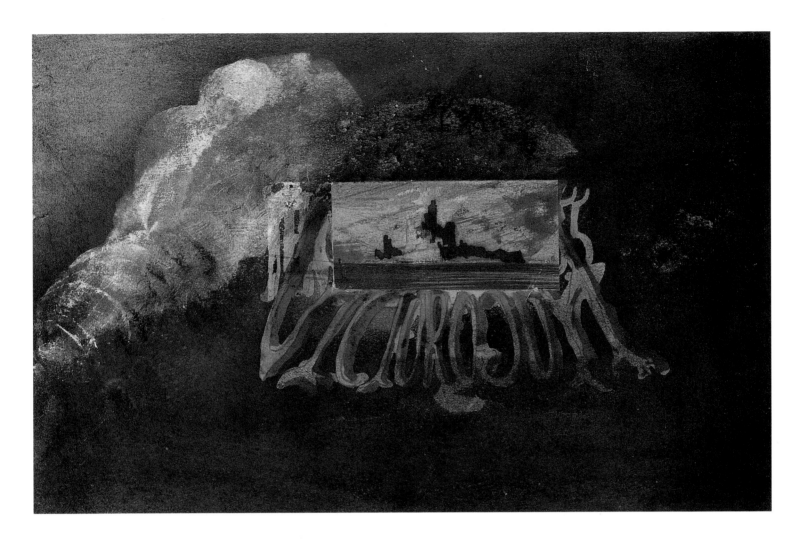

60 *Calling card*
1855

Pen, brown ink and watercolor with highlights of
gouache and Prussian blue on paper, partly scraped
5½ × 8⁷⁄₁₆" (140 × 215 mm)
At bottom, with surname reversed *VICTOR HUGO*
and, to either side, *JER ... 55*
Private collection
PROVENANCE Hugo Family Estate
EXHIBITIONS Villequier and Paris 1971–72, no. 54;
Paris 1972, no. 22; London 1974, no. 28; Bologna 1983,
no. 27; Paris 1985, no. 8
LITERATURE Massin, II, 1969, no. 1023

This is one of the first calling cards Hugo
made and is remarkable for the range of
techniques he employed. In addition to the
witty play on letters, the unusual use of color
and the inclusion of an image within the
image, the physical act involved in actually
making a collage invests the card with a
certain intimacy.

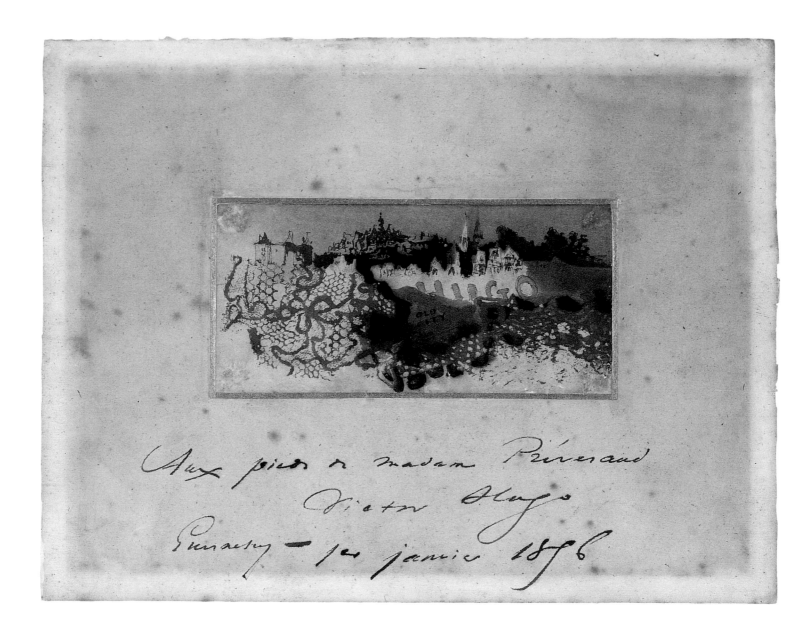

61 *"Old city"*
1856

Pen, brown-ink wash, applications of lace soaked in
brown and black ink with highlights of red and gold
gouache on bluish laid paper
2⅝ × 5½" (67 × 140 mm); gilt-paper border glued onto
a card (7³⁄₁₆ × 9½" [182 × 242 mm])
Inscribed *HUGO/ OLD CITY/ VICTOR.*
Inscribed and signed on mount *Aux pieds de Madame
Préveraud/Victor Hugo/Guernesey—1er janvier 1856*
(At the feet of Madame Préveraud/Victor Hugo/
Guernsey—January 1, 1856)
Villequier, Musée de Victor Hugo, inv. V 94–3
EXHIBITIONS Paris, Aittouarès, n.d., no. 37

This calling card is a perfect illustration of
Hugo's skill in reinterpreting random
particulars. Here the lace application is used to
conjure up the rudiments of a landscape. The
pattern of the fabric suggests copses behind
which an old city can be seen, sketched rapidly
with a pen. The letters forming Victor Hugo's
name are concealed in this mass of greenery
and under the rocks marked by dark, formless
splashes of diluted ink. The colors of the
drawing have unfortunately faded, and the
picture has doubtless lost much of its original
shine. This is generally the case with Hugo's

graphic work, for he made use of brittle papers
that poor-quality inks – or the less
conventional materials to which he readily
resorted – have further eroded over the years.

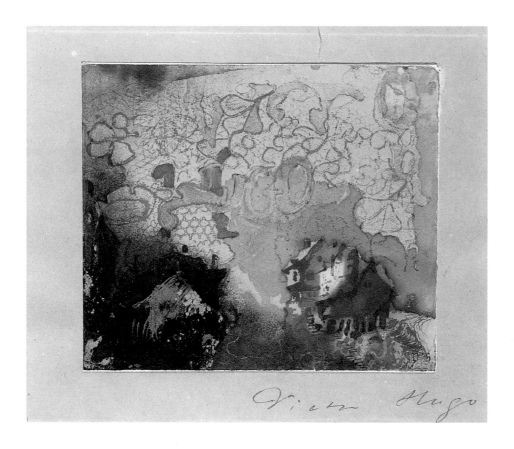

62 *Old house*

ca. 1856

Pen and brown-ink wash over graphite, black ink,
charcoal, gouache, watercolor, gold ink and lace
impression on vellum paper, partly rubbed
4⅛ × 4¹³⁄₁₆″ (105 × 122 mm)
Spelled out across the drawing in large gold and red
capital letters *VICTO/R/ HUGO*
At bottom right on mount (6³⁄₁₆ × 7⁵⁄₁₆″
[157 × 185 mm]), in brown ink *Victor Hugo*
Paris, Maison de Victor Hugo, inv. 867
EXHIBITIONS Paris 1888, no. 130?; Geneva 1951,
no. 73
LITERATURE Alexandre 1903, p. 156; Planès 1907,
no. 316?; Sergent 1934, no. 147; Sergent 1957, no. 162;
Cornaille and Herscher 1963, no. 137; Massin, II, 1969,
no. 1011; Picon and Focillon 1985, no. 132; Maison de
Victor Hugo 1985, no. 867

This drawing, similar in technique to the
previous one, is equally inventive in the use it
makes of the arbitrary effects of the lace in
developing a reverie. Very similar in format,
coloring and inspiration, the drawing in all
likelihood dates from the same year, 1856, and
may likewise have been used to send New
Year greetings. It comes as no surprise to find
patterns of lace impressions in the images
Hugo sent to his nearest and dearest. The
stitch of the fabric is suggestive of close ties,
of intimate knowledge and carnal attraction.

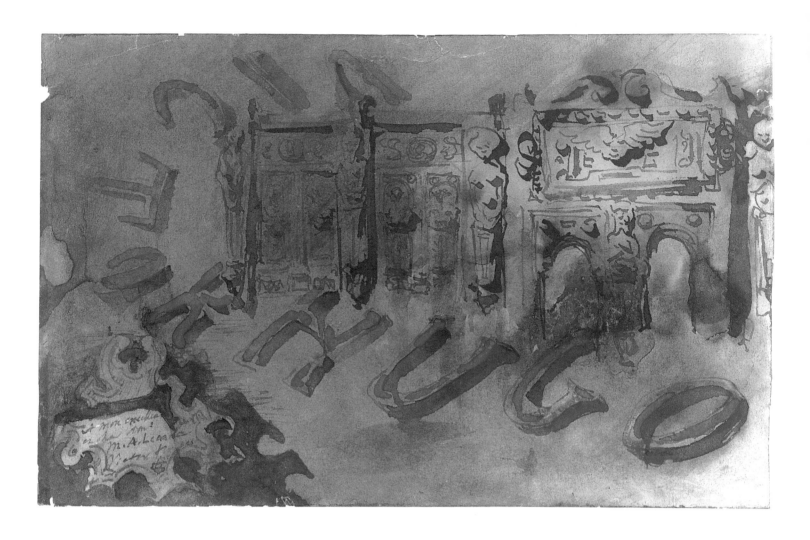

63 Calling card

ca. 1865–67

Pen and brown-ink wash with highlights of
watercolor on cream paper
6½ × 10³⁄₁₆″ (165 × 258 mm)
Bottom left "*A mon excellent et cher ami M. A.
Lecanu / Victor Hugo*" (To my excellent and dear friend
M.A. Lecanu/Victor Hugo)
Paris, Bibliothèque nationale de France, Mss, Smith-
Lesouëf 314–2
EXHIBITIONS Villequier and Paris 1971–72, no. 145;
Bologna 1983, no. 65; Paris 1985, no. 308
LITERATURE Seghers 1983, p. 21

This particular calling card is dedicated to
Alphonse Lecanu, a Republican lawyer who
visited the poet in Guernsey. Hugo noted
drawings sent as New Year greetings in his
account books; from these we learn that he
sent Lecanu New Year drawings three years
running. As a different wash drawing was sent
in 1867, the present drawing must have been
sent on January 1, 1866 or 1868, and can
therefore be dated to December 1865 or 1867.

The architectural motifs include, to the left,
a tympanum, to the right a Roman triumphal
arch. The drawing is a reminder of the
creativity Hugo showed in decorating his
home in Guernsey, notably in the furniture he
designed for Hauteville House and for Juliette
Drouet's home, Fairy House; in his notebooks
we see Hugo hunting around for old trunks,
for example, then having them dismantled so
that he can work them into other pieces of
furniture. MLP

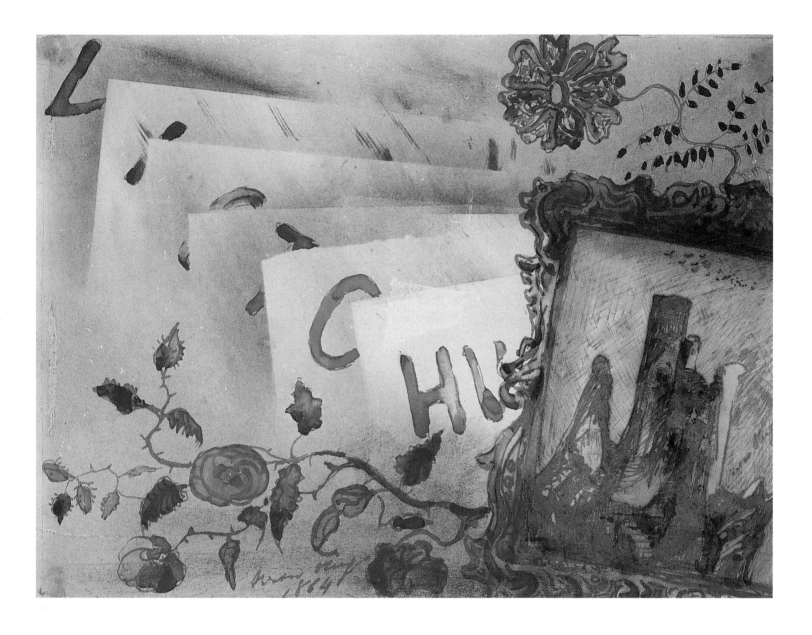

64 *Calling card*
1864

Pen, brush, charcoal, brown ink, gouache and
watercolor on beige paper
7³⁄₁₆ × 9½" (182 × 242 mm)
From top left to bottom right, on the sheets drawn
with a stencil *V/I/C/T/O— HU*
In the frame drawn on the right *Victor Hugo*
Near bottom left *Victor Hugo/1864*
Private collection
PROVENANCE Hugo Family Estate
EXHIBITIONS London 1974, no. 59; Monaco 1981,
lot 36; Paris 1985, no. 274
LITERATURE Massin, II, 1969, no. 1022

In this visual poem Hugo gives free rein to his
fantasy, piling up one *trompe-l'œil* after
another. The letters of his name are dealt out
like cards: the addressee is thereby included in
the game and placed on an intimate footing
with the player leading. One feels that this
entertaining, friendly rhetoric must have been
highly effective. It is also a sign of the constant
affection the poet showed to his nearest and
dearest, despite the difficulties and the
distance between them. The floral motifs used
to decorate the frame turn up in several

drawings from this period. Whenever he
decided to frame one of his compositions,
Hugo liked to decorate the wooden borders
with lush vegetation or landscapes that serve
to carry the picture beyond its natural limits
and integrate it with its surroundings (see
fig. 10, p. 16).

Castles, Cities, and Architectural Visions

It would be pointless to list all the occasions on which the motif of the castle (*burg*) appears in Hugo's work. His letters and notebooks abound in descriptions or sketches of castles visited in the course of his many voyages through Normandy, Belgium, Germany and Flanders, and later in the Channel Islands. Nor is there a single novel of his in which one of these seats of real and, above all, imaginary power, one of these lofty constructions visible from a distance and from which the gaze extends as far as the eye can see, does not have some important part to play. These impregnable fortresses, moreover, are all but indissociable from their equivalents in hollows, caves, underground passages, and dungeons, from which one can escape only by some superhuman feat of will; or they are lairs which shroud the runaway, hero or criminal in darkness. Ruins, churches, belfries, and castles on land, or, facing the sea, lighthouses, reefs, rocks, and cliffs – all conjure up in their different ways the same basic idea of invincibility, permanence, courage and the mind standing watch.

In addition to isolation and resistance to the enemy, the high-perched castle surrounded by walls and towers also expresses Hugo's passion for redundant detail. An enemy of the straight line and uniformity, Hugo took pleasure in medieval building for the layerings of time and the urgent improvisations he found there. Everything in the 'burg' is an echo of Hugo's own vitality, everywhere one finds irregularities, protuberances, embroiderings, chisellings, bristlings, incongruities. Like the close-set roofs of the houses in the town, like reefs that have endured the repeated onslaught of waves and of which the fantastic outlines echo the laciness of foam, the heights of the castle are the outward signs of an energy that attests both to the troubles and to the dogged inventiveness of mankind, to its capacity to protect itself against acts of violence on the part of a hostile nature.

Though a member of the Commission des Arts et des Monuments, Hugo did not glorify signs of the past for their own sake, in opposition to the inventions of modernity. If he was fiercely opposed to that contemporary rigor which banished from buildings the swarm of opposing forces required by the mind, and lined up in smooth and orderly urban monoliths all that in the past was contour, outgrowth, "balcons, balusters, turrets, cells," hide-outs, nooks or passages, it was because he wished to stress movement, procreation, the teeming of life. Accumulation, moreover, is one of the forms of exhilaration in Hugo's work, both as a draftsman and as a poet. Just think of the extraordinary heap of assorted objects thrown out by the besieged behind the Saint-Antoine barricade in *Les Misérables*, or the bric-à-brac miraculously salvaged and studiously classified by the cunning Gilliat on his desert island. The sense of urgency and vulnerability which leads to the motley accumulation of all these objects is not foreign to the concern which was to dictate, at the turn of this century, the approach of artists like Kurt Schwitters, Johannes Baader, or, later, Joseph Cornell.

A series of drawings made between 1848 and 1851, that is to say a few years before Hugo's exile in the Channel Islands, form a special group. During this period, Hugo was devoting the better part of his time to politics; as a deputy in the Assemblée nationale, he committed himself whole-heartedly to fighting for ideas, wrote speeches and pamphlets, and, as a result, almost completely ceased writing verse. He did, on the other hand, have an attic studio converted at 37, rue de la Tour-d'Auvergne in the 9th *arrondissement* of Paris, where he moved in with his family in October 1848. There, his activities as a draftsman suddenly grew in scale. Not only does the size of the drawings increase substantially, sometimes attaining that of an easel painting; above all, Hugo's technical approach grows more complex. His vision increasingly throws up images and recollections of solitary castles visited during voyages in the past, silhouettes of ruined towers and castles detached from their foundations in vast landscapes, or of strange allegories whose incongruous details (or details extravagantly enlarged as though by a magnifying glass) make them seem like some oppressive and disturbing dream.

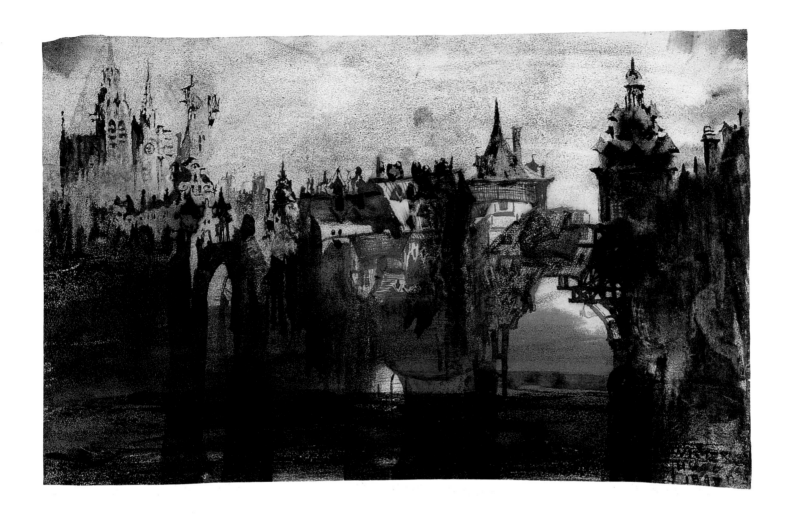

65 *Town with tumbledown bridge*
1847

Pen, brown-ink wash, black crayon, watercolor and
stencil on vellum paper, partly scraped
5⅜ × 8¼″ (137 × 209 mm)
Bottom right, in brown ink *VICTOR/HUGO/1847*
Paris, Maison de Victor Hugo, inv. 51
EXHIBITIONS Paris 1919–20, no. 57; Paris 1930,
no. 767; Geneva 1951, no. 57; Paris 1953, no. 687; Paris
1956, no. 89; London 1959, no. 765; Frankfurt 1975–76,
no. D.37; Le Vésinet 1978; Paris 1983–84, no. 71
LITERATURE Hugo-Méaulle, *Le Rhin* (n.d.), pl. 5;
Escholier 1926, p. 74; Sergent 1934, no. 96; Sergent
1955, pl. XI; Sergent 1957, no. 109; Cornaille and
Herscher 1963, no. 53; Massin, II, 1969, no. 550; Bory
1980, p. 76; Lafargue 1983, p. 23; Picon and Focillon
1985, no. 53; Maison de Victor Hugo 1985, no. 51

This drawing, which skillfully combines a
variety of wash techniques with stencil and
penwork, also brings together several themes
dear to Hugo. One of these is the town. Here,
the houses bristling with pointed roofs, gables,
pinnacles, garrets and chimneys show how the
town has grown up and bunched together in a
confused way around its church. Another
theme is the symbolic motif of the bridge (see
cats. 15, 34 and 99).

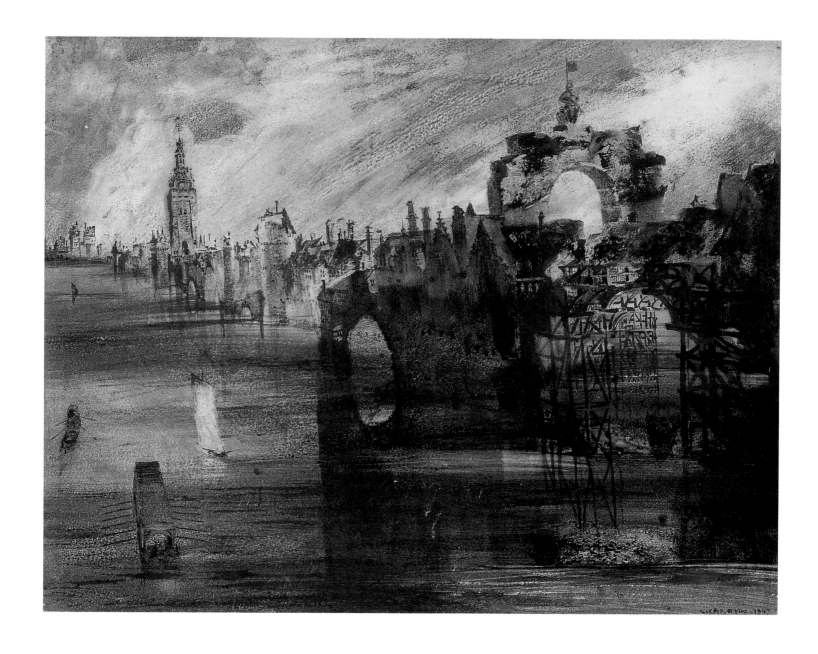

66 *Castle overlooking a river*
ca. 1847

Pen, brown-ink wash, crayon and stencil (?) on paper
11 × 13³⁄₁₆″ (279 × 335 mm)
New York, Collection John and Paul Herring

Very similar in inspiration to the previous drawing, this version was probably made the same year and employs much the same techniques. The enlarged, forcedly angular perspective appears in several of Hugo's landscapes, notably in the famous *View of a bridge* belonging to the Louvre and in the drawing called *Causeway* or *Dyke* (cat. 70). Its distant view is a reminder of Hugo's keen vision, famously capable of distinguishing from the towers of Notre-Dame the red robe of a young woman standing several kilometers away at a window of the Arsenal. Combined with meticulous detail and architectural extravagance, it encourages a certain escapism, leading into distances that are no longer wholly of the here and now and which serve to heighten the eye's sense of nostalgia and desire. At this time, prior to his exile, Hugo did not yet possess the fluency of touch when rendering the movements of water that he was to acquire a few years later: for the moment, water is merely a smooth surface, with neither depth nor transparency, on which boats are carried along and reflected.

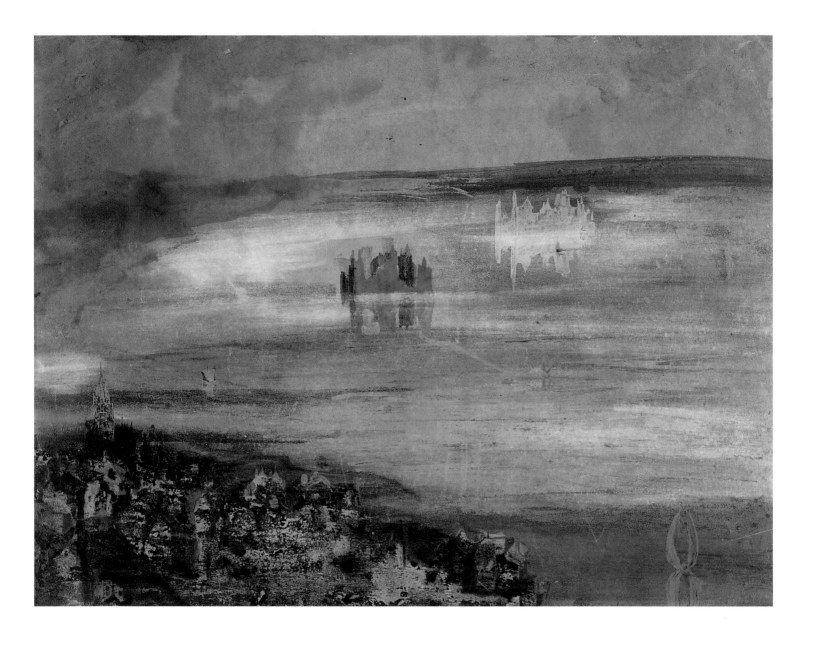

67 Town beside a lake
ca. 1850

Pen and brown-ink wash over graphite, watercolor,
gouache and stencil foldings on vellum paper with
the watermark *J. Whatman*, partly scraped
19¹⁄₁₆ × 24¹⁵⁄₁₆″ (484 × 634 mm)
Paris, Maison de Victor Hugo, inv. 35
EXHIBITIONS Paris 1919–20, no. 35; Paris 1930,
no. 750; Paris 1935, no. 347; Geneva 1951, no. 32; Paris
1953, no. 635; Le Vésinet 1978; Zurich 1987, no. 10;
Tokyo 1996, no. 90
LITERATURE Escholier 1926, p. 114; Sergent 1934,
no. 67; Sergent 1957, no. 110; Cornaille and Herscher

1963, no. 74; Massin, II, 1969, no. 541; Lafargue 1983,
p. 31; Picon and Focillon 1985, no. 73; Maison de
Victor Hugo 1985, no. 35

It is not always easy to identify accurately the
techniques used by Hugo in these large
drawings from 1850, but on several occasions a
rather loose structure of ink and pencil can be
discerned, which Hugo alternately dabs and
scrapes. This structure, occasionally reworked
with a fine pen, enables Hugo to suggest at

once a confusion of houses in a distant town,
the banked stones of a shore, the bark of an old
tree or the flaking walls of a castle – all
moving, changing surfaces deluding the eye.
The dreamy atmosphere is further reinforced
by the imperfectly repeated silhouette of the
citadel floating between two banks, made in
reserve from a paper cut-out that has been
folded in two.

68 *The two castles*
1850

Pen and brown wash over charcoal and gouache,
stencil, on laid paper
13⅜ × 19⁵⁄₁₆" (339 × 490 mm)
Signed and dated at bottom *Victor/HUGO 1850*
Paris, Maison de Victor Hugo, inv. 16 (on loan to the
Musée des Beaux-Arts de Besançon)
PROVENANCE Collection Paul Meurice; gift of Paul
Meurice (1903)
EXHIBITIONS Paris 1888, no. 59; Paris 1919–20,
no. 19; Paris 1930, no. 732; Geneva 1951, no. 42;
Lugano 1977; Bologna 1983, no. 20; Besançon 1985,
no. VII
LITERATURE Album Méaulle 1882; Alexandre 1903,
p. 130; Planès 1907, no. 283?; Escholier 1926, p. 20;
Sergent 1934, no. 80; Sergent 1957, no. 88; Cornaille
and Herscher 1963, no. 69; Delalande 1964, fig. 48;
Massin, II, 1969, no. 554; Picon and Focillon 1985, no.
67; Maison de Victor Hugo 1985, no. 16

Two contrasting styles of drawing form the
picture. The first, made with a pen, is precise
and mimetic, rendering the sharp forms of the
castle shown at the bottom left of the image.
The second, made with a stencil, produces a
castle suspended in space at the top right. The
large, nocturnal fields, drawn with charcoal,
which separate the fragment of real castle from
the distant silhouette of the dream castle
induce a sense of moving from one realm to
another. The inversions of black and white set
in flux both the landscape and the time of day
in which it exists. The technique and paper
used are similar to those used in another
meditation on the borderline separating reality
from dreams, *Causeway* (cat. 70).

This is the drawing Hugo mentions in a
letter sent to his wife from Brussels in
February 1852: "Next to my bed … is a large
and very successful drawing of two castles,
one of which is in the distance. Have it framed
with about three inches of white margin and
give it to Paul Meurice for me."

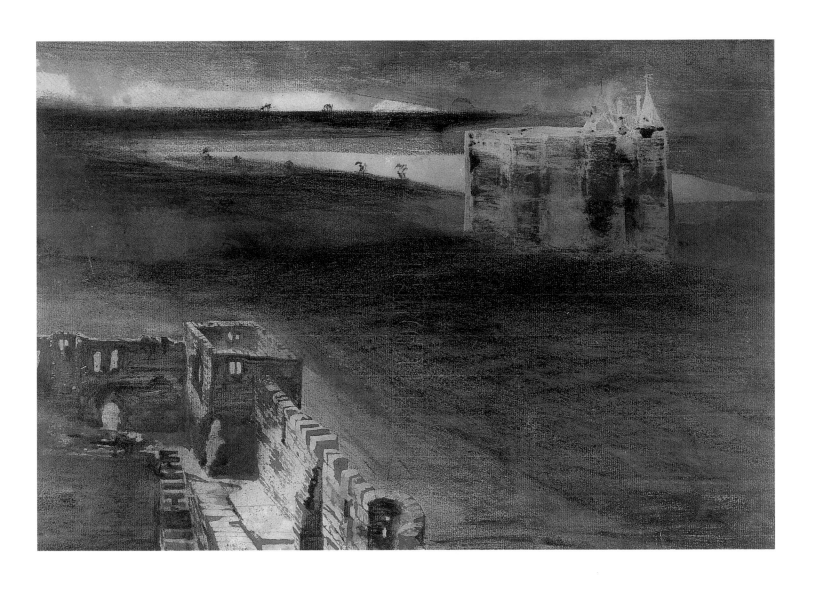

69 *View of Paris*

ca. 1849

Brown wash, graphite, charcoal, gouache and stencil
on thick paper, partly rubbed
19¹⁄₁₆ × 25" (484 × 635 mm)
Paris, Maison de Victor Hugo, inv. 804 (on loan to the
Musée des Beaux-Arts de Besançon)
PROVENANCE Gift of Pierre Lefevre-Vacquerie to
the Musée Carnavalet; on loan to the Maison de
Victor Hugo; on loan to the Musée des Beaux-Arts
de Besançon
EXHIBITIONS Paris 1888, no. 28; Geneva 1951,
no. 4; Paris 1934, no. 250; Stockholm 1974; Paris 1976,
no. 76; Bologna 1983, no. 18; Besançon 1985, no. VIII
LITERATURE Escholier 1926, p. 74; Sergent 1934,
no. 9; Sergent 1957, no. 225; Cornaille and Herscher
1963, no. 63; Delalande 1964, fig. 18; Massin, II, 1969,
no. 534; Picon and Focillon 1985, no. 63; cat. Maison
de Victor Hugo 1985, no. 804

This *View of Paris*, apparently made from Hugo's new Parisian studio in the rue de la Tour-d'Auvergne, illustrates some of the most persistent features of the draftsman's vision. To begin with, this high-angle view of the city is a tribute to his notoriously keen vision, which could make out tiny details at exceptionally great distances. Combining breadth and depth, the elevated viewpoint conjures up a panoramic view of a complex urban fabric; among the jumble of houses and what Henri Focillon calls the "debris of civilizations," the occasional steeple or dome can be made out. Contrasting with this broad, almost dream-like overview are the unresolved foregrounds and the ambiguous light of a blurred sun. Blind walls, contradictory perspectives, dead-end streets and bewildering shadows conjure up a somewhat disturbing place of transit, one of those deserted spots on the margins of the city and mankind where Hugo's heroes like to linger. A lack of firmness in the outlines, abundant use of stencils and the meanderings of the wash as it mingles with pencil lines further emphasize the sense of solitude and indeterminacy of this picture.

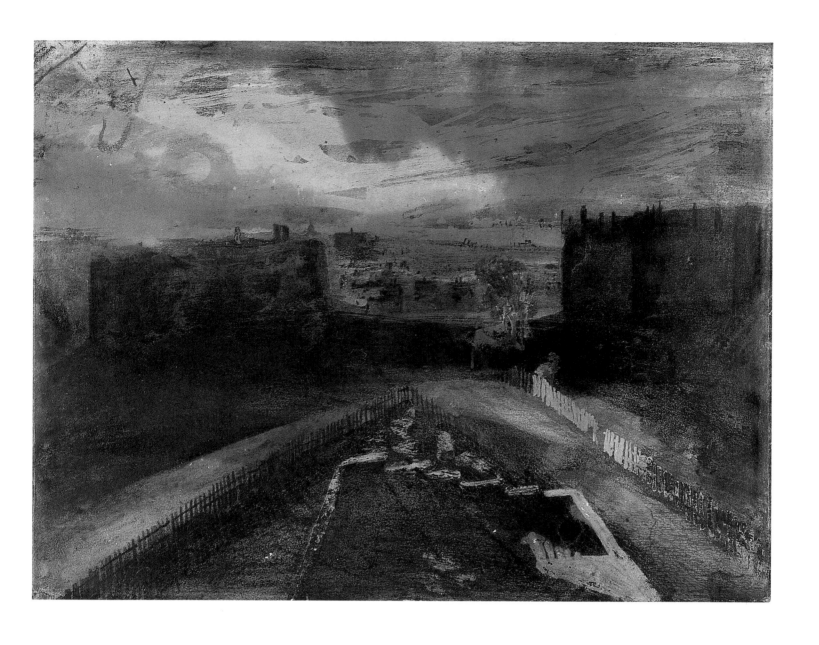

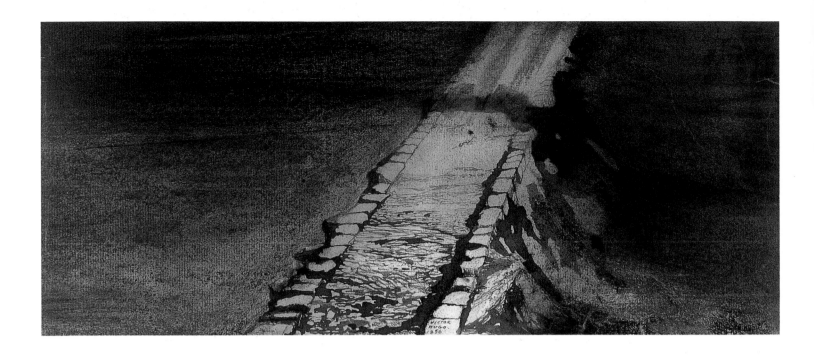

70 *Causeway* or *Dyke*
1850

Pen, brown-ink wash, black ink, graphite and black crayon on watermarked laid paper
6⅛ × 14⅜" (156 × 365 mm)
Bottom center *VICTOR/HUGO./1850*
Paris, Maison de Victor Hugo, inv. 943
EXHIBITIONS Besançon 1952, no. 198; Tours 1988, no. 28
LITERATURE Sergent 1957, no. 225; Cornaille and Herscher 1963, no. 82; Massin, II, 1969, no. 534; Bory 1980, p. 34; Picon and Focillon 1985, no. 81; Maison de Victor Hugo 1985, no. 943

This drawing was deemed by its author sufficiently important for him to sign and date it on one of the stones. The preparatory work in black crayon and graphite, to which pen-strokes and wash have then been added, makes deliberate use of the structure of the laid paper. As in Seurat's large 'black drawings,' the silence in which the forms seem captured, frozen, reinforces the feeling of mystery. This large, solid stone causeway leading nowhere dissolves into a nocturnal dream, the foreground merges with the infinite, the direction given cannot prevent a loss of bearings. The effect is also due to a not altogether satisfactory handling of perspective. The undecided manner in which the converging lines have been drawn is not entirely disguised by the brushstrokes of wash supposed to signify the waters rushing in.

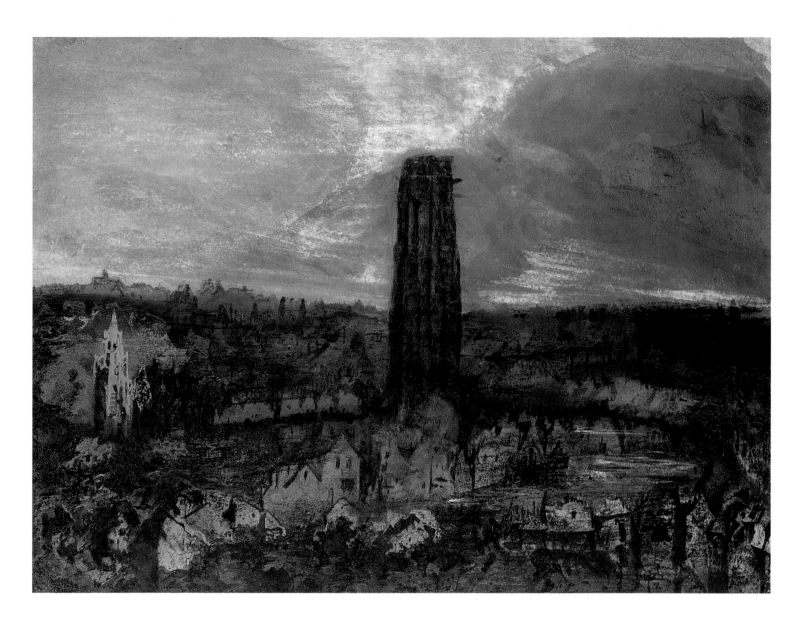

71 *The tower of Saint-Rombault de Malines,*
in the center of an imaginary town
1850

Pen, brown-ink wash, black ink, charcoal, gouache
and reserves on paper, partly rubbed and scraped
18⅞ × 24¾" (480 × 630 mm)
On verso in the artist's hand *fait le 29 septembre 1850*
Victor Hugo
Private collection, Switzerland; courtesy of Galerie
Jan Krugier, Ditesheim & Cie, Geneva
PROVENANCE R. Lyna
EXHIBITIONS New York and Geneva 1990–91,
no. 10
LITERATURE Cornaille and Herscher 1963, no. 77

As in many of Hugo's works from the period
immediately before his exile, the fascination
exerted by this important drawing stems from
a juxtaposition of the real and the imaginary,
and from the numerous ambiguities that
ensue. The tower of Saint-Rombault, which
Hugo had admired during a voyage in
Belgium, looks as though it has been inserted
into a landscape otherwise conjured up
entirely from dreams. As Hugo himself
declared: "One must look inside oneself"
(*c'est au dedans de soi qu'il faut regarder*).

Encompassing a boundless horizon, this
lugubrious cityscape is strangely deserted.
Excess detail and distorted perspectives make
its expanse impossible to grasp. Hugo is now
master of a graphic treatment that 'derealizes'
forms. The extraordinary variety of dabbings,
rubbings, fingerprints, scrapings and reserves,
with superimpositions and accidents reworked
with a pen, results in what Jean Dubuffet
would have called "texturologies."

72 The saltcellar

ca. 1850

Pen, brown-ink wash, rubbed charcoal and gouache
on paper
17¹¹⁄₁₆ × 23⅜″ (450 × 600 mm)
Bottom left *VICTOR HUGO*
Private collection
PROVENANCE Collection Paul Meurice; Mme
Clemenceau-Meurice
EXHIBITIONS Paris 1888, no. 58; Villequier and
Paris 1971–72, no. 35; London 1974, no. 22; Bologna
1983, no. 21; Paris 1985, no. 127; Zurich 1987, no. 8
LITERATURE Bertaux 1903, p. 164; Cornaille and
Herscher 1963, no. 68; Massin, II, 1969, no. 542;
Georgel, *Sources*, 1971, p. 287; Bory 1980, p. 84;
Seghers 1983, p. 35; Lafargue 1983, p. 83; Picon and
Focillon 1985, no. 70

Abnormally enlarged details are a feature of drawings from this period (see cats. 71 and 73). They are the result of contemplative staring at objects for too long, losing all sense of context and proportion as the eye begins to squint. This frenzy in the act of seeing abolishes all sense of distance or resistance, sunders the visible in two and finally allows the eye to cross over into the invisible with complete impunity. In this particular drawing, Hugo's imagination has placed a saltcellar – usually found on the family table – in the middle of a pond, offering it a new function in the landscape. Moving objects about in this way is not uncommon to painting, and as early as 1840 Hugo himself had underlined the interest certain northern artists took in reproducing items of crockery "on a gigantic scale." There would be nothing very striking about this collage were it not for the incongruousness of this excessively refined object placed plum in the middle of the marsh, with its misleadingly calm waters.

As Judith Petit remarked in the catalogue of the exhibition *Soleil d'encre*, Hugo worked into the background of his drawing (made in about 1850) the urn that decorated the garden of his home on the place Royale in Paris (that he left in 1848). The urn would later be turned into a garden fountain for Hauteville House in Guernsey, while the saltcellar would be given pride of place in the dining-room. Such is the restlessness of Hugo's eye that he is forever envisaging old designs in a future light, interlacing, cutting up, piecing together, superimposing and replacing the fragments of the whole with astonishing inner logic.

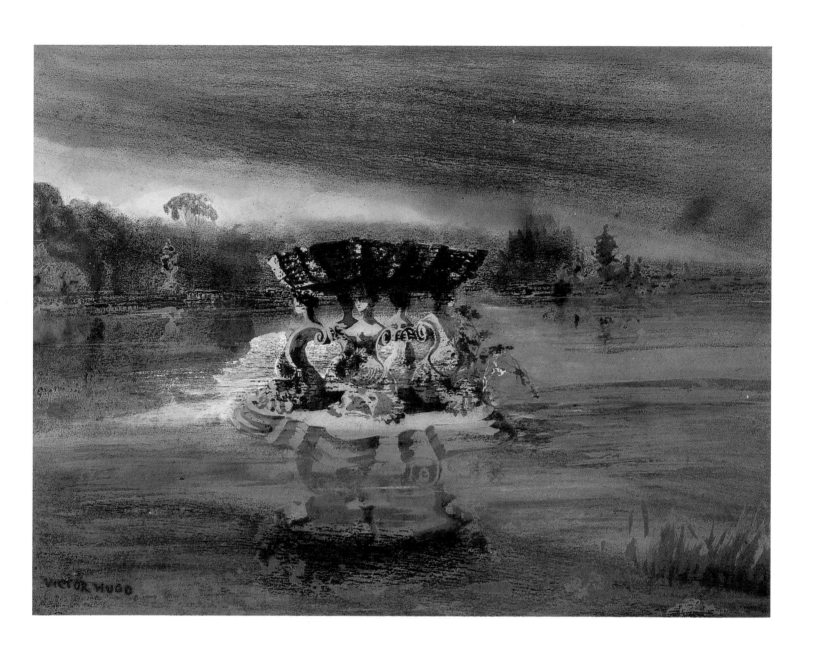

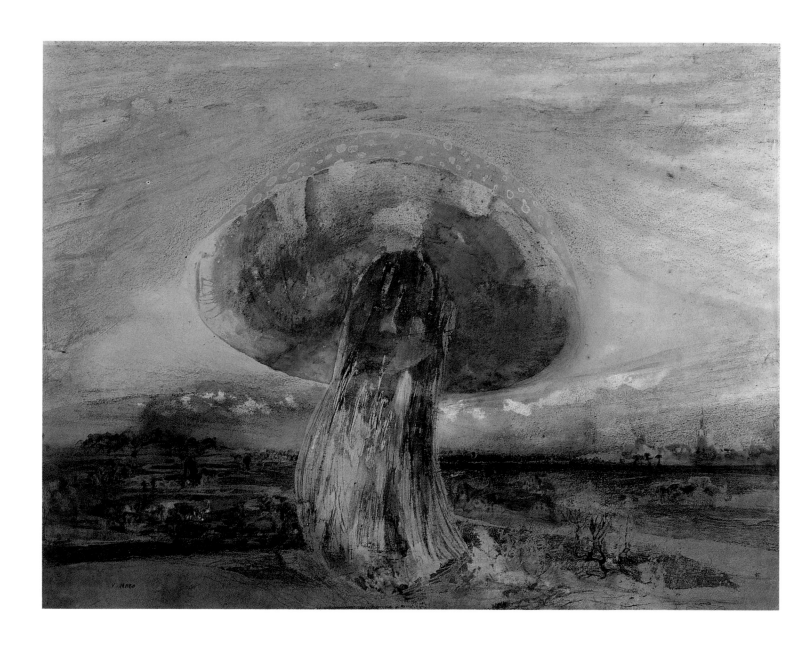

73 Mushroom

ca. 1850

Pen, brown-ink wash, black ink, black crayon,
charcoal, gouache, watercolor, fingerprints, reserves
and stencil on paper, partly scraped and rubbed
18¹¹⁄₁₆ × 23¹⁵⁄₁₆″ (474 × 608 mm)
Bottom left, in brown ink *V. HUGO*
Paris, Maison de Victor Hugo, inv. 812
PROVENANCE Collection Juliette Drouet; collection
Louis Koch; bought by Paul Meurice; gift of Paul
Meurice to the Ville de Paris (1903)
EXHIBITIONS Geneva 1951, no. 128; Rome 1959–60,
no. 153

LITERATURE Planès 1907, no. 232; Escholier 1926,
p. 118; Sergent 1934, no. 282; Sergent 1955, pl. XVII;
Sergent 1957, no. 328; Cornaille and Herscher 1963,
no. 80; Delalande 1964, fig. 60; Massin, II, 1969,
no. 532; Picon and Focillon 1985, no. 79; Maison de
Victor Hugo 1985, no. 812

This drawing displays nearly all of Hugo's
techniques and a mastery of the spatial logic
that binds together the large, low landscape on
the horizon (where, despite the distance,
buildings and clumps of trees can be
discerned), the sky which occupies two thirds
of the background, and the monstrously
outsized mushroom, doubtless made with a
cut-out. Viscous, fetid, rotting, speckled with
morbid colors, and sometimes dangerous,
associated with the mysteries of the
underworld and thrusting up spontaneously
from decaying matter, this gigantic, solitary
toadstool effects an inversion of perspectives,
rendering minute the landscape behind it.

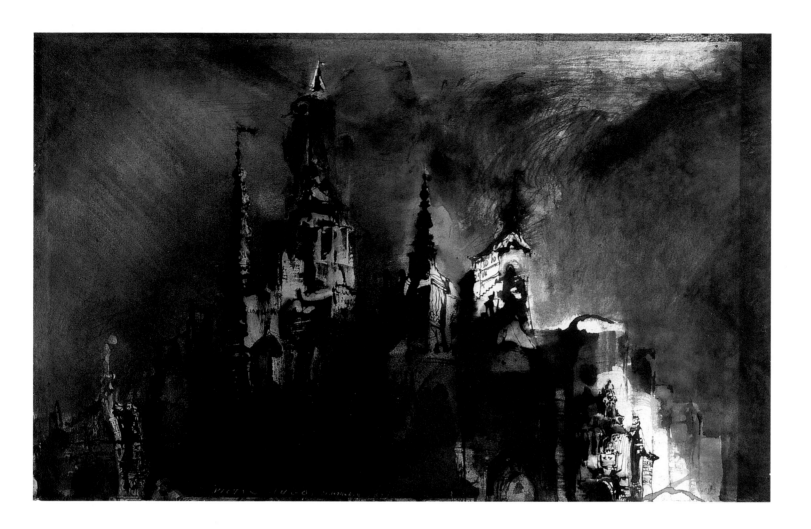

74 *Fantastic castle at dusk*
1857

Pen, brown-ink wash, black ink and stump with
highlights of gouache on beige paper, partly rubbed
12⁵⁄₁₆ × 19″ (313 × 482 mm)
Signed near bottom center, in white gouache *VICTOR
HUGO—Guernesey. 1857*
Paris, Galerie Berès
PROVENANCE Private collection, France

Some seven years later than the two previous,
this drawing was made during Hugo's exile in
the Channel Islands and therefore far from any
possible model. It shows his ability to
transform a relatively well worn theme into an
extraordinarily effective vision. The black ink,
rapidly applied, sets up a flurry of *taches* that
contrast strongly with the masked-off areas of
the paper. Working out from this central core
with its extremes of *chiaroscuro*, the fine nib of
the pen makes use of the running ink, adding
details swiftly and drawing out forms,
transforming them into slender flamelets and
constructing a half-Gothic, half-oriental dream
of towers and gables which, defying gravity,
dissolves in broad, conflicting surges formed
by rubbing, stumping or by highlights of
gouache.

75 *Vianden seen through a spider's web*
1871

Pen, brown-ink and violet-ink wash over graphite
and watercolor on vellum paper, partly rubbed or
scraped
10 1/16 × 11 15/16" (255 × 303 mm)
Paris, Maison de Victor Hugo, inv. 83
PROVENANCE From a sketchbook
EXHIBITIONS Paris 1930, no. 515; Geneva 1951,
no. 96
LITERATURE Alexandre 1903, p. 71; Simon 1904,
p. 52; Planès 1907, no. 257; Escholier 1926, p. 64;
Sergent 1934, no. 206; Sergent 1955, pl. XV; Sergent
1957, no. 38; Cornaille and Herscher 1963, no. 338;
Delalande 1964, fig. 26; Massin, I, 1967, no. 272; Bory
1980, p. 70; Müller 1982, pl. 46; Picon and Focillon
1985, no. 327; Maison de Victor Hugo 1985, no. 83

In one of his notebooks, under the date August
13, 1871, Hugo wrote: "I've drawn on my
travel book the large spider's web through
which the ruins of Vianden can be seen like a
ghost. Just the thing for a 13th." In 1871, Hugo
was once more expelled from Belgium, this
time for giving hospitality to members of the
Commune. He took refuge in the neighboring
territory of Luxembourg and, from June 8 to
August 22, stayed in Vianden, at the foot of the
ruined castle. In the present drawing the
contours of the castle are so blurred as to be
almost invisible. Instead, interest focuses on
the way the image is presented on the page,
and on the violently enlarged detail of the
spider in the foreground, whose web is
attached to wooden beams which resemble a
gallows. Like the octopus underwater (see cat.
25), like the forest or the night, or like the
prison which swallows up the condemned
man, the heartless insect spins a trap for his
victim from which there can be no escape.

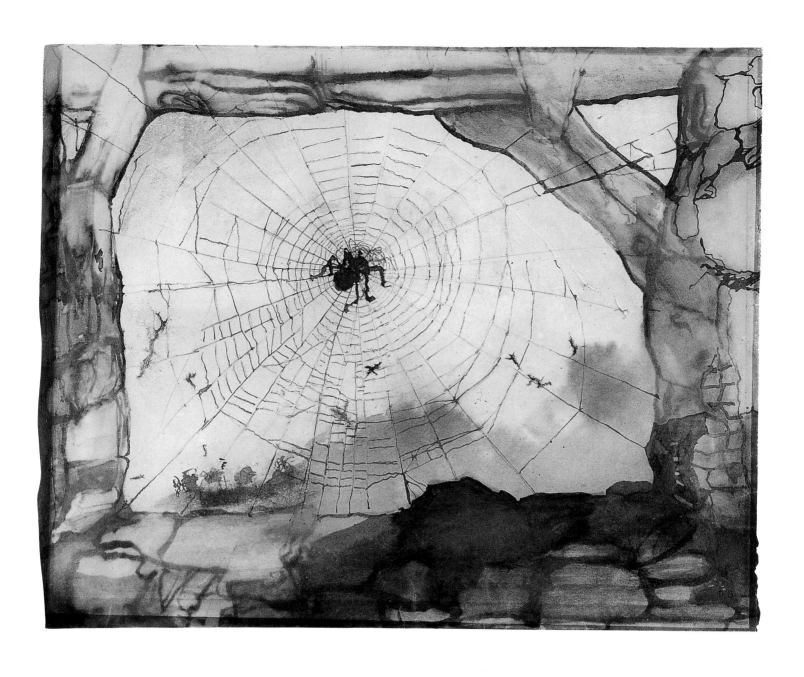

Night, Spiritualism, and the Grotesque

In August 1852, Hugo left Brussels, his first stopover as an exile, for the island of Jersey. He settled with his family in Marine Terrace, a house overlooking the sea that he would later denounce for its chilling, strait-laced, four-square appearance (see cat. 59 and fig. 23, p. 96). He would remain there until he was expelled, three years later, for remarks judged insulting to England, and for playing too active a political role among the French exiles on the island. Paradoxically, Hugo reacted to being kept out of things and to his enforced isolation by a new burst of activity. He did more writing than drawing, and in prolific quantities, including pamphlets, speeches and the political poems of *Les Châtiments*, published in 1853. He also collected together his lyric poetry, both old poems and more recent work, in *Les Contemplations*, publication of which enabled him to purchase Hauteville House in Guernsey in 1856.

Moving to the Channel Islands meant more than discovering a new horizon. Being exiled in the middle of the ocean forced Hugo to adopt a new way of life, modified and heightened his spiritual vision, and led him to carry out new experiments. These included photography, a field which his sons Charles and François-Victor were exploring with Auguste Vacquerie. Their activities may have had a certain influence on Hugo's graphic art, for he made frequent use of stencils around this time; and stencils, in their reversal of values, are reminiscent of photographic negatives. Hugo often used these cut-outs to dramatize a scene, with low-angle perspective views and violent contrasts in lighting bringing out the forms of night with great force and conjuring up a feeling of suspense and flight. In Jersey, Hugo readily drew on some of the island's architectural motifs for inspiration (the dyke, the observation post, the chapel of Saint Elizabeth, and so forth).

In fall 1853, during a visit to Marine Terrace, Delphine de Girardin introduced the family circle and a few friends to table-turning. Hugo became particularly interested when his daughter Léopoldine, drowned ten years earlier, began speaking through the medium of the table. Although, in October 1855, Hugo abruptly called a halt to the experiment when one of the participants went mad, the experience encouraged him to listen even more carefully to the voice from the depths. Many of the texts he wrote around this time, the most famous of these being '*Ce que dit la bouche d'ombre*' (What the shadow's mouth says) in the final section of *Les Contemplations*, reveal a willingness to draw near to the abyss, "to contemplate the obscure, the unknown, the invisible." Likewise, his most inspired poems, such as *La Fin de Satan* and *Dieu*, begun in 1854 and 1855 respectively, are the fruits of long hours spent letting the night, the ocean and death, the irrational and the fantastic flow through his soul.

These drawings made at the séance table are not Hugo's handiwork, since it was a pencil attached to the foot of the planchette that drew them. But he may have reworked them from time to time, and, in any case, was passionately interested in trying to establish what, however clumsy and incoherent they might appear, they might mean. They differ from his abstract compositions made with *taches* or foldings in their indifference to representation, showing no regard for the way in which the page is organized: they are seismographs, not of thought, nor of sensation even, but of the invisible. To let the hand run free without supervising it, to surrender to instinct or darkness for a while, to trust in the random impulses that disturb one's dreams, regardless of preconceived ideas or aesthetic hierarchies, are beliefs to which Hugo remained committed throughout his life-long exploration of the unknown. Nevertheless, the drawings which testify to these experiments in self-surrender are few and far between; inevitably, the artist's integrity reasserts its rights.

Following the séance drawings there appear, around 1856–57, scribblings that the hand draws without thinking while the mind is occupied elsewhere – like a dance of the hand nonchalantly inscribing figures in frames, circles or cartouches, embryonic figures that have no other goal, it seems, than to express themselves. Though much freer and in a more whimsical vein, they can be compared to the caricatures Hugo had been producing from a very early age, those awkwardly drawn signs, bizarre figures and grotesque forms whose trembling, abbreviated contours combine laughter and dread.

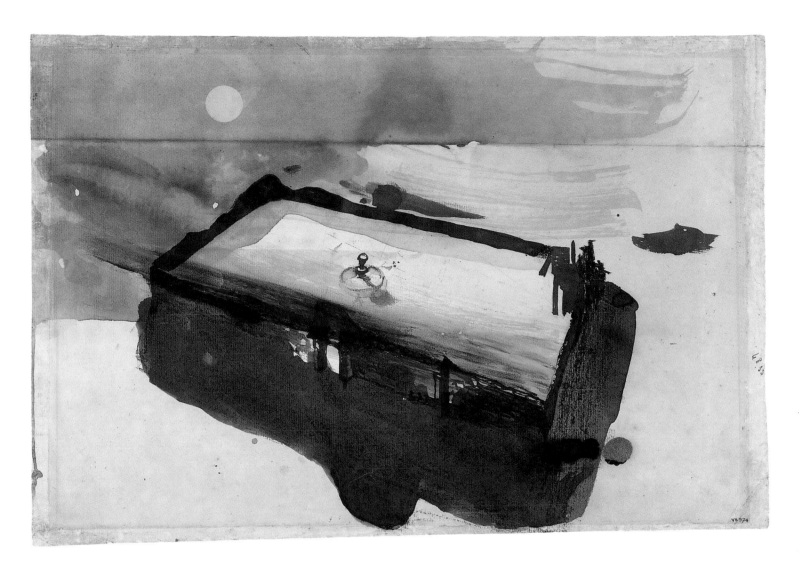

76 *Full moon*
ca. 1856?

Pen and brown-ink wash over graphite, black ink,
charcoal, black crayon, watercolor and reserve on laid
paper folded along the top
13¾ × 19¹⁵⁄₁₆″ (350 × 507 mm)
Verso: reworked in brown ink (?), black ink, black
crayon and gouache, partly rubbed
Paris, Maison de Victor Hugo, inv. 974
LITERATURE Cornaille and Herscher 1963, no. 159;
Massin, II, 1969, no. 534; Picon and Focillon 1985,
no. 153; Maison de Victor Hugo 1985, no. 974

An eye accustomed to the visual ambiguities
invented by Surrealist artists, in particular Max
Ernst, is needed to appreciate the strange
charm of this drawing. Nothing here is really
intended, nor is anything really drawn, with
the exception of the high, endless horizon
marked by a slight fold in the paper. A
modern eye is needed, one not taken aback by
clumsy brushstrokes less concerned with
representing than with suggesting an
uncertain landscape of memory or dream. The
awkwardness of the drawing arises from a
conflict between the accuracy of the spatial
data and the remarkably offhand manner in
which Hugo wields his brush, from which the
ink dissolves crudely in the flat tints already
applied. The result is a spatial distortion and
unsteadiness reminiscent of the semi-conscious
state of the waking dreamer. The moonlight in
which this mental desert is bathed (along with
the pool, with its lugubrious, frozen water)
makes it one of the most desperate and chilling
images in Hugo's entire graphic work.

77 ECCE

1854

Black ink and brown wash with highlights of white
gouache on paper
20½ × 13" (521 × 330 mm)
Bottom center, in reserve, with highlights of white
gouache *ECCE*
To the left, in reserve, with highlights of white
gouache *Victor Hugo / Jersey 1854*
Paris, Musée du Louvre, Cabinet des Dessins,
RF 23314
EXHIBITIONS Paris 1888, no. 20; Villequier and
Paris 1971–72, no. 61
LITERATURE Chenay 1860, pp. 69–78; Voland 1861;
Bertaux 1903, p. 481; Escholier 1926, p. 94; Delalande
1964, fig. 57; Massin, I, 1967, no. 502; Georgel 1971,
no. 10; Georgel 1985, p. 482

This drawing, also known as *The hanged man* or
John Brown, is one of four versions in which
Hugo treated the subject of the gallows. In
early 1854, profoundly moved by the trial and
hanging of a murderer in Guernsey, he made
several drawings evoking the torment of
capital punishment. A few years later, in 1859,
he once again sought in vain to prevent the
execution of John Brown, who had taken up
the defense of black slaves in the United States
and had been condemned to death. When the
news of Brown's hanging reached Hauteville
House in December 1859, Paul Chenay, an
engraver by profession who had recently
become Hugo's brother-in-law, was present.
He had expressed his desire to Hugo of
making engravings from some of his drawings.
Seizing the opportunity that now presented
itself, he offered to make an engraving of *The
hanged man*, which the writer had displayed on
the walls of Hauteville House. Hugo allowed
himself to be talked into it, in the hope that
disseminating the picture among the public
would have more impact than his written
protests. The model for the engraving,
published in 1860, which did indeed receive
wide coverage, was doubtless this copy, now
preserved in the Louvre.

Hugo gave Chenay his drawing because it
was for a worthy cause: "*Gravez-le, publiez,
faites*" (Engrave it, publish it, do it), he wrote to
Paul Chenay on January 10, 1860. "Anything
that furthers the great aim, Liberty, is a duty as
far as I am concerned, and I shall be happy if
this drawing, reproduced many times over by
your art, helps keep ever-present in people's
souls the memory of this liberator of our black
brethren … ." The publication was such a
success that Hugo agreed to entrust his
brother-in-law with a new series of drawings.
This second publishing venture, however,
which culminated after a great many trials in
what is called *L'Album Chenay*, consisting of
reproductions of thirteen drawings by the poet
and an important preface by Théophile
Gautier, proved a complete flop.

This extremely powerful picture is similar
in terms of nocturnal atmosphere and low-
angle view to several drawings in this section.
The upright, which is too tall to support the
weight of the body, has no real foundation and
rises up out of the all-consuming darkness of
night. To the right, one can just make out a
horizon separating sea and sky (more legible
in the print; see fig. 8 on p. 15). The impact of
the picture stems from a combination of wash
and rubbed charcoal or graphite, which gives
the darkness its density. The moonlight is
formed by reserves in the off-white paper and
by a few small touches of gouache which
highlight, by way of contrast, the deep silence
of this dramatic composition.

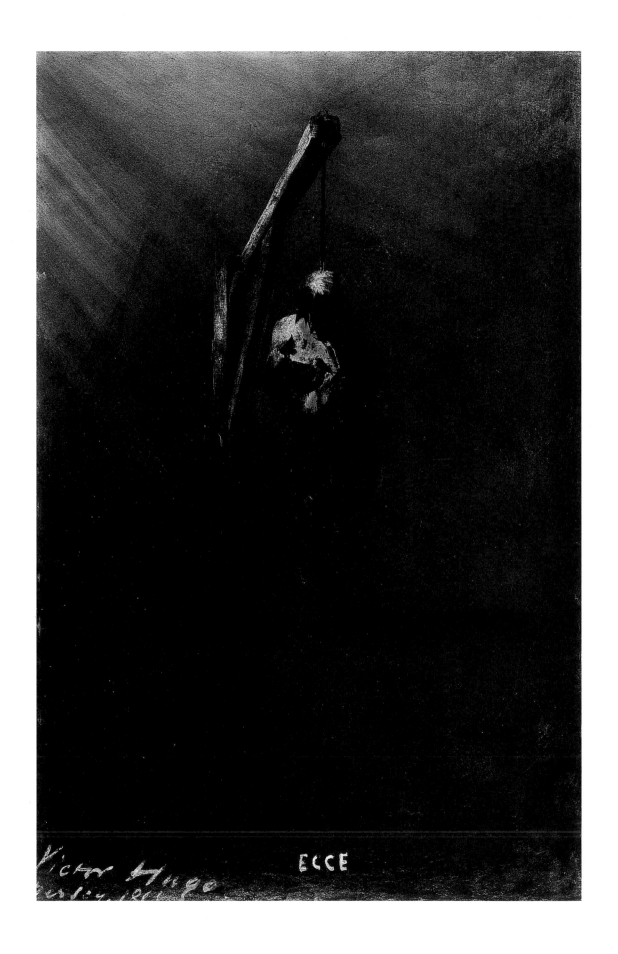

ECCE

78 *The Hermitage*

1855

Pen, brown-ink wash, black ink, graphite, black
crayon, charcoal, soot (?) and stencil on beige paper,
partly scraped and rubbed
14 × 9¹⁄₁₆″ (356 × 230 mm)
At bottom right *Victor Hugo/Jersey—3/7bre 1855*
Paris, Maison de Victor Hugo, inv. 42
Exhibitions Paris 1919–20, no. 45; Paris 1930,
no. 756; Geneva 1951, no. 28; Guernsey 1955, no. 26;
Zurich 1987, no. 20; Venice 1993, no. 15
Literature Planès 1907, no. 310; Sergent 1934,
no. 84; Sergent 1957, no. 206; Cornaille and Herscher
1963, no. 122; Massin, II, 1969, no. 642; Picon and
Focillon 1985, no. 123; Maison de Victor Hugo 1985,
no. 42

This nocturnal vision of the chapel of Saint
Elizabeth perched on the rock of the
Hermitage forming the outer harbor of Saint
Helier is one of the last drawings Hugo made
in Jersey before being driven from the island in
October 1855. The dark background, swarming
with activity, has been conjured up by varying
the materials (graphite, charcoal, black stone,
soot) and the different ways in which they can
be applied to paper (scraping, rubbing or
stumpwork). Against this background sketch
used to define the sky lit up by lightning or by
a sudden burst of moonlight from the clouds,
the rocky mass rises up, its summit crowned
by the ruined castle drawn from a stencil and
touched in with brown wash. At the center of
this great, eviscerated peak a staircase opens
out, leading hesitantly down to the foot. In the
foreground, foaming waves or wreaths of mist
isolate the building. A remarkable use of
reserve makes the silhouette of the chapel of
Saint Elizabeth loom up out of the night like a
lighthouse. Note the vigor of Hugo's hand, the
direction of the pencil strokes which impose
his rhythm on the picture: it is as though the
draftsman was still struggling to elude the
slanting movement from left to right that is
primarily that of the writer.

FIG. 24 Charles Hugo, *The ruins of the
chapel of Saint Elizabeth, Jersey*, photograph
Paris, Maison de Victor Hugo

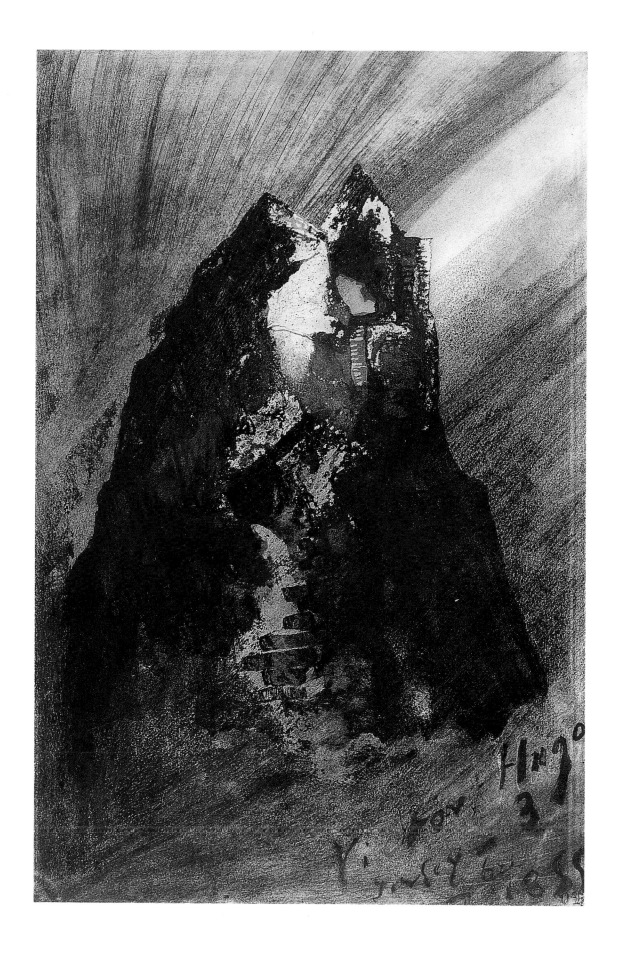

79 *An observation post in Jersey*
ca. 1854–55

Pen and India-ink wash over rubbed charcoal with
highlights of gouache on paper
18⅛ × 11¼″ (460 × 285 mm)
Bottom left, in gouache *Victor Hugo / Marine Terrace*
On top edge of frame, in pen *Jersey. Marine Terrace*,
and at bottom right-hand corner, at the root of the
plant *Victor Hugo / 1855* (?)
Paris, Musée du Louvre, Cabinet des Dessins,
RF 34770
PROVENANCE Framed by Hugo and exhibited,
probably in 1859, in the billiard room at Hauteville
House; Hugo Family Estate; acquired from Jean Hugo
in 1972
EXHIBITIONS Paris 1888, no. 9; Paris 1952, no. 371;
Villequier and Paris 1971–72, no. 71; London 1974,
no. 32
LITERATURE Bertaux 1903, no. 2; Delalande 1947,
pp. 30–31; Cornaille and Herscher 1963, no. 105;
Massin, II, 1969, no. 640; Georgel 1973, no. 41;
Georgel 1985, p. 486; Picon and Focillon 1985, no. 104

This is probably an observation post or a
fisheries in Jersey. The hovering bird, Georgel
remarks, may have been taken from a print by
Félix Bracquemond after Jules Laurens (1855),
sent to Hugo by Laurens in 1855. It is an
exceptionally well preserved drawing on pale
yellow paper which brings out the light in
dazzling contrast to the vivid blacks. The
technique is rich and varied: after rubbing the
paper with dry charcoal, Hugo has worked
over it with crushed crayon in the manner of a
stump drawing to give the beams of light a
more dynamic focus. The structure depicted is
a sturdy assemblage of beams supporting a
small cabin made from planks crudely
arranged in a triangle. The low-angle
perspective stresses not only that the shelter is
cramped and precarious, but that it overlooks
a void. The violence of the elements all round,
the abrupt light cast by the moon as it passes
between two clouds, opening, closing,
suspending this construction between heaven
and earth, all give this picture a strange power
to disturb.

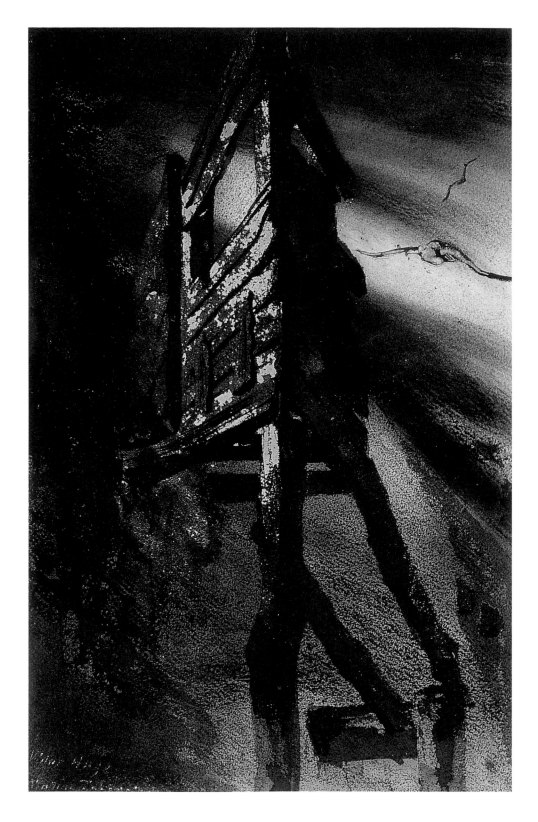

80 *The cellist*

ca. 1856

Pen and brown ink on white paper
14¹⁵⁄₁₆ × 9½" (380 × 241 mm)
Villequier, Musée Victor Hugo, inv. 2667
EXHIBITIONS Villequier and Paris 1971–72, no. 94;
Paris 1972, no. 39
LITERATURE Massin, I, 1967, no. 436; Chirol 1982,
no. 30

This drawing is similar to a series of figures
Hugo made *ca.* 1856–57 giving the impression
of having been executed with his left hand, or
with his eyes closed, following a distinct
rhythm – while listening to music, for
example. The line traced by the pencil, which
never leaves the paper, constantly loops back
on itself and, by the end of its journey, has
conjured up some odd-looking figures that are
not devoid of humor. In the course of its
circular journey it spawns vegetable growths
and bristling cliffs in which the outline of an
animal or some grotesque figure can be made
out. These formal analogies and shifts in
meaning are not unusual in artists' work:
Mannerist painters made a point of cultivating
visual tropes of this kind. In Hugo's drawings
they not only denote a restless freedom that
forms part of the poet's obsession with vitality
and his thirst for spiritual activity, they are
also a sign of that whimsical high spirit that is
always ready to find expression in his work.

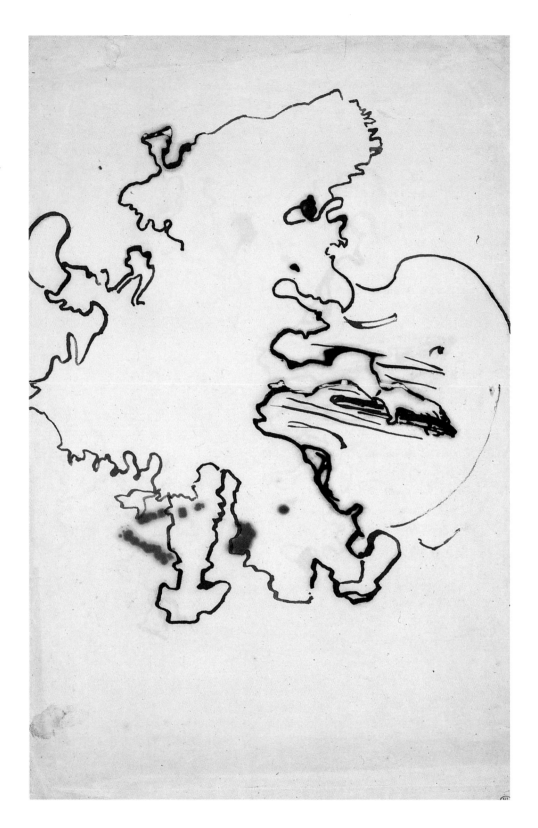

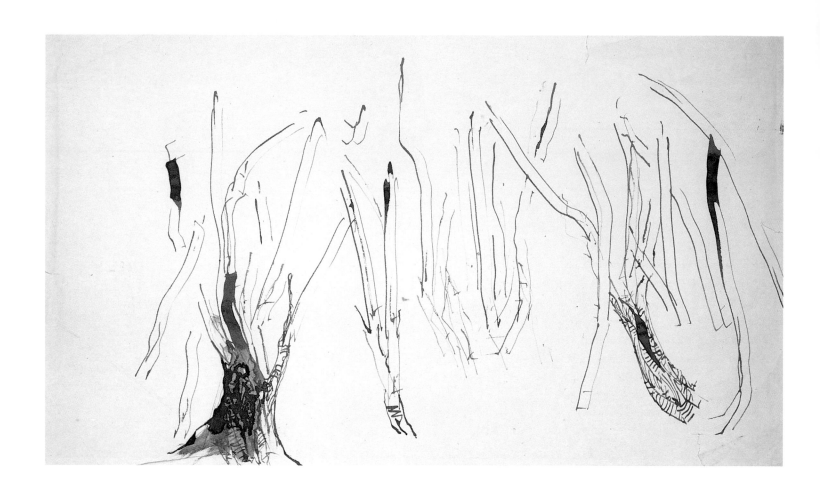

81 *Trees*
ca. 1854–56?

Pen and brown ink on white paper
7¾ × 12½″ (200 × 318 mm)
Private collection
PROVENANCE Hugo Family Estate
EXHIBITIONS Paris 1972, no. 94
LITERATURE Massin, II, 1969, no. 945

Characteristic of a certain nonchalance in
Hugo's graphic work, in which the hand lets
itself be guided by the line that has just been
drawn, this drawing can be read either as a
series of capital Vs or as the silhouettes of
some rather bony-looking shrubs.

82 *Spiritualist drawing*

ca. 1854

Pen and black ink on white paper

9¹⁄₁₆ × 5⁷⁄₁₆″ (230 × 138 mm)

At bottom, in Hugo's handwriting, *deux mains seulement* or *d'une main seulement* (only two hands *or* with only one hand)

Villequier, Musée Victor Hugo, inv. 2665

PROVENANCE Hugo Family Estate

EXHIBITIONS Paris 1972, no. 20

LITERATURE Massin, I, 1967, no. 302; Chirol 1982, no. 25

The pen here has been entrusted to the séance planchette, which has scrawled a few exceptionally violent lines on the paper. Flames rising from the spiritualist encounter mix into clumsier and more faintly drawn figures that float freely in space. The sense of indeterminacy is particularly acute.

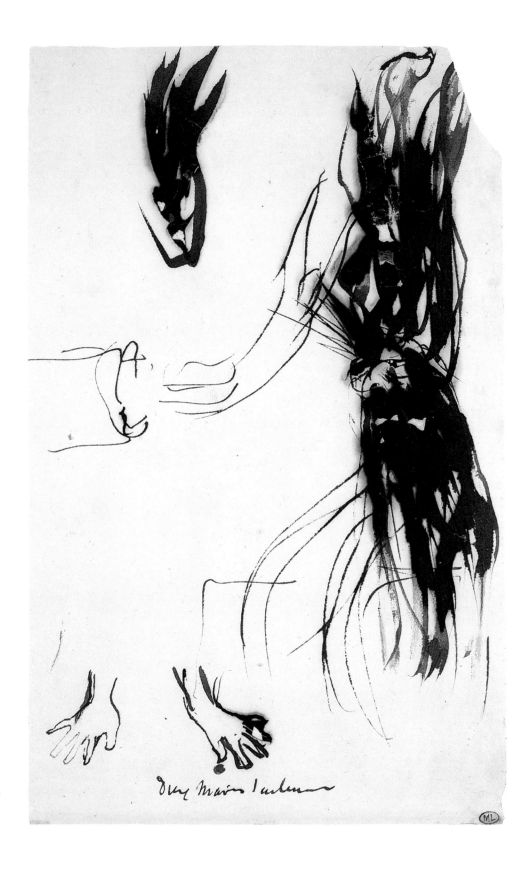

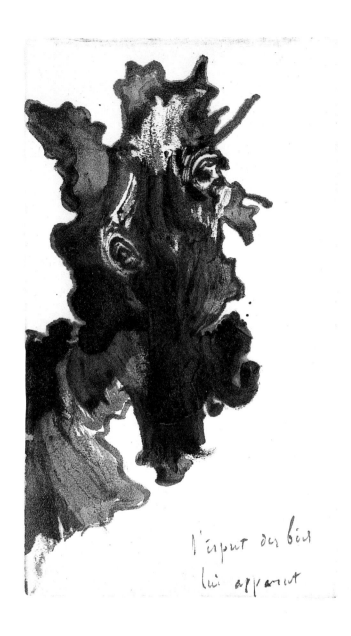

83 *"L'esprit des bois lui apparut"* (The spirit
of the woods appeared to him)
1856

Pen and brown-ink wash on white paper
$5^{13}/_{16} \times 3^{3}/_{8}$" (147 × 85 mm)
Bottom right *l'esprit des bois/ lui apparut*
Villequier, Musée Victor Hugo, inv. V. 93–12
PROVENANCE From one of Hugo's notebooks,
dated June 17–late August 1856, fol. 32
EXHIBITIONS Paris, Aittouarès, n.d., no. 29; Venice
1993, no. 33

84 *"Le nain de la nuit"* (The dwarf of the night)
1856

Pen, brown-ink wash, black ink, charcoal, fingerprints, soot (?) and coffee (?) with highlights of red, yellow and white gouache on vellum paper, partly rubbed
15¹⁄₁₆ × 9⁵⁄₁₆" (383 × 237 mm)
At bottom *Le nain de la nuit.* [several words illegible]/ *V. H. 1856.*
Paris, Maison de Victor Hugo, inv. 95
EXHIBITIONS Guernsey 1955, no. 224
LITERATURE Album Méaulle 1882, pl. 4; Simon 1904, p. 71; Planès 1907, no. 280; Sergent 1934, no. 218; Sergent 1957, no. 248; Cornaille and Herscher 1963, no. 190; Delalande 1964, fig. 63; Massin, I, 1967, no. 300; Picon and Focillon 1985, no. 187; Maison de Victor Hugo 1985, no. 95

Brother to the figure in the drawing opposite, *The dwarf of the night*, according to Hugo, is a creature born of superstition and ignorance. It has a deformed appearance and bristles with warts which make it both difficult to grasp and repulsive to the eye. It is as though creation had come to a halt while in its early stages, unable to define itself in an outline. Such presences are frequent in Hugo's work, starting with the unforgettable figure of Quasimodo whose monstrous body is the object of one of the poet's most baroque descriptions. Here, unlike the sketch of the *"Roi des Auxcriniers"* (cat. 86), which is far more literary, it is not only the character who is frightening, chimerical and of a clown-like ugliness, but also the technique that oversteps the bounds of the normal. The draftsman submits his figure to an astonishing mixture of rubbings, scribblings, grindings, graftings and patchings-up. The monstrous savagery and coarseness of the technique is at one with the figure's profile.

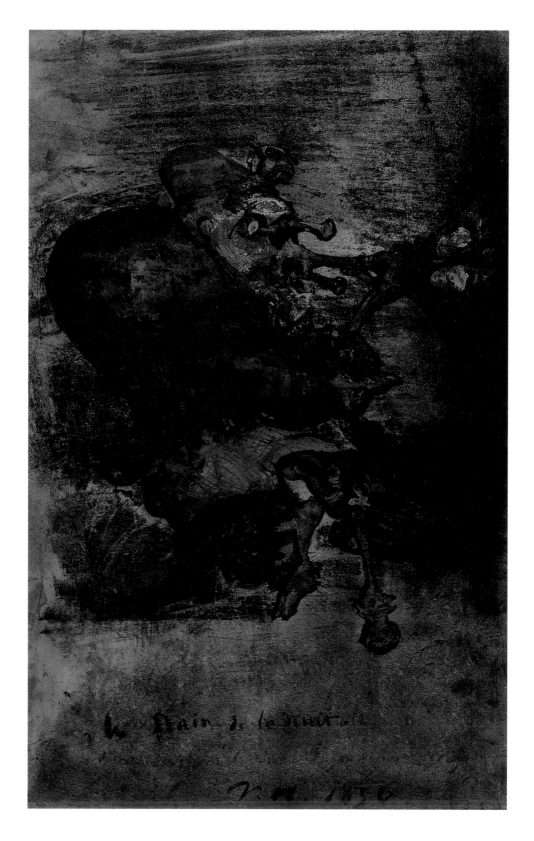

Les Travailleurs de la mer

Between June 1864 and the following April, Hugo composed his great novel based on life in the Channel Islands, on the climate, landscapes and the lives of their inhabitants. Unlike Hugo's other novels, the writing of *Les Travailleurs de la mer* (Toilers of the Sea) was accompanied by drawings relating to the plot of the story – illustrations for a particular episode, notes, even sketches that would later serve as a basis for the final, written version. Once it had been completed, the poet had thirty-six drawings bound in with the manuscript of the novel, a sure sign that he viewed the two graphic activities as complementary. Several examples from this group of drawings, which is today preserved in the Bibliothèque nationale de France, are presented here (see cats. 25, 86, 89, 91, 93); other works, such as *The Ortach Rock* (cat. 97) or *Skeleton of a stranded boat* (cat. 85), are very similar in theme and style, as are certain drawings made a few years earlier and likewise relating to the sea.

The ocean, the world of the ocean with its shores, its shifting moods, its sea-green transparencies and its changing colors, accounts for many of the themes of the drawings presented in this exhibition. Hugo's enforced stay in the Channel Islands was to prove of crucial significance in this respect. The landscape was inconceivably wild; gales were violent and the horizon constantly changing; added to this was the inner turmoil of the man himself. From his years in exile date Hugo's densest, as well as his most mystical texts, with their descriptions of cosmic visions, descents into the abyss, the terror felt when faced with the chaos of the elements or the call of oblivion.

In Hugo's eyes, shipwreck was a particularly apt metaphor for the condition of mankind, driven hither and thither as if over the ocean by the injustices and incoherencies of fate. "Wreckage is the ideal of powerlessness," he writes in *The Laughing Man.* "To be close to land yet unable to reach it, to float and be unable to sail, to be standing on something which seems solid but which is fragile, to be full of life and death at the same time, to be a prisoner in the wide open, to be shut in between the sky and the sea, to be locked in the infinite like a dungeon, to be surrounded by escaping breath and waves, and to be seized, strapped down, paralyzed, the exhaus-

tion, depression, despondency stupifies and infuriates. One can almost see the sniggering of the unknown combatant." The same storm holds sway in the mind of Jean Valjean, overwhelmed by his fate in the penal colony at Toulon; and the same doubts plague all the sleepers in Hugo's work, whose "broken-down thought floats above them, the smell of life and death combining with possibility which also thinks in space."

The haunting presence of the ocean is clearly responsible for a graphic style in which the infinite variations and fragility of that moving, liquid mass at work both without and within find their way onto paper. The spectacle of the sea and its shorelines is a constant source of inspiration to Hugo, as are the damage it wreaks and its threatening undertows. And just as waves, rain and the minglings of mist and foam are all forms of water, so ink laid on as wash or rubbed, the roughly handled brush lightly filled with ink or drowned in sepia, or the addition of watercolor and highlights of gouache are all ways of expressing, in a lively, windswept script running left to right, water in all its forms and states.

Nevertheless, at this stage in his work Hugo's vision of the chaos of the elements is no longer indebted solely to chance encounters, tricks or experiments. The balance of the white reserves, spatial nuances suggested by different degrees of transparency, or rhythms set up by varying the choice of instrument, indicate a mastery of the means of drawing and the possession of a rich vocabulary suited to the needs of expression. In a drawing like *The vision ship* (cat. 89) Hugo reveals a personal syntax that is intense, almost hallucinatory, capable at the same time of suggesting both the speed of a split-second instant and the threat of extinction. The manner in which the wash is applied – lighter in some places, darker in others – suggests the swell of the waves, while the rhythm of Hugo's pen – swift and incisive, sketching the silhouette rather than describing it in detail – allows him to conjure up the image of the wreck or, thanks to some reflection or highlight of white gouache, to render audible the sound of the wind or the waves or of wood warring with the raging sea.

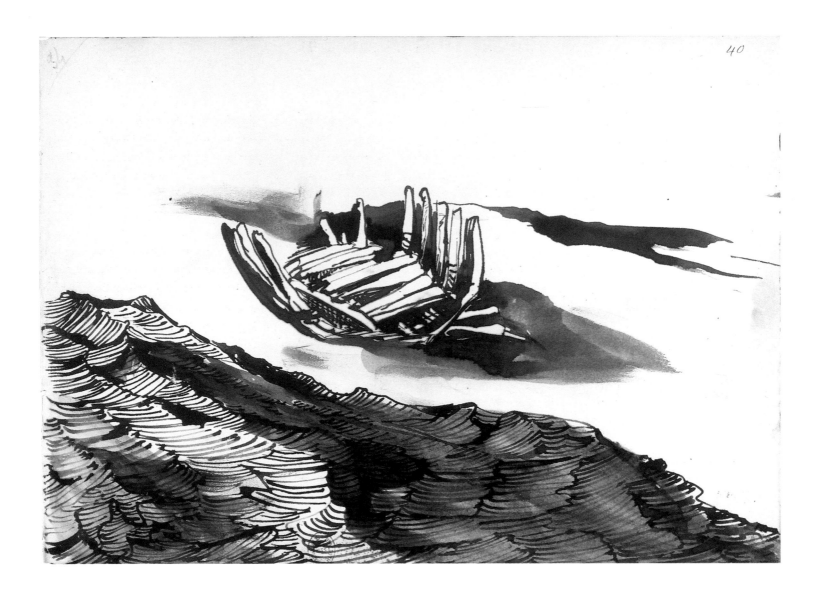

85 *Skeleton of a stranded boat*
ca. 1864–65

Pen, brush, brown ink and fingertips
7¹¹⁄₁₆ × 10¼" (195 × 260 mm)
Paris, Bibliothèque nationale de France, Mss, NAF
13345, fol. 40
LITERATURE Cornaille and Herscher 1963, no. 254;
Massin, II, 1969, no. 690; Picon and Focillon 1985,
no. 243; Paris 1985, no. 293

This drawing comes from an album filled in
1864–65, initially during Hugo's trip through
Belgium, Holland and along the Rhine valley,
and then in Guernsey. From this album,
thirteen pictures were taken out by Hugo to
illustrate *Toilers of the Sea*, whereas others,
which would also have fitted the bill
thematically, were left in the album; such is the
case with this seascape. This image of a wreck,
floundering like an abandoned carcass, fits
with the image of the sea evoked by the novel:

"There is no creature that devours its prey like
the sea. The water is full of claws. The wind
bites, the tide devours; the wave is a jaw. It
tears apart and crushes. The ocean has the
power of the lion's paw."
(*Toilers of the Sea*, Part II, Book II, ch. 2)
M L P

133

86 *"Le Roi des Auxcriniers"*
1865

Pen, brush, brown-ink wash and reserves on paper
7⁹⁄₁₆ × 9¹⁵⁄₁₆" (192 × 253 mm)
Inscribed in the bottom margin *Le roi des Auxcriniers*
Paris, Bibliothèque nationale de France, Mss, NAF
24745-1, fol. 57
PROVENANCE Removed from a sketchbook and
mounted on paper (16⁷⁄₁₆ × 11½" [418 × 292 mm])
EXHIBITIONS Paris 1952, no. 341b; London 1974,
no. 61; Stockholm 1974, no. 148; Paris 1985, no. 320
LITERATURE Album Méaulle 1882, pl. 3; Hugues
1883, p. 21; Cornaille and Herscher 1963, no. 255;
Massin, I, 1967, no. 476; Georgel 1970, pp. 284–86;
Bory 1980, p. 53; Picon and Focillon 1985, no. 244;
Georgel 1985, no. 3

First published in March 1866, the novel *Toilers of the Sea* was the object of three illustrated editions in ten years: the first by Gustave Doré, the second by François Chifflart, the third by Daniel Vierge. Hugo had the manuscript bound and, on May 29, 1866, recorded in his notebook that he had had his drawings inserted into it. Most were apparently chosen at random from works executed before, during and even after the novel was written and published, and accompany rather than illustrate the text. In this particular case, however, there is perfect unity between drawing and text:

"Only the most ignorant are unaware of the fact that the greatest danger of the coasts of the Channel Islands is the King of the Auxcriniers. No inhabitant of the seas is more redoubtable. Whoever has seen him is certain to be wrecked between one St Michel and the other. He is little, being a dwarf; and is deaf, in his quality of king. He knows the names of all those who have been drowned in the seas, and the spots where they lie. He has a profound knowledge of that great graveyard which stretches far and wide beneath the waters of the ocean. A head, massive in the lower part and narrow in the forehead; a squat and corpulent figure; a skull, covered with warty excrescences; long legs, long arms, fins for feet, claws for hands, and a sea-green countenance – such are the characteristics of this king. His claws have palms like hands; his fins human nails. Imagine a spectral fish with the face of a human being … . Nothing is more unpleasant than an interview with this monster; amid the rolling waves and breakers, or in the thick of the mist, the sailor perceives sometimes a strange creature with a beetle brow, wide nostrils, flattened ears, an enormous mouth, gap-toothed jaws, peaked eyebrows, and great grinning eyes. When the lightning is livid, he appears red; when it is purple, he looks wan. He has a stiff, spreading beard, running with water, and overlapping a sort of pelerine, ornamented with fourteen shells, seven before and seven behind."
(*Toilers of the Sea*, Part I, Book I, ch. 4)

Pierre Georgel has discovered that Hugo's drawing is based on an illustration in Champfleury's *Histoire de la caricature antique* representing the Egyptian god Bes. The fictional character is the novelist's own creation, as is the name Auxcriniers, born of a reverie during a sleepless moment. MLP

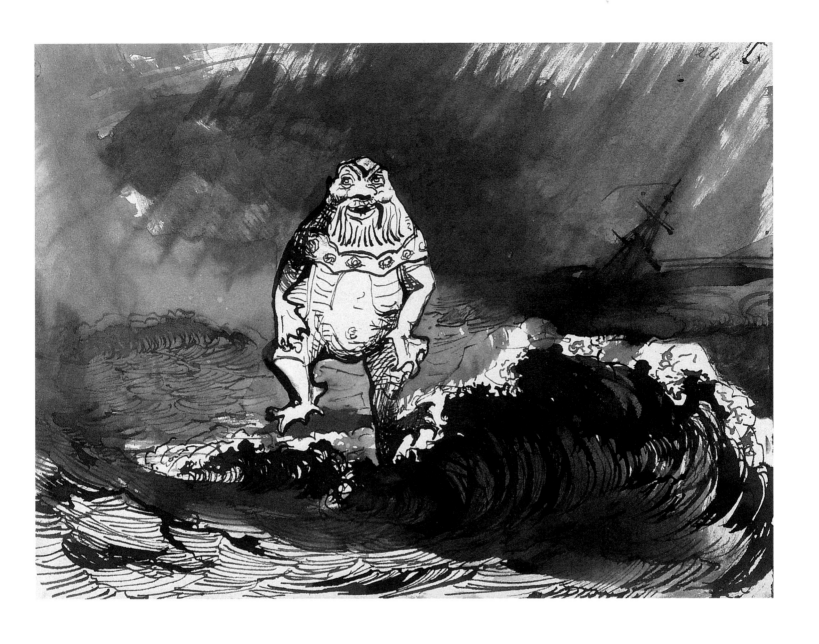

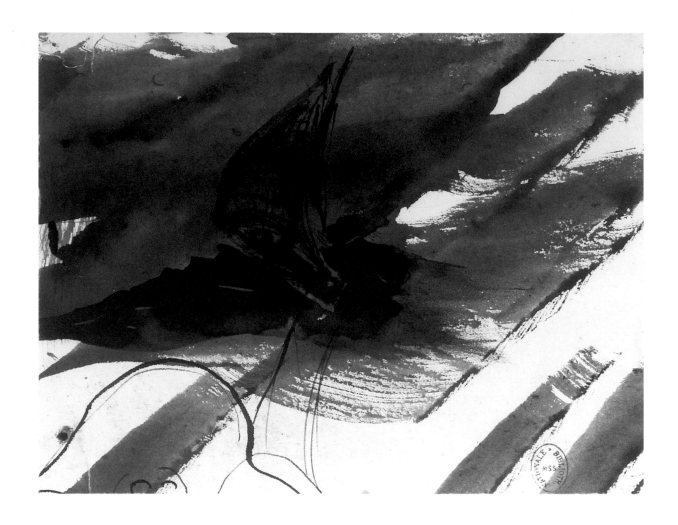

87 Small boat in full sail
ca. 1866–69

Pen, brown ink and wash on cream paper
4¹³⁄₁₆ × 6⁵⁄₁₆″ (122 × 160 mm)
Paris, Bibliothèque nationale de France, Mss, NAF
13351, fol. 21
EXHIBITIONS Paris 1985, no. 215; Zurich 1987,
no. 32; Venice 1993, no. 53
LITERATURE Journet and Robert 1963, p. 28;
Massin, II, 1969, no. 686

Judging by the paper employed, this drawing
seems to have been made between 1866 and
1869. Note that it has been recentered, and that
all that remains of the octopus is the sketch of
the head. The *tache* moves in the opposite
direction from the waves that carry the boat
along. MLP

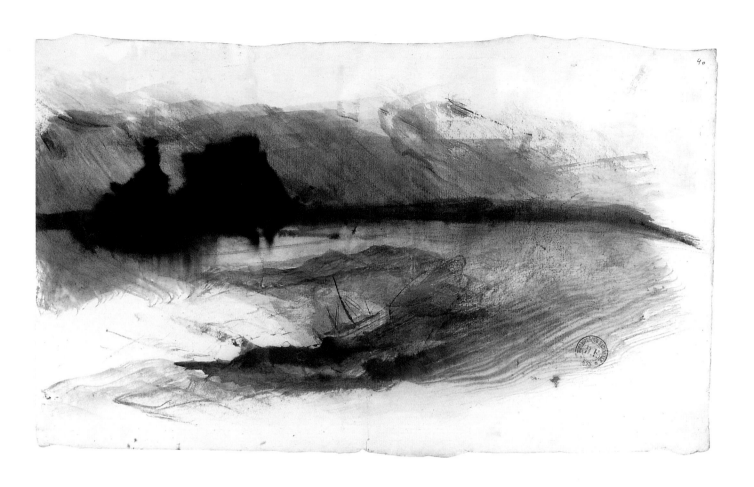

88 *Ship in a storm*
ca. 1875

Black ink and wash on cream-colored laid paper with
the watermark *DAMBRICOURT FRERES* (used with
the horizontal chain lines, sheet cut out from the
same laid paper as fols. 41–42v, where the sheet is
whole)
10⁷⁄₁₆ × 17¼″ (265 × 438 mm)
Verso: estate stamp of Maître Gâtine
Paris, Bibliothèque nationale de France, Mss, NAF
24807, fol. 40
EXHIBITIONS London 1974, no. 79; Bologna 1983,
no. 72; Paris 1985, no. 424; Zurich 1987, no. 65
LITERATURE Journet and Robert 1963, pl. 18;
Massin, II, 1969, no. 703

The paper used for this and the following
drawing appears in manuscripts that can be
dated *ca.* 1875–78. MLP

89 *The vision ship*
1864–65

Pen, brush, brown-ink wash and reserves on cream
paper
7⁷⁄₁₆ × 10¹⁄₁₆" (192 × 255 mm)
Paris, Bibliothèque nationale de France, Mss, NAF
24745-1, fol. 111
PROVENANCE From a sketchbook, NAF 13345,
and glued onto a backing sheet (16⁷⁄₁₆ × 11⁹⁄₁₆"
[417 × 293 mm])
EXHIBITIONS Paris 1952, no. 341i; Stockholm 1974,
no. 155; Paris 1985, no. 332; Zurich 1987, no. 85
LITERATURE Album Méaulle 1882, pl. 41 (with the
caption *Le Tempête. La Dernière lutte*); Hugues 1883,
p. 245; Cornaille and Herscher 1963, no. 268; Massin,
II, 1969, no. 713; Lafargue 1983, p. 89; Picon and
Focillon 1985, no. 259; Georgel 1985, no. 15

This drawing was inserted in *Toilers of the Sea* at the beginning of Chapter 6, Part I, Book IV, entitled "The luck of the shipwrecked crew to have met that sloop." The castaways can be seen gesticulating—an allusion, Georgel suggests, to *The wreck of the Medusa*. It might also refer, he adds, to the scene which takes place after the *Durande*'s dingy has put out to sea, when the crew and passengers move away from the ship, cheering the captain who has remained on board.

The penwork in the treatment of the waves is altogether characteristic of the seascapes of 1864–66, and may notably be compared with *"Le Roi des Auxcriniers"* (cat. 86). Also reminiscent of another drawing called *"Ma destinée,"* which is today at the Maison de Victor Hugo, this drawing may, further, recall the preface Hugo wrote for the novel, dated Hauteville House, March 1866:

"Religion, society, nature: these are the three struggles of mankind. These three struggles are at the same time three needs; he must believe, hence the temple; he must create; hence the city; he must live, hence the plough and the boat. But the three solutions contain three wars. The mysterious difficulty of life is the result of all three. Mankind has to deal with obstacles in the form of superstition, in the form of prejudice, and in the form of the elements. A three-fold *ananke* [necessity] lies heavy on us: the *ananke* of dogmas, the *ananke* of laws, the *ananke* of things. In *Notre-Dame de Paris*, the author denounced the first of these; in *Les Misérables*, he pointed out the second; in this book he indicates the third." MLP

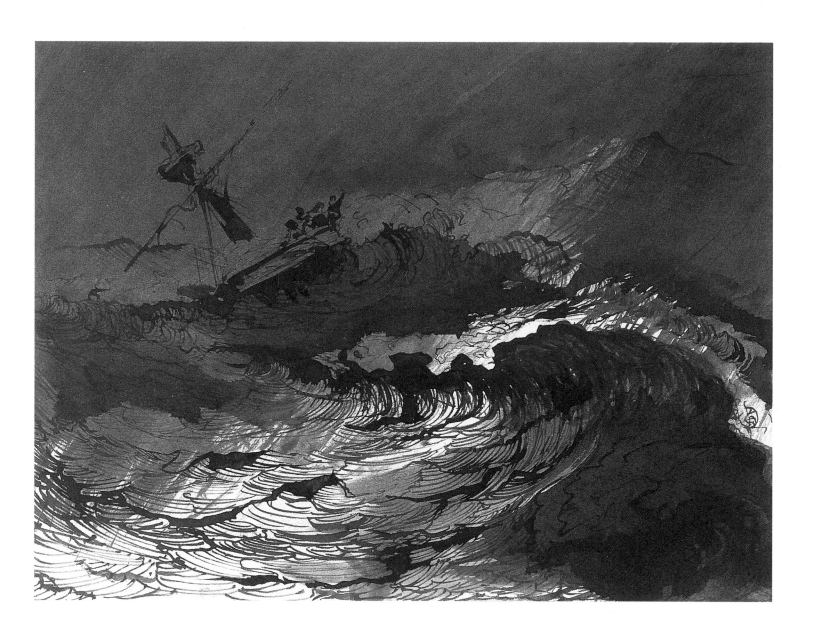

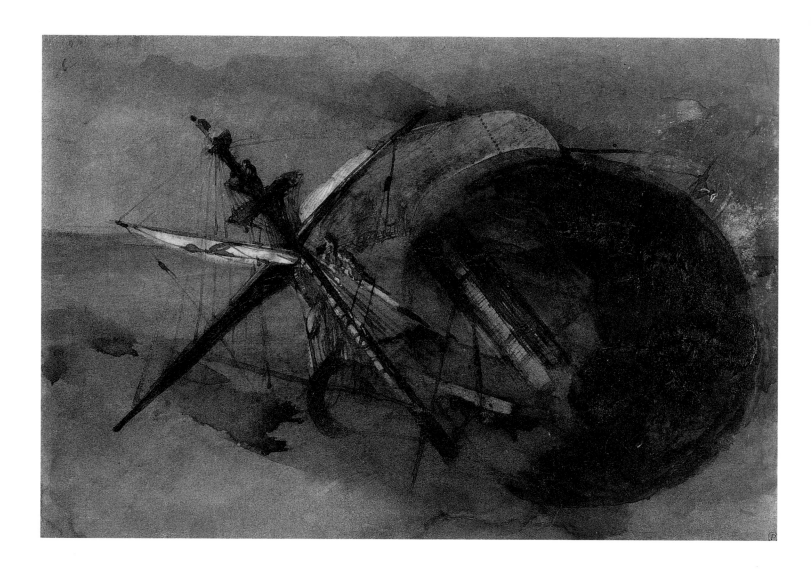

90 *The squall*
1865

Pen and brown-ink wash with highlights of white
gouache on beige paper
6¹³/₁₆ × 9¾″ (173 × 251 mm)
Bottom right *Victor Hugo / 1865*
Top left, collector's mark
Paris, Collection Louis-Antoine Prat
PROVENANCE Drawing originally inserted in a
copy of the Hugues edition of *Toilers of the Sea*, from
the library of Achille Fould and Léon Rattier; Hôtel
Drouot, Paris, December 13, 1982, lot 199
EXHIBITIONS Besançon 1985, no. XI; Ottawa 1990,
no. 99; Venice 1993, no. 69; Paris 1995, no. 84
LITERATURE Album Méaulle 1882, pl. 42; Hugues
1883, p. 181; Georgel 1985, p. 29

Though the drawing is signed and dated at
bottom right, the engraving made from it by
Fortuné-Louis Méaulle was printed the wrong
way up in the Hugues edition of *Toilers of the
Sea* published in 1883. That the picture can be
reversed in this way hardly comes as a
surprise; the possibility of reading Hugo's
images either way up is an important feature
of his graphic work. Mysterious and
incongruous, on the other hand, is the
enormous ball of ink that seems to have turned
the boat upside down and shattered it. By
turns planet, eye or, in disguised form, the
trough of a wave or a twister, the sphere
generally expresses a concentration of energy
in Hugo's poetry. Out of it comes either excess

darkness or blinding light. An irrepressibly
violent core that sweeps everything before it in
its path, the whirlwind or squall, constantly
revolving about its own center, unites
opposites in a single movement as it
fragments, scatters and reassembles; and
finally, by always returning to its starting
point, ensures the world's perpetual return
and unity.

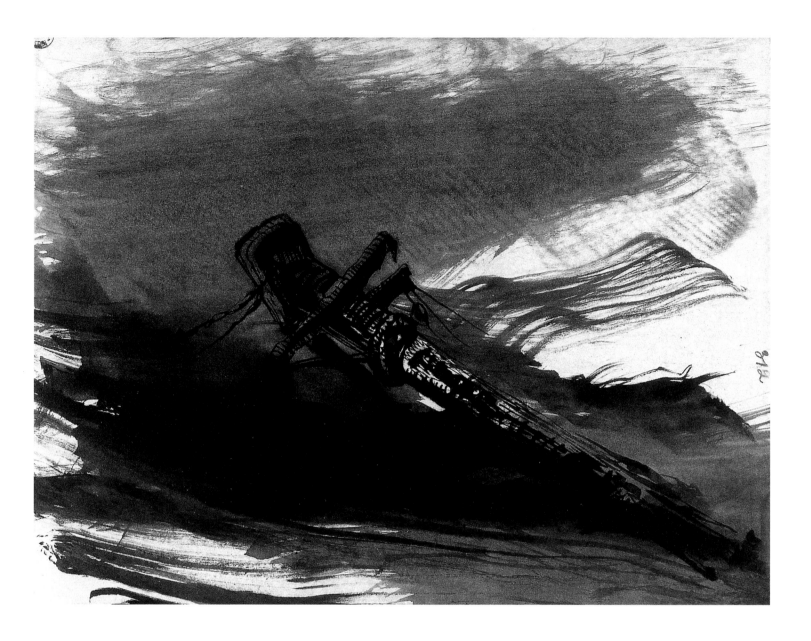

91 *The wreck*
1864–65

Pen, brush, brown-ink wash and reserves on cream paper
7⁹⁄₁₆ × 9¹¹⁄₁₆" (192 × 246 mm)
Paris, Bibliothèque nationale de France, Mss, NAF 24745-2, fol. 314
PROVENANCE From a sketchbook, NAF 13345, and inserted at the end of *Toilers of the Sea*, II, iii, 2
EXHIBITIONS Paris 1952, no. 341; Stockholm 1974, no. 165; Paris 1985, no. 345; Zurich 1987, no. 59; Venice 1993, no. 61
LITERATURE Album Méaulle 1882, pl. 51; Hugues 1883, p. 273; Massin, II, 1969, no. 728; Georgel 1985, no. 28

This drawing was inserted at the end of the chapter 'The Ocean Winds:' "In the loneliness of the ocean they batter the ships. Remorselessly, day and night, throughout the seasons, from the tropics to the poles, sounding their dreadful horn, they hunt down their prey of vessels in distress through the tangled thickets of cloud and wave."
(*Toilers of the Sea*, Part II, Book III, ch. 2)
MLP

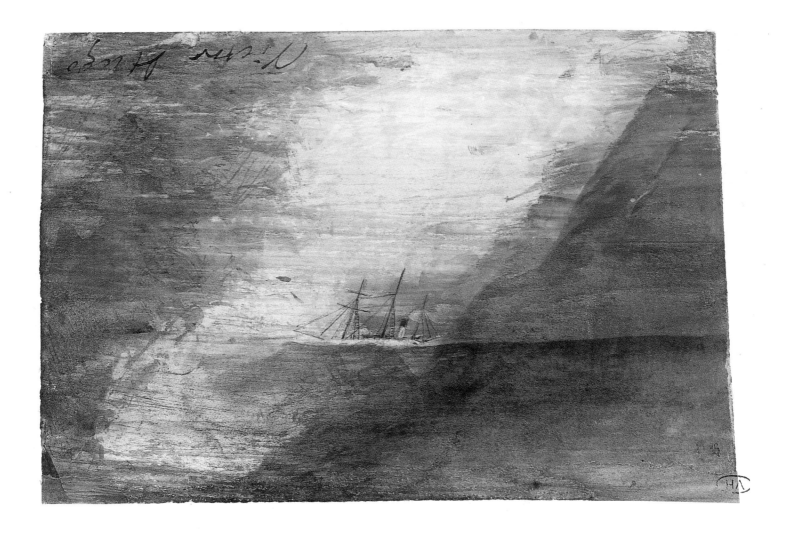

92 *Three-masted steamer*

ca. 1856

Pen and brown-ink wash over graphite, black ink, gouache and watercolor on vellum paper

5⅛ × 7½″ (130 × 190 mm)

Signed at top left, in reverse *Victor Hugo*

Paris, Maison de Victor Hugo, inv. 89

EXHIBITIONS Paris 1930, no. 661 or 667; Paris 1935, no. 308; Paris 1965, no. 101

LITERATURE Album Méaulle 1882, pl. 54; Hugues 1883, p. 209; Sergent 1934, no. 175; Sergent 1957, no. 38; Massin, II, 1969, no. 741; Maison de Victor Hugo 1985, no. 89

The vessel resembles a child's toy, so blurred have its contours become, in a sort of whirlwind of sea, rain, mist, hail and snow. Long streaks of gouache added to layers of wash of varying density suggest a sudden bright spell, a gap in the mist that fills the entire sheet of paper. There is a drawing made in Guernsey, dated September 1856 (private collection; fig. 19, p. 27), that renders the turbulent weather in a similar manner but does not include the detail of the boat, rapidly sketched with the tip of the pen.

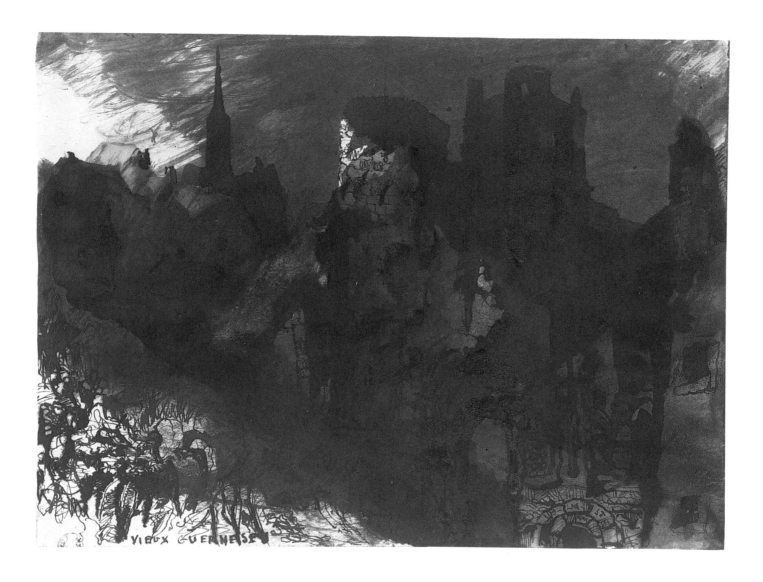

93 *"Vieux Guernesey"*
1864–65

Pen, brush, brown-ink wash and reserves with
highlights of white gouache on cream paper
7⁹⁄₁₆ × 10⅛" (192 × 257 mm)
Bottom left *VIEUX GUERNESEY*
Paris, Bibliothèque nationale de France, Mss, NAF
24745-1, fol. 69
PROVENANCE From a sketchbook, NAF 13345, and
glued onto backing paper 16½ × 24½" (420 × 625 mm)
EXHIBITIONS Paris 1952, no. 341c; Paris 1985,
no. 323
LITERATURE Album Méaulle 1882, pl. 11; Massin,
II, 1969, no. 707; Georgel 1985, no. 6

Inserted in *Toilers of the Sea*, this drawing
conjures up the Guernsey of Gilliatt and Mess
Lethierry. Placing this drawing and the two
that followed (*La Durande* and *"The figurehead
of* La Durande") at the end of Book I, Hugo
prepared the way for the character whose
name was used for the title. MLP

Ocean and Chaos

The phenomenal variety of graphic languages that Hugo was constantly inventing and testing becomes fully apparent in a number of compositions ambitious both in size and in imaginative scope. In these, we must learn to look at things differently – no longer from the outside on our fixed Euclidian plane, but as if we had passed over into the very heart of movement and had entered the eye of the hurricane. Space is no longer reliable and reassuring but disorderly, chaotic, random: at times, forms are swept away, carrying with them buildings, walls, doors, arches, bridges and dykes, in a floodtide where all sense of depth or limit is lost. Alternatively, the space is hard-edged and violent: a rock rises up, rending it in two, a flash of moonlight forces a passage. Shadows are ambiguous; fragments signify anxiety. Anything is possible in such spaces.

They become an open frontier where categories merge and the endless contradictions of being and non-being, darkness and light, reality and imagination meet.

Drawings like these subject the gaze almost against its will to a twofold movement, rather like that of a half-waking state in which the mind, though drowsy, nevertheless moves at the speed of light. For all their gravity things appear to have no real foundation, emerging slowly, then all of a sudden collapsing. The mist enveloping them suddenly crystallizes, surface becomes depth, "a drop of water becomes a world." What bore things up is suspended, space has slipped its moorings, infinity is a detail and one is immersed in the immensity of dreams.

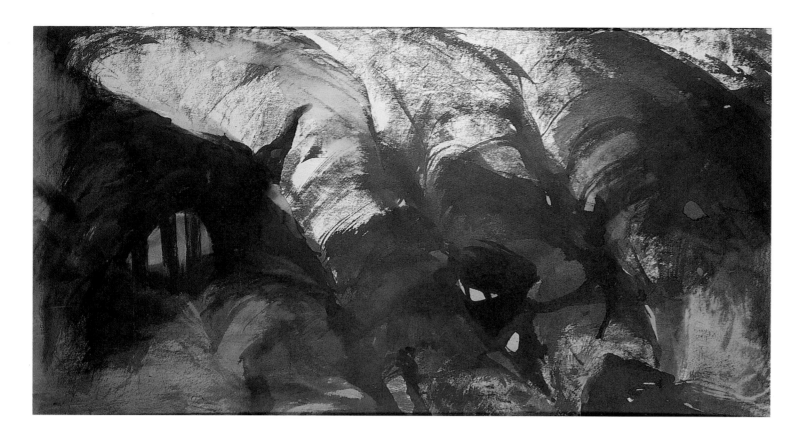

94 *The bowels of Leviathan*

ca. 1866

Pen, brown-ink wash and black ink with highlights of
gouache on laid paper
19¼ × 35⁹⁄₁₆" (489 × 904 mm)
Paris, Maison de Victor Hugo, inv. 808
PROVENANCE Collection Monsieur Demotte;
acquired in 1920
EXHIBITIONS Paris 1930, no. 598; Geneva 1951,
no. 102; Stockholm 1974, no. 136; Zurich 1987, no. 47;
Venice 1993, no. 55
LITERATURE Escholier 1926, p. 76; Sergent 1934,
no. 215; Sergent 1957, no. 245; Cornaille and Herscher
1963, no. 236; Massin, II, 1969, no. 777; Lafargue 1983,
p. 39; Picon and Focillon 1985, no. 226; Maison de
Victor Hugo 1985, no. 808

The literary reference at the origin of this
image – "What are the bowels of Paris? – Its
sewers" (*Les Misérables,* Part V, Book II, ch. 1) –
is far surpassed by the expressive power of the
drawing. The technique itself evokes the
subject as it is itself dirty, slovenly and sewer-
like. Depending on the angle of one's gaze,
details can be seen looming up from under the
vigorous sweep of Hugo's pen among the
chaos of waves and backwash – an eye, a
muzzle, a backbone, fragments of buildings,
plants, trees, thickets or tree-trunks struck by
lightning.

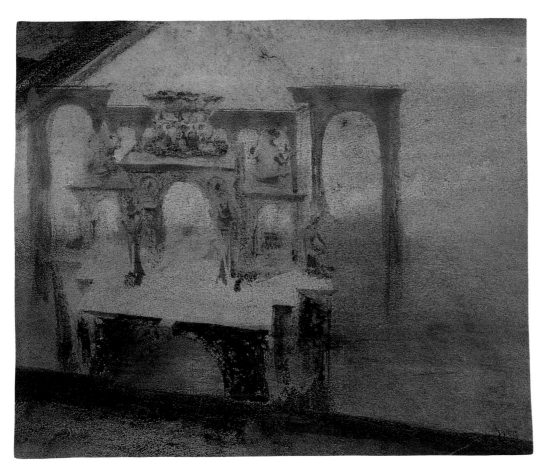

95 Renaissance architecture

Pen, brown-ink wash, black ink, gouache, graphite,
black crayon, fingerprints and stencils (?) on
vellum paper, partly rubbed
8³⁄₁₆ × 9⁵⁄₈″ (208 × 244 mm)
Paris, Maison de Victor Hugo, inv. 935
PROVENANCE Collection Paul Meurice; Hôtel
Drouot, Paris, December 17, 1945
EXHIBITIONS Geneva 1951, no. 68
LITERATURE Sergent 1934, no. 890; Sergent 1957,
no. 161; Massin, II, 1969, no. 630; Maison de Victor
Hugo 1985, no. 935

In this very fine drawing, where everything
depends on suggestion and transparency,
Hugo's perfect command of his materials and
means allows him to conjure up structures
which, as in dreams, serve no purpose, but are
mere whims of the imagination which seem to
defy gravity, lead nowhere and are doomed
shortly to be engulfed. Stone liquifies,
perspectives overlap or are superimposed on
one another, indications of verticality or depth
are cancelled. Before long, however, stepping
out of the mist and destruction, reduplicated,
inscribed in a triumphal arch, comes the initial
H of Hugo's name.

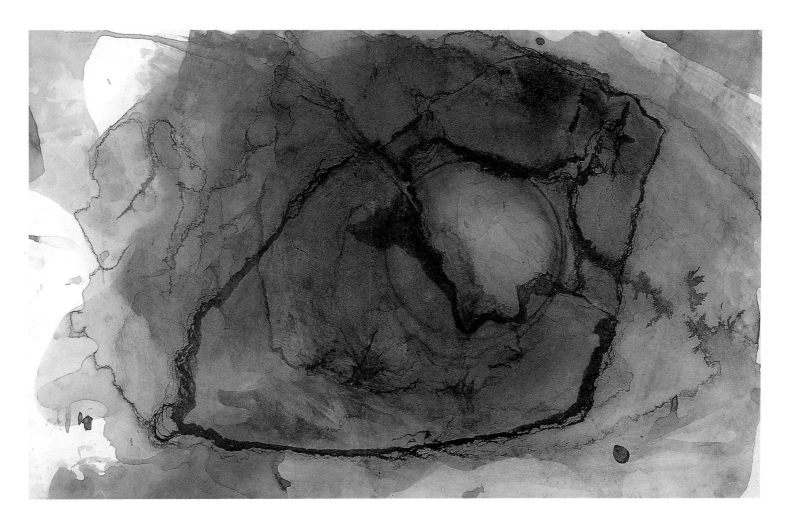

96 *'Planet' taches*
ca. 1853–55

India-ink wash with circular imprint on white paper
folded in two
11¼ × 17½" (285 × 445 mm)
Dijon, Musée des Beaux-Arts, Donation Granville,
inv. DG 624
PROVENANCE Hugo Family Estate; acquired in
1962
EXHIBITIONS Villequier and Paris 1971–72, no. 58;
Paris 1985, no. 6; Zurich 1987, no. 15; Tokyo 1993,
no. 110
LITERATURE Georgel 1971, no. 14; Donation
Granville 1976, no. 147

This drawing shows once again the dissolution
of any fixed point of reference, the sense of a
kind of cosmic spasm is conjured up by the
superimposed layers of translucent ink and by
the network of streaks of pigment suspended
in water. This immersion in the primeval soup
could also be read, however, as an image of
infusoria in their glassy medium, throbbing
away beneath the lens of a microscope. That
the artist does not intervene, but is content to
supervise these hazy effusions as they roll out
over the page, contributes to the unsettling
mystery of the image.

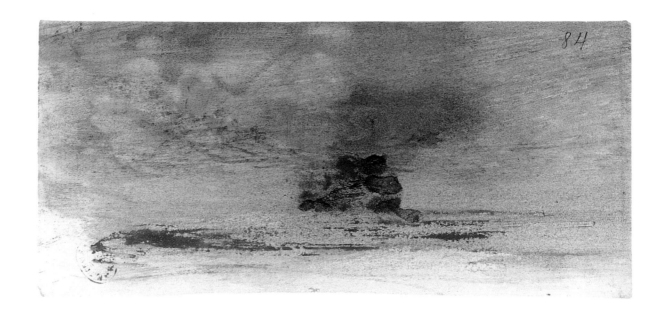

97 *The Ortach Rock*
ca. 1864

Black lead, brown ink and wash with highlights of
blue on cream paper
2¹⁵⁄₁₆ × 6¼" (74 × 158 mm)
Paris, Bibliothèque nationale de France, Mss, NAF
13355, fol. 84
EXHIBITIONS Marseille 1985, no. 52; Paris 1985,
no. 310; Zurich 1987, no. 54; Venice 1993, no. 72
LITERATURE Journet and Robert 1963, p. 52;
Cornaille and Herscher 1963, no. 157; Massin, II, 1969,
no. 681 and 681 bis; Lafargue 1983, p. 127; Picon and
Focillon 1985, no. 152; Georgel 1985, no. 38

The Ortach Rock, near Jersey and Guernsey, is
often evoked in Hugo's literary work, from
Toilers of the Sea to *The Laughing Man*:

"The Ortach Rock is a paving stone in the
middle of the ocean. The Ortach reef, all of a
piece above the thwarted impact of the
surging sea, rises straight up to a height of
eighty feet. Waves and ships break on it.
Immutable cube, it plunges its straight flanks
sheer into the innumerable winding curves of
the sea. In a storm, it awaits the blow of the
axe, the thunderbolt"
(*The Laughing Man*, Part I, Book II, ch. 14)

The blue used here compares with that of
another drawing (Massin, II, 1969, no. 1028)
dated to around 1864. MLP

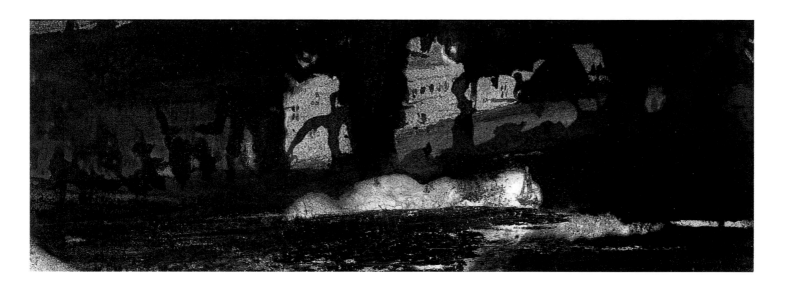

98 *Seascape*

Pen, brown-ink wash, black ink, application of
lace (?), white- and blue-ink highlights on paper
2⅛ × 7½" (66 × 194 mm)
Collection of Carol Selle
PROVENANCE Collection Valentine Hugo

The danger of lengthy contemplation is that
the object of consideration gradually loses its
consistency. During his exile in Guernsey,
Hugo more than once associated gazing with
sleep and death. "In certain places, at certain
times of day, it is poisonous to look at the sea,"
he wrote in *Toilers of the Sea*. Just as the night
changes the most familiar figures into ghosts,
the ebb and flow of the ocean undoes the most
solid constructions.

The drawing conveys the proximity of
darkness and danger in its long trails of wash
– leaving gaps in which the wall of a castle
perched on rocks appears – also in the glinting
sea, and in the tiny silhouette of a sloop
battling with the waters and about to be hit by
the unimaginable enormity of the cliffs.
Paradoxically, it is by always watching the
way the materials react that the artist manages
to create this impression. He seems to keep his
distance, intervening only when necessary and
always at the right moment.

99 *Ruined aqueduct*
ca. 1850

Pen, brown-ink wash, black ink, graphite, black
crayon, fingerprints and reserves on beige, gilt-edged
vellum paper, partly rubbed (*taches* on verso)
9¹³⁄₁₆ × 12¹⁵⁄₁₆″ (249 × 329 mm)
Paris, Maison de Victor Hugo, inv. 820
EXHIBITIONS Geneva 1951, no. 76; Tours 1988,
no. 29; Venice 1993, no. 5
LITERATURE Sergent 1934, no. 149; Sergent 1957,
no. 164; Cornaille and Herscher 1963, no. 161; Massin,
II, 1969, no. 626; Picon and Focillon 1985, no. 154;
Maison de Victor Hugo 1985, no. 820

This is one of Hugo's richest drawings from
the point of view of technique. The artist turns
everything to good account: the quality, color
and possible imperfections of the paper, the
dilutions of matter and the *taches* that he
manipulates, the different degrees of oiliness
of his crayons. He makes rubbings, contrives
reserves, uses his fingers, foresees the way the
ink will pull and the time it needs to dry – in
short, tries everything. The range of textures,
the blending of different elements and the
degree of expression accorded the same
element at different stages (water that is calm
or turbulent, soil that is loose, clayey, sooty or
dry, mist that is dense and smokey, fine spray,
fire, lava, and so forth) combine to articulate
an astonishing vision of active chaos, of a truly
Heraclitan 'everything flows.'

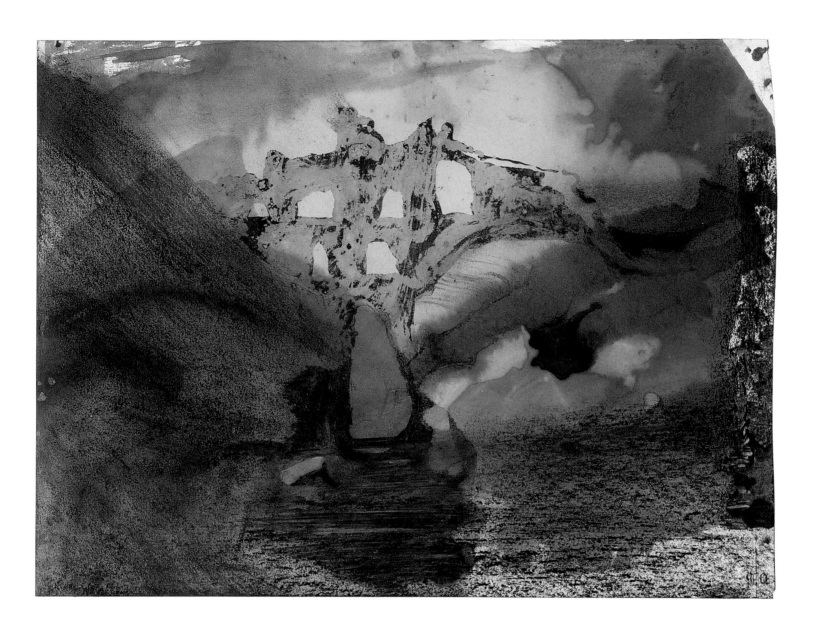

151

100 *"Hic clavis, alias porta"* (The key is here, the gate elsewhere)
1871

Pen, brown-ink wash, black ink, graphite, black crayon, charcoal, reserves and fingerprints or dabbings with highlights of white gouache on vellum paper, partly rubbed and scraped
18½ × 18¹³⁄₁₆″ (470 × 478 mm)
Bottom center, on a flagstone
HIC/CLAVIS/ALIAS/PORTA
Bottom right *Victor/Victor Hugo*
Paris, Maison de Victor Hugo, inv. 126
EXHIBITIONS Geneva 1951, no. 66; Paris 1959, no. 88; Zurich 1987, no. 6
LITERATURE Alexandre 1903, p. 183; Planès 1907, no. 252; Escholier 1926, p. 39; Sergent 1934, no. 114; Sergent 1957, no. 130; Massin, II, 1969, no. 602; Seghers 1983, p. 24; Maison de Victor Hugo 1985, no. 126

The strangeness of this drawing stems from the fact that the space is oversized, cluttered and opaque, the distances being too remote and the steps too high. Once again, the drawing is complex in the extreme: Hugo wields his technical arsenal with enormous pleasure and the supreme skill of a visionary.

It is not merely the title that makes this space so strange, but everything about the way it is staged: the dim light of the entrance-way, where a door is to be found (others see a fireplace) surmounted by the statue of a man whose brow is decorated with bumps and by a high pediment on which a cartouche containing a vessel surrounded by an illegible motto can be seen. We do not know where we are – whether underground, in Gilliatt's cave beneath the sea, or in some hell or Valhalla. The motifs that recur throughout Hugo's graphic work abound: flagstones, arches, yawning gaps, crypts, oval windows, wooden beams, standing or tumbledown columns, sections of wall that form enormous letters, clouds – in short, an architecture fit for giants rather than men, mineral, grandiose, terrifying, from some other age than ours.

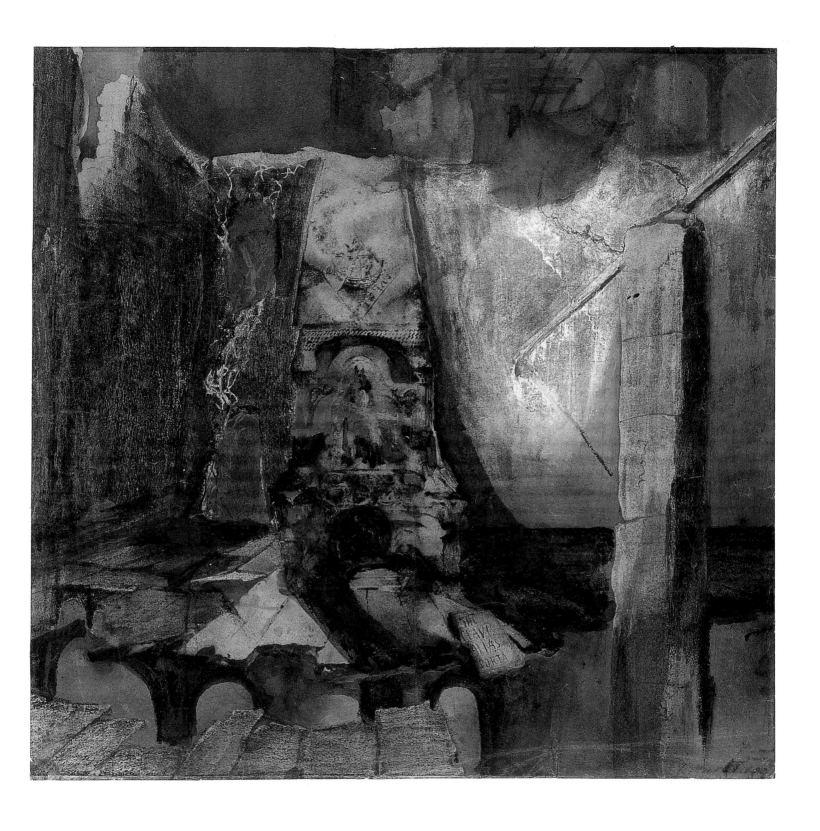

153

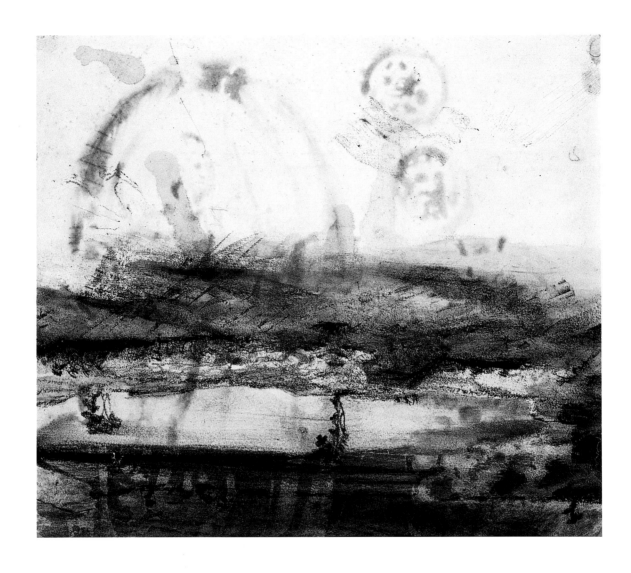

101 *Landscape*

ca. 1850

Pen, black-ink wash, charcoal, black crayon, graphite
and stump on white vellum paper, partly rubbed
8⅞ × 9¾″ (226 × 248 mm)
Verso: Ornamental motifs and figures, estate stamp of
Maître Gâtine
Galerie Jan Krugier, Ditesheim & Cie, Geneva,
inv. 3418
EXHIBITIONS Villequier and Paris 1971–72, no. 50;
Zurich 1987, no. 48; New York and Geneva 1990–91,
no. 23; Venice 1993, no. 3; Valencia 1996, no. 28
LITERATURE Massin, I, 1967, no. 208

The motifs drawn on the other side of the
paper have become visible on the recto, further
complicating a composition which already
combines penwork, ink washes, charcoal and
black crayon, delicately applied either in the
manner of stumpwork or by rubbing. The
result is a picture in which nothing – neither
form nor space – is fixed.

102 *Mountain landscape*
ca. 1863?

Pen, brown-ink wash, black ink, watercolor
(gouache?), charcoal and graphite on white paper
7¾ × 5¹⁄₁₆" (200 × 129 mm)
Villequier, Musée Victor Hugo, inv. 1694 (III) 1
PROVENANCE Collection Louis Barthou; Collection
H. Guiter; Hôtel Drouot, Paris, June 15, 1973
EXHIBITIONS Bologna 1983, no. 56; Zurich 1987,
no. 40; Mainz 1990, p. 97; Venice 1993, no. 1985
LITERATURE Chirol 1982, no. 37

Unlike the previous drawings, which mostly
take vortex for their theme, this composition,
related to other works made around 1863,
suggests rather a raising-up of space. The
diaphanous splashes of sky-blue watercolor
are initially responsible for this feeling of
lightness, but also the large blank area in the
bottom half of the picture, punctuated by a
streak of very lightly drawn gray charcoal,
reinforces this sense. For once, Hugo puts
aside his fascination with fluids, turning
instead to the all-inspiring air and radiant
light.

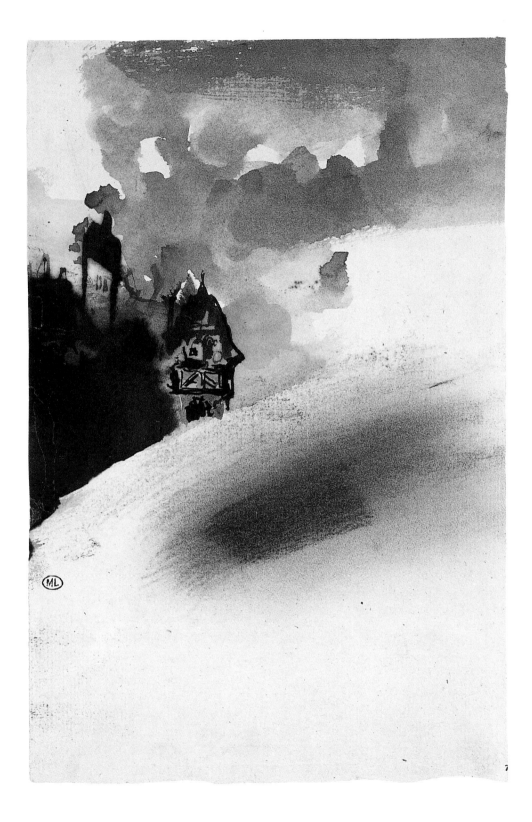

BIBLIOGRAPHY

Album Méaulle 1882
Dessins de Victor Hugo: Les Travailleurs de la mer, engraved by F. Méaulle, Paris (Atelier de reproductions artistiques) 1882

Alexandre 1903
Arsène Alexandre, *La Maison de Victor Hugo*, Paris (Hachette) 1903

A. Barbou, *Victor Hugo et son temps: édition illustrée de 120 dessins inédits ... et d'un très grand nombre de dessins de Victor Hugo gravés par Méaulle*, Paris (E. Hugues) 1881

Jean-Bertrand Barrère, *Hugo, l'homme et l'œuvre*, Paris (Boivin) 1952

Jean-Bertrand Barrère, *La Fantaisie de Victor Hugo* [1919], reprinted Paris (Corti) 1950, 1960; Paris (Klincsieck) 1972

Albert Béguin, *L'Ame romantique et le rêve*, Paris (Corti) 1939

Bertaux 1903
Emile Bertaux, 'Victor Hugo artiste: I. Le dessinateur,' *Gazette des Beaux-Arts*, XXIX, 1903, pp. 465–89

Emile Bertaux, 'Victor Hugo artiste: II. Le décorateur,' *Gazette des Beaux-Arts*, XXX, 1903, pp. 146–172

Besançon 1985
Victor Hugo au Musée, dessins et souvenirs, exhib. cat., Besançon, Musée des Beaux-Arts, 1985

Bologna 1983
I disegni di Victor Hugo, exhib. cat. by Sandra Costa, with essay by Henri Focillon, Bologna, Palazzo Pepoli Campogrande, 1983

Bory 1980
Jean-François Bory, *Victor Hugo: Dessins*, Paris (H. Veyrier) 1980

Philippe Burty, 'Les Dessins de Victor Hugo,' *L'Art*, no. 37, September 12, 1875

Chirol 1982
Le Musée Victor Hugo de Villequier, cat. of the collection by Elisabeth Chirol, Rouen (Lecerf) 1982

Cornaille and Herscher 1963
Roger Cornaille and Georges Herscher, *Victor Hugo dessinateur*, preface by Gaétan Picon, Paris (Editions du Minotaure) 1963

Jean Delalande, *Victor Hugo à Hauteville House*, Paris (Albin Michel) 1947

Delalande 1964
Jean Delalande, *Victor Hugo dessinateur génial et halluciné*, Paris (Nouvelles Editions latines) 1964

Dessins de Victor Hugo gravés par Paul Chenay, preface by Théophile Gautier, Paris (Castel) 1863

Donation Granville 1976
Serge Lemoine, *Donation Granville: tome I: peintures, dessins ... œuvres réalisées avant 1900* Dijon (Musée des Beaux-Arts) 1976

Escholier 1926
Raymond Escholier, *Victor Hugo artiste*, Paris (Crès) 1926

Henri Focillon, 'Les Dessins de Victor Hugo,' *Bulletin des Amis de l'Université de Lyon*, March–April 1914

Henri Focillon, *Technique et sentiment, études sur l'art moderne*, Paris (Laurens) 1919

Frankfurt 1975–76
Charles Meryon, exhib. cat., Frankfurt, Städelsche Kunstinstitut und Städtische Galerie, 1975–76

Jean Gaudon, *Ce que disent les tables parlantes: Victor Hugo à Jersey*, Paris (Pauvert) 1963

Jean Gaudon, *Le temps de la contemplation*, Paris (Flammarion) 1969

Geneva 1951
Dessins de Victor Hugo des collections de la Maison Victor Hugo, Paris, preface by Jean Sergent, Geneva, Musée Rath, 1951

Georgel 1971
Pierre Georgel, 'Dessins de Victor Hugo dans les collections publiques françaises,' *La Revue du Louvre*, nos. 4–5, 1971, pp. 251–68

Georgel, *Sources*, 1971
Pierre Georgel, 'Les "sources" de quelques dessins de Victor Hugo,' *Bulletin de la Société de l'art français*, 1971, pp. 281–95

Georgel 1973
Pierre Georgel, 'Le Romantisme des années 1860 (correspondance Victor Hugo–Philippe Burty),' *Revue de l'art*, no. 20, 1973, pp. 8–64

Georgel 1974
Pierre Georgel, 'La vision en silhouette,' *L'Arc*, no. 57, 1974, pp. 24–32

Georgel 1985
Pierre Georgel, *Les dessins de Victor Hugo pour 'Les Travailleurs de la mer' de la Bibliothèque nationale*, intro. by Roger Pierrot, Paris (Herscher) 1985

Pierre Georgel, 'Le dessinateur,' in *Encyclopædia Universalis*, XI, p. 721, Paris (Encyclopædia Universalis) 1989

La Gloire de Victor Hugo, exhib. cat. by Pierre Georgel, Paris, Galeries nationales du Grand-Palais, 1985

Sophie Grossiord, *Victor Hugo*, Paris (Gallimard Découvertes) 1998

Guernsey 1955
Victor Hugo en exil, exhib. cat., preface by Jean Sergent, Guernsey, Hauteville House, 1955

Georges Herscher, 'Papiers découpés de Victor Hugo,' *L'Œil*, no. 107, November 1963, pp. 34–39

Georges Hugo, *Mon grand-père*, Paris (Calmann-Lévy) 1902

Victor Hugo, *L'Archipel de la Manche*, Paris (Calmann-Lévy) 1883

Victor Hugo, *Œuvres complètes*, ed. Jean Massin, Paris, 24 vols., Paris (Club Français du Livre), 1967–71

Victor Hugo, *Correspondance familiale et écrits intimes*, 2 vols., edd. Jean Gaudon, Sheila Gaudon, and Bernard Leuilliot, Paris (Laffont) 1988

Victor Hugo, *Œuvres complètes*, 15 vols., ed. Jacques Seebacher, Paris (Laffont) 1988

Hugo-Méaulle, *Le Rhin* (n.d.)
Victor Hugo, *Le Rhin*, illustrated by Victor Hugo, engravings by P. Méaulle, Paris (Hugues) n.d.

Hugues 1883
Victor Hugo, *Les Travailleurs de la mer*, Paris (Hugues) [1883]

Journet and Robert 1963
Victor Hugo: trois albums, edd. René Journet and Guy Robert, Annales Littéraires de l'Université de Besançon, vol. 55, Paris (Editions Les Belles-Lettres), 1963

Krugier 1983
Dix ans d'activité, Geneva (Galerie Jan Krugier) 1983

Lafargue 1983
Jacqueline Lafargue, *Victor Hugo, dessins et lavis*, Paris (Editions Hervas) 1983

Arnaud Laster, *Victor Hugo*, Paris (Belfond) 1984

Jean-Claude Lebensztjein, *L'Art de la tache*, intro. by Alexander Cozens, Paris (Editions du Limon) 1990

London 1959
The Romantic Movement, exhib. cat., London, Tate Gallery, 1959

London 1974
Drawings by Victor Hugo, exhib. cat. by Pierre Georgel, London, Victoria and Albert Museum, 1974

Lugano 1977
Alter Ego: pittori, scrittori, exhib. cat., Lugano, Villa Malpensata, 1977

Mainz 1990
Victor Hugo und Deutschland, exhib. cat. by Adolf Wildt, Mainz, Gutenberg Museum, 1990

Maison de Victor Hugo 1985
Dessins de Victor Hugo, cat. of collection by Sophie Grossiord, Paris (Maison de Victor Hugo) 1985

Marseille 1985
Une famille ... Les Hugo, exhib. cat., Marseille, Musée Borély, and Lunéville, 1985

Massin, I, 1967
'Dessins et lavis I,' in Victor Hugo, *Œuvres complètes*, XVII, ed. Jean Massin, preface by Pierre Georgel, Paris (Club Français du Livre) 1967

Massin, II, 1969
'Dessins et lavis II,' in Victor Hugo, *Œuvres complètes*, XVIII, ed. Jean Massin, preface by Gaétan Picon, Paris (Club Français du Livre) 1969

Maturité de Victor Hugo (1829–1848), exhib. cat. by Jean Sergent, Paris, Maison de Victor Hugo, 1952

Les Misérables (1862–1962), exhib. cat. by Martin Ecalle and Josette Lumbroso, Paris, Maison de Victor Hugo, 1962

Monaco 1981
Cinquante dessins de Victor Hugo, sale catalogue, Monaco, Sotheby Parke Bernet, 1981

Müller 1982
Joseph-Emile Müller, *Victor Hugo au Luxembourg: vues et visions*, Luxembourg (Arts et des Lettres de l'Institut grand-ducal) 1982

Neuchâtel 1952
Victor Hugo: dessins rares ou inédits, Neuchâtel and Paris (Ides et Calendes) 1952

New York and Geneva 1990–91
Victor Hugo and the Romantic Vision, exhib. cat. by Evelyne Ferlay, preface by Jean Leymarie, Geneva and New York, Jan Krugier Gallery, 1990–91; French edition *Victor Hugo et la vision romantique*

Ottawa 1990
De Main de maître: trois siècles de dessin français dans la Collection Prat, exhib. cat., Ottawa, Musée des Beaux-Arts du Canada, and Paris, Musée du Louvre, 1990

Paris 1888
Dessins et manuscrits de Victor Hugo au bénéfice de la souscription pour sa statue, exhib. cat., Paris, Galerie Georges Petit, 1888

Paris 1919–20
Exposition du Rhin, exhib. cat. by Raymond Escholier, Paris, Maison de Victor Hugo, 1919–20

Paris 1930
Le Romantisme, exhib. cat., Paris, Bibliothèque nationale, 1930

Paris 1935
Les Séjours de Victor Hugo, exhib. cat. by Jean Sergent, Paris, Maison de Victor Hugo, 1935

Paris 1952
Enfance et jeunesse de Victor Hugo, exhib. cat. by Jean Sergent, Paris, Maison de Victor Hugo, 1952

Paris 1959
Victor Hugo: carnet, edd. René Journet and Guy Robert, Annales Littéraires de l'Université de Besançon, Paris (Les Belles-Lettres), vol. 24, 1959

Paris 1965
Trois millénaire d'art et de marine, exhib. cat., Paris, Musée du Petit-Palais, 1965

Paris 1972
Dessins et ébauches de Victor Hugo provenant de la succession Hugo, exhib. cat., Paris, Galerie Lucie Weill, 1972

Paris 1976
Dessins parisiens des XIXe et XXe siècle, exhib. cat., Paris, Musée Carnavalet, 1976

Paris 1983–84
Dessins d'écrivains français du XIXe siècle, exhib. cat., Paris, Maison de Balzac, 1983–84

Paris 1985
Soleil d'encre: manuscrits et dessins de Victor Hugo, exhib. cat. by Judit Petit, Roger Pierrot, and Marie-Laure Prévost, Paris, Musée du Petit-Palais, 1985

Paris 1995
Dessins français de la collection Prat, Paris (Réunion des Musées nationaux) 1995

Picon and Focillon 1985
Gaétan Picon and Henri Focillon, *Victor Hugo dessins*, commentaries by Geneviève Picon and Réjane Bargiel, Paris (Gallimard) 1985

Planès 1907
E. Planès, *Catalogue de la Maison de Victor Hugo*, Paris (Maison de Victor Hugo), 1907

Gérard Pouchain, *Promenades dans l'Archipel de la Manche avec un guide nommé Victor Hugo*, Condé-sur-Noiseau (Editions Charles Corlet) 1985

Le Rhin, le voyage de Victor Hugo en 1840, exhib. cat. by Jean Gaudon and Evelyn Blewer, Paris, Maison de Victor Hugo, 1985

Jean-Pierre Richard, *Etudes sur le Romantisme*, Paris (Le Seuil) 1970

Florian Rodari, *Le Collage*, Geneva (Editions d'Art A. Skira) 1988

Rome 1959–60
Il disegno francese da Fouquet à Toulouse-Lautrec, exhib. cat., Rome, Palazzo di Venezia, 1959–60

Pierre Schneider, 'Victor Hugo,' *Temps modernes*, no. 66, [1948?], reprinted in *Peinture et déluge* (forthcoming)

Seghers 1983
Pierre Seghers, *Victor Hugo visionnaire*, Paris (Laffont) 1983

Sergent 1934
Maison de Victor Hugo, cat. of the collection by Jean Sergent, Paris 1934

Sergent 1955
Jean Sergent, *Dessins de Victor Hugo*, Paris and Geneva (La Palatine) 1955

Sergent 1957
Revised edition of Sergent 1934, Paris (Maison de Victor Hugo) 1957

Simon 1904
Gustave Simon, *Visite à la Maison Victor Hugo*, Paris, Librairie Ollendorff, 1904

Stockholm 1974
Goethe, Hugo, Strindberg, diktare, bildkönstnärer, exhib. cat., Stockholm, Nationalmuseum, 1974

Tokyo 1996
Le Siècle de Victor Hugo, exhib. cat. by Jean Gaudon, Tokyo, Odakyu Museum, 1996; exhibition traveled to Osaka, Koriyama, Hiroshima

Tours 1988
Violons d'Ingres, exhib. cat., Tours, Musée des Beaux-Arts, 1988

Valencia 1996
A través del claroscuro, exhib. cat., Valencia, Fundación Bancaja, 1996

Venice 1993
Victor Hugo pittore, exhib. cat. by Jean-Jacques Lebel and Marie-Laure Prévost, Venice, Galleria d'arte moderna, Ca' Pesaro, 1993; French edition *Victor Hugo peintre*

Vésinet 1978
Villes imaginaires – monuments étranges, exhib. cat., Le Vésinet, Centre des Arts et Loisirs, 1978

Victor Hugo: cent-cinquantième anniversaire de sa naissance, exhib. cat., Besançon, Musée des Beaux-Arts, 1952

Victor Hugo: dessins et ébauches, exhib. cat., Neuchâtel, Musée d'Art et d'Histoire, 1972

Victor Hugo et la Normandie, exhib. cat. by Elisabeth Chirol, Villequier, Musée Victor Hugo, 1985

Victor Hugo et les images, colloquium, edd. Madeleine Blondel and Pierre Georgel, Dijon (Aux Amateurs de Livres) 1989

Victor Hugo: exposition du cent-cinquantième anniversaire de la naissance, exhib. cat. by Georges Huard, Roger Pierrot, and Jean Prinet, Paris, Bibliothèque nationale, 1952

Victor Hugo: homme politique, exhib. cat., Paris, Maison de Victor Hugo, 1956

Victor Hugo raconté par l'image, Paris, Maison de Victor Hugo, 1930

Victor Hugo: théâtre de la gaîté, edd. René and Guy Robert, Annales Littéraires de l'Université de Besançon, Paris (Les Belles-Lettres) 1961

Vienna 1989
Wunderblock: eine Geschichte der moderne Seele, exhib. cat., Vienna, Wiener Festwochen, 1989

Villequier and Paris 1971–72
Dessins de Victor Hugo, exhib. cat. by Pierre Georgel, with essay by André Masson, Villequier, Musée Victor Hugo, and Paris, Maison de Victor Hugo, 1971

René Weiss, *La maison de Victor Hugo à Guernesey*, Paris (Imprimerie nationale) 1928

Zeichen ist Sehen. Meisterwerke von Ingres bis Cézanne aus dem Museum der Bildenden Künste Budapest und aus Schweizer Sammlungen, exhib. cat., Berne, Kunstmuseum and Hamburg, Hamburger Kunsthalle, 1996

Zurich 1987
Victor Hugo (1802–1885), Phantasien in Tusche, exhib. cat. by Harald Szeeman, Zurich, Kunsthaus, 1987

CHRONOLOGY

1802 February 26, Victor-Marie Hugo is born in Besançon (Doubs), the son of an army officer.

1817 Awarded a distinction by the Académie française for his competition poem. First illustrations made in school books.

1818 Hugo's parents obtain legal separation. First draft of *Bug-Jargal* (published in 1820).

1820 Granted royal gratuity for his ode *La Mort du duc de Berry*. Secret correspondence with Adèle Foucher.

1821 June 27, death of Hugo's mother, Sophie. Hugo's father remarries on July 20, marrying his mistress Catherine Thomas. Engagement of Victor and Adèle. Hugo begins the novel *Han d'Islande* (published in 1823).

1822 Victor awarded grant following *Odes et poésies diverses*. Adèle and Victor married at the church of St-Sulpice and set up home at 39, rue du Cherche-Midi.

1824 *Nouvelles Odes*. Léopoldine born on August 28. Participates in arts evenings in the Arsenal at Charles Nodier's house. Friendship with Achille Dévéria and Louis Boulanger.

1825 Made Chevalier de la Légion d'Honneur. In summer, travels to Geneva and Chamonix with Charles Nodier.

1826 Publication of the second version of *Bug-Jargal*, and *Odes et Ballades*. Begins *Cromwell*, published in 1827. Charles born on November 2.

1828 January 29, death of Hugo's father. François-Victor Hugo born on October 27.

1829 *Les Orientales* (*The Last Day of a Condemned Man*).

1830 In February, première of *Hernani*, performed amid riots. Daughter Adèle born on July 28. Hugo and his wife become increasingly estranged.

1831 *Notre-Dame de Paris. Les Feuilles d'automne*. First drawings: some interiors (chimneys, furniture) and childish caricatures. Illustrations decorate his plays.

1833 *Lucrèce Borgia*. Beginning of affair with Juliette Drouet.

1834 Beginnings of travels with Juliette. He sketches some of the visited places.

1835 *Angelo, tyran de Padoue. Chants du crépuscule*. Travels to Normandy and Picardy. Rupture with Sainte-Beuve. Literary caricatures and the creation of characters and cartoon strips for his children, such as *Pista* and *L'Histoire de l'enfant Troussard*.

1836 Fails twice to get into the Académie française. Travels to Brittany and Normandy, accompanied by Juliette Drouet and Célestin Nanteuil, who created the frontispieces for several of his early works. During these excursions, Hugo notes his observations with a pen: landscapes and architecture take up more and more space in his notebooks.

1837 *Les Voix intérieures*. Promoted to rank of Officier de la Légion d'Honneur. Travels to Belgium and Normandy. Becomes passionate about the intricate details of Gothic architecture. First wash drawings.

1838 *Ruy Blas*. Travels to Champagne.

1839 Begins *Les Jumeaux*. Travels with Juliette to Alsace, Switzerland, Provence and Burgundy.

1840 *Les Rayons et les Ombres, Le Retour de l'Empereur*. Travels with Juliette to the Rhine Valley. The drawings made during this trip alternate between topography and the pleasures of imagination. Wash drawings are still very rare.

1841 Elected to the Académie française.

1842 *Le Rhin*. Begins *Les Burgraves*. His son François-Victor becomes very ill with pleurisy.

1843 *Les Burgraves*. February 15, marriage of Léopoldine and Charles Vacquerie. Travels with Juliette to Spain and the Pyrenees. Remaining strictly descriptive, the drawings made this summer illustrate Hugo's theory of the unity of nature, forms melting into each other, slipping from vegetable to mineral, solid to liquid,

microscopic to gigantesque. September 4, Léopoldine and Charles drowned in the Seine. Victor Hugo only learns of their death five days later, reading the newspaper in Rochefort. Beginning of affair with Léonie Biard d'Aunet.

1845 Hugo appointed Peer of France. Begins writing *Les Misères*, later to become *Les Misérables*.

1846 Speeches before the Chamber of Peers. Death of Claire Pradier, the only child of Juliette Drouet. Charles becomes ill with typhoid. Since the death of his daughter Hugo has not traveled, with the exception of little excursions into the countryside near Paris and in Normandy. Drawings using wash and charcoal evoke landscapes of scrubland, sometimes reminiscent of the contemporary Barbizon school.

1847 Working on his novel *Les Misères*. Makes speech favorably inclined towards the return of the Bonaparte family in France. François-Victor and his mother become ill with typhoid. Four drawings etched by Alfred Marvy.

1848 The provisional government abolishes the Chamber of Peers. Hugo elected Paris Deputy for the Constituent Assembly. *L'Evénement*, favoring Louis-Napoléon Bonaparte as candidate for President of the Republic, is founded with his support. Speech on the freedom of the press. In a garret of his new apartment, Victor Hugo establishes a studio where he begins to work assiduously on drawings. His technique, formats and themes become richer, marking his ambition. *Taches*, stencils and mixed-media appear from this period.

1849 Hugo elected Paris deputy for the Legislative Assembly. President of the Peace Congress. Speeches on destitution and misery. Travels to Normandy. First folded drawings.

1850 Speech on freedom of teaching. Speech on support of universal suffrage. Large-scale drawings given to his friends, dedicated and sometimes framed. Many show castles or ruined towns.

1851 Violent speech against Louis Bonaparte.

Publication of *Quatorze discours*, grouping political opinion from these years. December, Hugo participates in the *coup d'état*. On December 11 he takes the train to Brussels. This marks the beginning of the exile from which he will not return until September 5, 1870, the day after the proclamation of the Third Republic.

1852 Louis Bonaparte signs his expulsion warrant. In August he leaves for Jersey and moves with his family into a big house on the sea, Marine Terrace. Article by Théophile Gautier in *La Presse* praising Hugo's art.

1853 Intense literary activity. Publication of *Châtiments,* an epic work renewing political verse. In early September Delphine de Girardin visits her exiled friends in Jersey and initiates them in table-turning. Hugo joins in these séances when his daughter, Léopoldine, dead for ten years, is manifested through a medium. Spiritualist drawings.

1854 *Lettre à Lord Palmerston.* Begins to write *La Fin de Satan* and other verses which will be placed in *Les Contemplations.* Spiritualist drawings and abandon to chance: confronted with the movement of the ocean and then the revelations of table-turning, wash is increasingly used. Hugo also makes a series of hanging pictures in reaction to the death sentence of J.C. Tapner, who killed to steal. Hugo's sons, with Auguste Vacquerie, become interested in photography and set up a studio. It is from this date that Hugo sends visiting cards to his friends, inscribed with his name or initials.

1855 Begins the major poem, *Dieu*. Séances end following the dementia of one of the participants, Jules Allix. Many drawings using folding, stencils and lace impressions; some of the more dramatic ones inspired by areas of the island. In fall expelled from Jersey because political activity deemed excessive. Arrives in Guernsey.

1856 Publication of *Les Contemplations*, collection of texts dating from various eras mark one of the peaks of French poetry. With the fees from this book, Hugo buys Hauteville House in which he installs himself on October 7. He actively takes over the interior decoration of the house, and makes numerous pencil and pen sketches detailing the layout of the rooms. As a continuation of the spirit drawings, the poet fills pages of his albums with

'bizarre' compositions. His daughter Adèle falls seriously ill.

1857 The publisher Hetzel rejects *Dieu* and *La Fin de Satan*, but asks for *Les Misérables*. Short visit paid by Alexandre Dumas. Juliette Drouet moves to Guernsey. Great activity in the decoration of Hauteville House. Seascapes inspired by the movement of the ocean introduce scenes from *Toilers of the Sea*.

1860 Interrupts *La Fin de Satan* and again picks up *Les Misérables*. Makes short visit to Jersey. His brother-in-law, Paul Chenay, successfully engraves a drawing of *Le Pendu* dating from 1854 under the title *John Brown*.

1861 For the first time since the exile, Hugo leaves the Channel Islands and goes to Belgium, where he finishes *Les Misérables*. He starts drawing again in a notebook interrupted in 1843. His son, Charles, decides to remain on the Continent.

1862 Publication of *Les Misérables*. Travels to Belgium, Luxembourg and the Rhine. Announcement of *Dessins de Victor Hugo*, engraved by Paul Chenay with a preface by Théophile Gautier.

1864 *William Shakespeare*. Begins *Les Travailleurs de la mer* (Toilers of the Sea). Travels to the Ardennes, the Rhineland and Belgium. Numerous sketches of places visited. Hugo's wife, Adèle, returns to Guernsey after an absence of over sixteen months.

1865 *Chansons des rues et des bois*. Many drawings made on trips to the sea which will be used in *Toilers of the Sea* or *The Laughing Man*. After the death of François-Victor's fiancée, Adèle Hugo settles with her two sons in Brussels. Hugo finishes *Toilers of the Sea*. He visits Brussels and travels to Germany and Luxembourg.

1866 Drafts *Mille francs de récompense*. Publication of *Toilers of the Sea*. He has bound into his own manuscript 36 wash drawings which fit closely with the story. Summer in Belgium, where he begins *L'Homme qui rit* (The Laughing Man).

1868 Finishes *The Laughing Man*. On August 27, his wife Adèle dies in Brussels. Hugo accompanies her coffin as far as the French border.

1869 Drafts *L'Epée. The Laughing Man*

published. Drafts *Torquemada*. Drawings of landscapes and heads. President of the Peace Congress in Lausanne.

1870 Charles and his family visit Guernsey. On September 5 Hugo returns triumphantly to France. Moves in with his friend Paul Meurice in Paris. First French edition of *Châtiments*.

1871 Elected Paris Deputy and joins the Assembly in Bordeaux, but resigns a month later. Sudden death of Charles in Bordeaux. Commune of Paris. Stays in Brussels and then in Vianden, where again he makes some remarkable drawings.

1872 *L'Année terrible*. Hugo returns to Guernsey where he remains for a year.

1873 Finishes *Quatre-vingt treize*.

1875 New series of drawings using *taches* and their random forms. Article by Philippe Burty in *L'Art*. Literary testament.

1876 Elected Senator. First popular publications of *Victor Hugo illustré* by Eugène Hugues.

1878 Suffers stroke. From this summer onwards virtually stops writing.

1881 Celebration to mark Hugo's eightieth year. Draws up his will, leaving manuscripts and drawings to the Bibliothèque nationale.

1883 Death of Juliette Drouet. Publication of *L'Archipel de la Manche*.

1885 May 15, suffers from a pulmonary congestion. May 22, he dies in Paris. June 1, State funeral.

1886 Posthumous publication of *La Fin de Satan*.

1888 First exhibition of drawings in Paris, initiated by his life-long friend, Paul Meurice.

1903 Creation of the Maison de Victor Hugo in 6, Place des Vosges, thanks to the efforts and generous gifts of Paul Meurice.

This chronology has been drawn up following those published by Sophie Grossiord in the general guide to the Maison de Victor Hugo and Hauteville House, Paris-Musées, Paris 1993 and 1994.

LENDERS TO THE EXHIBITION

The Art Institute of Chicago Bibliothèque nationale de France

Mr and Mrs Philippe Devinat John and Paul Herring

Galerie Berès, Paris Galerie Jan Krugier, Ditesheim & Cie, Geneva

Jan Krugier Gallery, New York Jan and Marie-Anne Krugier-Poniatowski

Maison de Victor Hugo, Paris Musée des Beaux-Arts, Dijon

Musée des Beaux-Arts et d'Archéologie, Besançon

Musée du Louvre, Paris Musée Victor Hugo, Villequier

Louis-Antoine Prat Carol Selle

PHOTOGRAPHIC ACKNOWLEDGEMENTS

When available, the names of photographers are provided in parentheses

The Art Institute of Chicago: cat. 55; Galerie Berès, Paris: cat. 74

Bibliothèque nationale de France, © Musées de la Ville de Paris: figs. 3, 7, 15, 17–18;
cats. 1–3, 17–19, 21–23, 25, 29, 32, 36–39, 63, 85–89, 91, 93, 97

Elisa Breton: fig. 4; Pierre Georgel: figs. 5, 12–14; John and Paul Herring (Camerarts, Inc.): cat. 66

Galerie Jan Krugier, Ditesheim & Cie, Geneva: cats. 7, 8, 9, 24, 45, 71, 101

Jan and Marie-Anne Krugier-Poniatowski: cats. 10, 35, 54, 58

Maison de Victor Hugo, Paris, © Musées de la Ville de Paris (Philippe Ladet): figs. 21, 23; cats. 4, 6, 15,
20, 33, 46, 56, 57, 62, 65, 67-70, 73, 75, 76, 78, 84, 92, 94, 95, 99, 100

Maison de Victor Hugo, Paris, © Musées de la Ville de Paris: half-titlepage, figs. 1–2, 8–11, 16, 20, 22, 24;
cats. 5, 16 (jacket/cover image)

Musée des Beaux-Arts, Dijon (François Jay): fig. 6; cats. 34, 96

Musée du Louvre, Paris, Réunion des Musées Nationaux (Michèle Bellot): cats. 77, 79

Musée Victor Hugo de Villequier (Yohann Deslandes): cats. 31, 40, 41, 49, 50, 61, 80, 82, 83, 102

private collection (Piotr Trawinski): fig. 19; cats. 11–14, 26–28, 30, 42–44, 47, 48, 51–53, 59, 60, 64, 72, 81

Private collection (Jacques L'Hoir): cat. 90; Private collection (Malcom Varon): cat. 98